SIENESE PAINTING

BOOKS BY BRUCE COLE

Italian Art 1250–1550
Sienese Painting in the Age of the Renaissance
The Renaissance Artist at Work
Sienese Painting from its Origins to the Fifteenth Century
Masaccio and the Art of Early Renaissance Florence
Giotto and Florentine Painting 1280–1375
Agnolo Gaddi

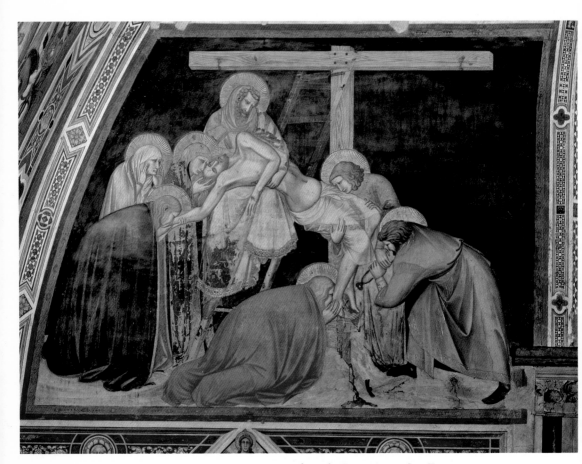

PLATE 1. Pietro Lorenzetti. *Deposition from the Cross*. Assisi, San Francesco.

SIENESE
PAINTING

From Its Origins
to the Fifteenth Century

BRUCE COLE

Icon Editions

1817

HARPER & ROW, PUBLISHERS, New York
Cambridge, Philadelphia, San Francisco, Washington
London, Mexico City, São Paulo, Singapore, Sydney

For Charles Mitchell

A hardcover edition of this book is published by Harper & Row, Publishers, Inc.

First ICON paperback edition published 1987.

Designer: Sidney Feinberg

Library of Congress Cataloging in Publication Data

Cole, Bruce, 1938–
 Sienese painting, from its origins to the
fifteenth century.
 (Icon editions)
 Bibliography: p.
 Includes index.
 1. Painting, Italian—Italy—Siena. 2. Painting,
Gothic—Italy—Siena. 3. Painting, Renaissance—
Italy—Siena. I. Title.
ND621.S6C65 1987 759.45′58 79-3670
ISBN: 0-06-430172-9 (pbk.)

87 88 89 90 91 HAL 10 9 8 7 6 5 4 3 2 1

CONTENTS

Color plates follow page 114.

PREFACE

THIS BOOK is designed to provide an introduction to painting in Siena from the inception of the school to the fifteenth century. That there is a need for such a book is clear to anyone who has been asked to recommend a survey of early Sienese painting or tried to buy something on the subject in a bookstore, even an art bookstore. Aside from E. Sandberg-Vavalà's splendid but long-out-of-print study (*Sienese Studies,* Florence, 1952) of the works in the Pinacoteca of Siena, there is little on the fourteenth century that is up to date or attractive to the general reader.

I have often wondered why there is a dearth of introductory literature on early Sienese painting, especially after the exciting pioneering work of Berenson, Mason Perkins, Pope-Hennessy, Brandi, Carli, and others. One reason may be that many younger students have turned away from the broad views of their predecessors toward a much narrower interest in the problems of dating and attribution. In fact, the great majority of studies published since World War II have been highly technical exercises in connoisseurship written by art historians for other art historians.

My book is not intended for professional art historians but for the general reader or student of art who wants an introduction to Siena's greatest period of painting. Consequently, I have concentrated on the story of the genesis and development of the early art of Siena and have tried to avoid the more tedious and often less worthwhile minutiae of the connoisseur's trade. On occasion I have omitted paintings of some importance in the belief that it is better to discuss a limited number of examples in detail than a great many superficially. I have

fashioned the notes and bibliography as a guide to those who wish to pursue more specific study.

The writing of this book has been a rewarding experience, for it has allowed me to live in daily contact with paintings which are, to use Berenson's words, life-enhancing. Days spent in the luminous quiet of the Siena Gallery, in the cool darkness of provincial churches and on the roads winding through the smiling Tuscan countryside remain among the happiest of memories. It is my single hope that I have been able to convey some of the excitement and joy I have felt while looking at these transcendent pictures.

I am grateful to the John Simon Guggenheim Memorial Foundation, the American Philosophical Society, the Samuel H. Kress Foundation, and Indiana University for grants which allowed me to spend time in Italy. In Bloomington, Helen Ronan helped with every stage of the book; without her it would still not be finished. Also I owe a sizeable debt to the editorial talent of Linda Baden and the encouragement of Heidi Gealt. Thanks are due as well to Alberto Cornice, Mary M. Davis, Carol E. W. Edwards, Barry Gealt, Pamela J. Jelley, Ulrich Middeldorf, and Carol Peters. My wife Doreen was a constant source of support, and Stephanie and Ryan provided just the right balance of interruption and peace. However, I am indebted above all to Cass Canfield, Jr., whose interest and aid made this book possible.

BRUCE COLE

Bloomington, Indiana

PREFACE TO THE PAPERBACK EDITION

IN THE SEVEN YEARS since this book first appeared, interest in early Sienese art has burgeoned. The number and quality of exhibitions, books, and articles on early Sienese art has increased dramatically, while the cleaning and restoration of panels in and around Siena has proceeded apace. All this has broadened and deepened our knowledge of Sienese painting and further confirmed its significance. Consequently, for this paperback edition I have appended a bibliography of the most important new books and catalogues; I have also used the occasion to hone the text and correct several errors.

February 1987 B.C.

INTRODUCTION

R ISING ABOVE THE SURROUNDING COUNTRYSIDE, Siena is visible for miles, the tall towers of its Cathedral and town hall beacons for the traveler. Like a three-pointed star, the city winds its way over the hills on which it sits, its narrow, building-lined streets twisting, turning, ascending and descending in chaotic fashion.

Siena is a city of brick and stone. The brick—its range of color runs from a deep brick red to almost pink—is especially impressive. There is a blending of this brick, the multicolored stone, the thousands of red tile roofs and the bright blue Tuscan sky which gives the city a sunny, welcoming quality.

Although walled, Siena retains many physical ties with the surrounding countryside. Filled with open green spaces in its courtyards and piazzas, it overlooks some of the most beautiful and varied areas of Tuscany.[1] Deep green cypresses and delicate silvery olives appear amongst the abundant vineyards and checkerboard fields of this long-cultivated land. Gently rolling hills covered with grain and capped by single, elegant cypresses dot the landscape, giving it a strange, wavelike feeling. The red roofs of little towns scattered throughout the countryside add spots of warm color. A more somber note is furnished by the desert-like clay hills to the south of the city. Gentle, rich, and everywhere bearing the mark of the human hand, the land enjoys a symbiotic relation with the city: one is impossible without the other, and both seem immutable.

The two major centers of Siena are the Palazzo Pubblico (the town hall) and the Duomo (the Cathedral). Because there was a constant intermingling of religious and civic life in Siena (as in all other Tuscan communes), there was no

polarity between the two centers. Rather they, and all aspects of the city's fabric, were part of a society that did not make distinctions between church and state.

The city's business was done in the huge Palazzo Pubblico, which sprawls in front of the fan-shaped piazza called the Campo.[2] Built of brick, fortress-like and dominating its surroundings, the Palazzo Pubblico was the seat of Siena's government and the symbol of its authority. Begun in the late thirteenth century, its construction coincides with the apex of Sienese power. It was also important for art: some of the most renowned artists of the city were commissioned to work in its spacious halls, where they painted and carved images of civic-religious content expressive of the ideals of the commune. These were a vital part of the Palazzo because they provided both examples of correct behavior and splendid decoration.

Looming over its neighborhood, the Cathedral is the other center of Sienese life.[3] One of the largest Tuscan churches, it is a wonder of exuberant decoration: striped in black and white marble, decorated with scores of architectural details and complete with an elaborately carved facade, the structure overwhelms the visitor standing in its spacious piazza.

In the darkness of its vast interior (also striped in black and white) were housed many of the treasures of Sienese art created by the same painters and sculptors employed in the Palazzo Pubblico. The crowning glory was Duccio's *Maestà,* placed on the high altar, but important works by generations of other Sienese painters also graced the building.

While the Duomo and the Palazzo Pubblico are the major centers of the city, there are many other noteworthy structures. The giant churches of San Domenico and San Francesco, the home of the mendicant orders so influential in town life in the thirteenth and fourteenth centuries, are among the most remarkable of the city's many religious houses. The houses of Siena's more worldly citizens, the elegant palaces of the nobles and wealthy burghers (some now converted into banks and museums), still furnish testimony to the ambition of Siena's vanished rulers and patrons of art. Everywhere there is an architectural elegance, sobriety and decorum that is characteristic of the city's art.

The impact of Sienese architecture and art did not stop at the city walls, but spilled out over all Sienese territory. In the many towns dependent on the city there still exist some of the masterpieces of Sienese style. The small provincial museums of Asciano, Montalcino, San Gimignano and Pienza, to name just four, contain works of astounding quality and importance.

Siena's origins are uncertain, but they were most likely Roman.[4] Before the middle of the twelfth century little is known about the city. Around 1150 it, like

a number of other Tuscan communes, began to grow in population, form its own institutions, and expand into the surrounding countryside. A fierce rivalry with Florence developed, which was to lead to the key battles of Montaperti—where in 1260 the Sienese routed the Florentines, who left 10,000 dead on the field— and Colle Val d'Elsa (1269), which marked the defeat of the Sienese and their decline as a Tuscan power.

Because it lacked the natural resources of Florence, especially water, Siena never became a manufacturing center. What wealth the city had was mainly derived from trading and banking: the Sienese were for many years the Pope's bankers, a lucrative appointment that helped them establish business contacts all over Europe. But without a strong manufacturing base the city was unable to become one of the powers of the Italian peninsula. The apex of Sienese territorial expansion and the height of the city's prosperity, in fact, roughly coincide with the chronological limits of this book. After the late fourteenth century Siena came increasingly under the sway of the Florentines and was relegated to a much more provincial role.

Sienese artistic life was organized around a workshop system where masters taught youthful apprentices the craft of painting. Each artist and every apprentice believed that he was practicing a trade about which there was nothing exotic. Hard work, long study, the imitation of other artists' work and a mastery of materials were the prerequisites for success: none of the modern notions of genius and eccentricity were attached to the making of pictures and sculpture.[5]

Many of the artists were related either by blood or marriage. Like some of the other trades, apprenticeship and entrance into the guild seems to have been easier with family connections. There were artistic clans in which the business (and probably the tools of the trade) was passed from generation to generation. The entire production of the art of Siena was controlled by family, apprenticeship, guild and contract.[6] As in most other activities of the fourteenth century, art was made within the confines of an ordered, highly legalistic system.

Nor did the artists have much choice over what they were to paint. While not all works were done on commission, the majority were ordered by a patron who had something specific in mind. There was a repertoire of images from which to choose, and here, as in all other aspects of early Italian art, imitation and a respect for tradition were encouraged.[7] Yet, as the illustrations to this book prove, the art of Siena was never static. Sometimes stunning invention occurred, but more often there was a slow development of images and style which resembled a variation on a musical theme in which, by contrast, each modification enriches

our appreciation and understanding of the central motif. It is astounding to realize how much freedom the artists had within the rigidly prescribed conventions of their time.

But the fourteenth century did not think of the paintings discussed in the following chapters as works of art in the same way that we do. They were not meant to be objects hung on the walls of museums and admired only for their beauty. Rather, paintings and statues were, first and foremost, holy things intimately connected with the liturgies that were performed before them in the churches. These holy images were thought to contain the power of the beings they represented; they were viewed with awe. There are numerous records of carved Christs and painted saints miraculously intervening in the lives of those who worshipped them.[8] It is true that the worshippers of the fourteenth century admired the splendor of the panels that stood on the altars and the statues that decorated the churches, but they also saw in them a supernatural force alien to our interpretation of these objects. To them they were much more than works of art.

During the fourteenth and early fifteenth centuries there was in Siena a bewildering, almost unique progression of artistic talent. This is remarkable when one considers that it sprang from a city set deep within the Tuscan hills, a city without ancient artistic traditions and lacking vast resources. Why this flowering of art should have taken place during these years is, like all fundamental questions concerning creativity, unanswerable. Yet the fact remains that the story of Sienese painting to which we now turn is one of the most engrossing in the history of art.

I

THE BEGINNINGS
OF SIENESE PAINTING

ONLY A FEW OF THE EARLIEST Sienese panels remain, mute witnesses to the beginning of the city's art. Perhaps the oldest extant paintings produced in and around Siena are several rather battered crosses which seem to date from the early years of the thirteenth century. Although these works probably originated in Siena, their style does not suggest that they are the products of artists trained in a recognizable, local tradition. Instead, they seem to be influenced by several other centers: in iconography by the artists of Spoleto, a city in Umbria, south of Siena, and in style by Lucca, one of the first Tuscan centers of artistic production during the Duecento.[1]

The paucity of surviving paintings and the eclectic nature of the early crosses suggest that there were few commissions, and hence few artists, working in late twelfth- and early thirteenth-century Siena. Like Florence, whose artistic personality was germinated even later (around the middle of the Duecento), Siena seems to have been a slow starter. The reasons for this are complex, but it is interesting to note that these two most important and influential schools of Tuscan painting —Florentine and Sienese—both emerged fully formed from a mysterious past only in the later part of the Duecento.[2]

Another of the first Sienese paintings is the 1215 dossal with the Blessing Christ surrounded by six scenes (Pinacoteca Nazionale, Siena) [1]. This splendid work makes telling use of the considerable amount of gold covering its surface. Almost everywhere—from the patterned borders to the areas between architecture and figures—the shimmering metal attracts and holds the spectator's glance. Of course, in the darkened chapel of a church illuminated only by lamp or

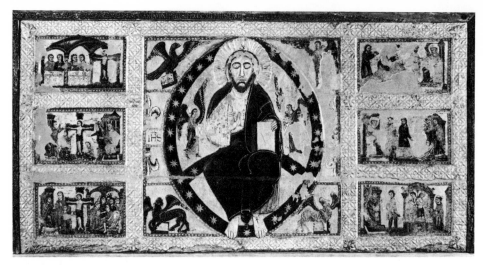

1. Sienese. *Blessing Christ and Six Scenes.* Dossal. Siena, Pinacoteca Nazionale.

candlelight, this gold would have been even more captivating.

The compositional style of this work seems to have been influenced by the established schools of west Tuscany, Pisa and Lucca especially. Architecture is rendered summarily, while the figures are set down in a schematic yet vigorous way, very reminiscent of some of the earliest Pisan crosses of a century before. One should be careful, however, not to overstate the differences between the various schools of Tuscany during the first three-quarters of the thirteenth century. On the whole, the artists of all these centers shared a more or less common pictorial language and iconographic tradition. Certainly, there were emerging local differences, but these were like varying accents in a single language.[3] This situation continued until the triumph of the independent idioms of Florence and Siena at the end of the Duecento.

Several points of similarity between the early Sienese crosses and the Pinacoteca dossal can be noted, however. Perhaps the strongest is found in the palettes. While these are not composed of exactly the same colors, they are all extremely colorful. The crosses are covered with blues, reds, blue-greens and browns, while the dossal, aside from the rather lavish use of gold, displays pinks, brick reds, blues, browns and black. Color is used both as an aid to the construction of form and as an independent, highly decorative compositional agent to enliven the surface of the picture.

This is interesting, for one of the most important characteristics of Sienese painting from the late Duecento to the late Quattrocento is its sophisticated, daring, and joyful use of color. It is tempting to see in these several early pictures

an already developed sense of color which was to be so important a part of the later history of Sienese painting.

On the upper frame of the Pinacoteca dossal is the date 1215. This indicates that by the very early years of the Duecento there was at least some artistic activity in Siena. The style of the Pinacoteca dossal and of the crosses suggests that during these early years Siena was a rather dependent, provincial center, influenced by the older and highly diffused idioms emanating from the western Tuscan centers of Lucca and Pisa, two cities which had developed economically, socially and artistically long before Siena.

After the first years of the Duecento there is a hiatus in our knowledge of the city's painting, lasting until the final decades of the century. Whether there was almost no artistic activity during the period c.1220 to c.1260, or whether nearly everything from that time has been destroyed, is unclear. It is fascinating but futile to speculate on what may have been happening during this dark period of Sienese art. In any case, the following decades of the sixties and seventies witnessed an artistic awakening, both in the number of commissions and in the very nature of the art that graced Siena.

In 1265, the great Pisan sculptor Nicola Pisano was employed to carve a large pulpit [2] for the Sienese Cathedral.[4] He must have already been famous for his earlier pulpit in the Pisa Baptistry, which made a decisive break with previous Tuscan sculpture. The Sienese pulpit, one of the largest and most monumental sculptural projects in the city's history, is executed in a more complex, more intricate, and more expressive style than the earlier Pisan work. This change can be explained in part by the role played by the four assistants on the project mentioned in the documents: Lapo, Donato, Arnolfo di Cambio and Giovanni Pisano, the artist's son. Lapo and especially Arnolfo were to become important sculptors whose styles had a profound impact on the art of the late Duecento.[5] Giovanni Pisano, apparently still an apprentice in the 1260s, was to develop a highly innovative and personal style which, as we shall see, was to have a noteworthy influence on Sienese Trecento painting.[6] Seldom, in fact, have such talented and noteworthy artists assisted on a single project.

Nicola's imposing pulpit, completed in 1268, must have been immediately admired and studied by every Sienese artist. From it they could have learned, as from no other work of sculpture in Siena, how to construct the human body and how to depict it in motion. The massive, rotund figures along the pulpit's base must have seemed almost unbelievably real to eyes trained in the tradition of the early Sienese crosses. Economical, graceful, direct and full of life, these figures and

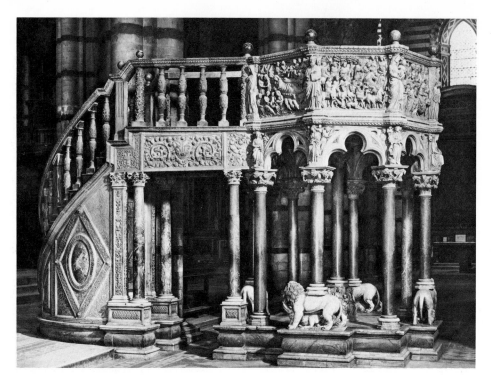

2. Nicola Pisano. Pulpit. Duomo, Siena.

the other statues that decorate the pulpit offered an artistic vision entirely new to provincial Siena.

The narratives which covered the upper part of the pulpit were equally stimulating. One has, for example, only to look at the *Crucifixion* with its volumetric, contorted Christ and waves of twisted spectators and mourners, to see that these scenes are conceived with a seriousness and power unmatched in previous Sienese art [3]. Nicola's ability to clearly express strong emotion—through both the gesture of the body and the handling of the face—is astounding today. To contemporary Sienese artists a relief like the *Crucifixion* must have been breathtaking indeed.

Shortly after the completion of Nicola's pulpit, the first art which can rightly be called Sienese in style appears. Guido da Siena seems to be the first Sienese artistic personality to whom a name and a body of works can be attached. He also appears to be the first painter to have established a style which found some acceptance among a group of followers. Although nothing is known of his life, he can, all in all, be called the earliest truly Sienese artist.[7]

Exactly when and where Guido was trained is unknown. Since one of his

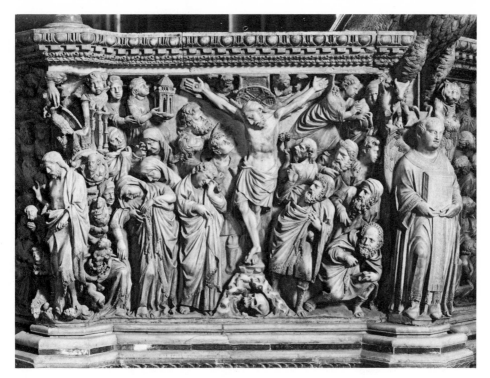

3. Nicola Pisano. *Crucifixion.* Duomo, Siena.

pictures bears an inscription dating it in the seventies, and another seems to have had an inscription with the date 1262, one can assume that Guido was an independent, fully trained artist by the late fifties or very early sixties. His last works—and again, there are no documents to verify this—appear to date from the ninth decade of the Duecento.

A large, once full-length *Madonna and Child* (Pinacoteca, Siena) seems to be among Guido's earliest panels [4], although, like many other pictures attributed to him, this is controversial; some critics claim that the panel is by his shop and others doubt that the date of 1262 (formerly on the panel) was original. But both the quality of the work and the nature of its style support an early dating and ascription to Guido.

Date aside, this panel is a stunning, beautifully colored altarpiece very much in the style of a small group of pictures identified as coming from Guido's hand. It rivets the spectator's glance by the power of its images and the formal language in which they are expressed. One really feels in the presence of these two highly volumetric figures, which are created with an amazing boldness and breadth.

To see just how evolved this style was, one can compare Guido's *Madonna*

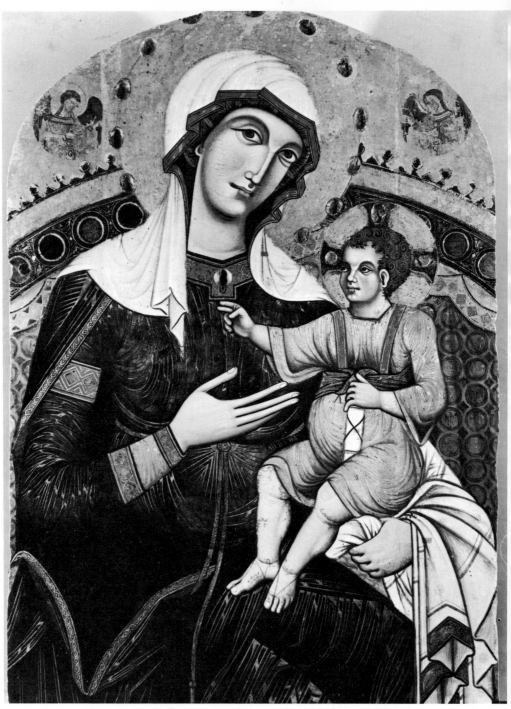

4. Guido da Siena. *Madonna and Child.* Siena, Pinacoteca Nazionale.

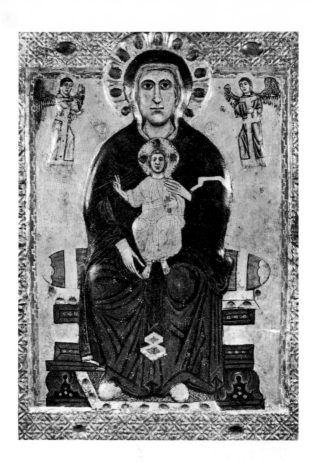

5.
Sienese. *Madonna degli Occhi Grossi.* Siena, Museo dell'Opera del Duomo.

with the so-called *Madonna degli Occhi Grossi* (Museo dell'Opera del Duomo, Siena) painted about forty years earlier [5]. At first glance one sees that the later Madonna is radically different. Instead of conceiving the figures as abstract, linear forms without volume, Guido has painted two beings who are much more convincing, palpable and definable. The highly iconic, removed and isolated Madonna of the *Madonna degli Occhi Grossi* has been supplanted by a personage who seems very aware of the viewer's presence.

In form and content these pictures represent two different worlds. Each panel clearly demonstrates how artists, their patrons and the worshippers who prayed before them visualized their two most important deities. The beginning of the thirteenth century still saw Christ and the Virgin as superhuman, removed, omnipotent. Unwaveringly, they look down upon those who ask their aid. They were icons to be feared and implored.

But with the gradual emergence of urban life in Tuscany and the rise of the personal, humane view of Christianity preached by St. Francis and his followers,

the spiritual life of the thirteenth century began to change. Devotional literature from this time, such as the *Meditations on the Life of Christ,* the *Golden Legend,* and a number of Franciscan tracts, increasingly emphasizes the human and fragile nature of Christ and the saints. The reader is constantly asked to put himself into the holy scenes and to partake in their action and emotion. A more personalized, less dogmatic religiosity was springing up among the burgeoning cities and hill towns of Tuscany.[8]

This new spirituality, which appears in the art of a number of Tuscan centers, including Siena, is at least partly responsible for the conceptual differences between the art of the early and late Duecento. It is as though the frozen and schematized lines of the *Madonna degli Occhi Grossi* have been vivified in Guido's pulsating picture. Of course, the *Madonna* by Guido is not (to modern eyes anyway) extremely lifelike. But she is, nonetheless, a much more palpable and communicative being than anything previously produced in Siena.

Where does this surprising and effective formal language originate? The usual answer points to the influence of Coppo di Marcovaldo, a Florentine painter —the first known by name—who was captured by the Sienese in the Battle of Montaperti in 1260 and who painted a large *Madonna* [6] in the church of the Servi the following year.[9] But is this hypothesis—which has become an accepted idea—really correct?

Coppo's *Madonna* (often called the *Madonna del Bordone*) was repainted around 1300; the face is entirely by the hand of someone very close to Duccio. But a radiograph reveals that the original face, which still exists below the repaint, is of a highly schematic and abstract nature.[10] Much the same is true of the other parts of the picture from which the repaint has been removed: the robes fall in extremely stiff, almost knife-edge folds; the striation on the drapery is pattern-like, with little correspondence to the actual folding of the material; the cloth on which Christ sits is rigid and convoluted; and the carpet, throne seat and bolsters are piled up without any attempt at creating a convincing spatial recession. Compared to Guido's Pinacoteca *Madonna* (probably dated 1262) or any other work by him or his circle, Coppo's 1261 *Madonna* seems less unified, more abstract, more geometricized. In short, more old-fashioned. His palette is also duller and less varied (browns, reds, red-yellows) than the brighter, more striking color of Guido's *Madonna.*

However, if one examines the other pictures attributed to Coppo (a Madonna in Orvieto or a cross in San Gimignano, both probably from the 1270s), one finds them more like Guido's work, more organic and resolved, both in their

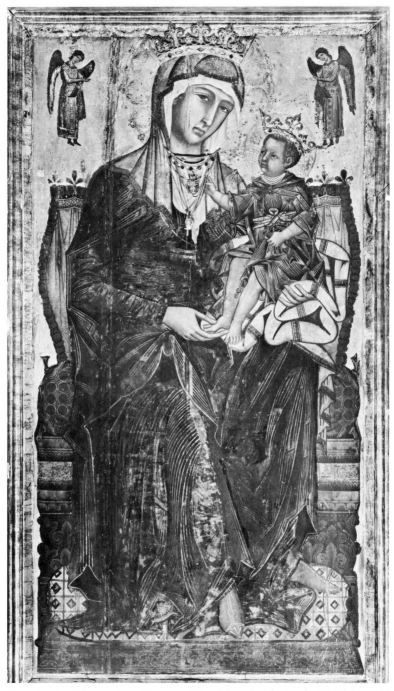

6. Coppo di Marcovaldo. *Madonna del Bordone*. Siena, Santa Maria dei Servi.

forms and the placement of those forms in space. In the works of Coppo and
Guido there is an evolution toward a more realistic treatment of images, and in
this development each artist participates in a formal process taking place in both
Siena and Florence during the late Duecento. But without more documentation
(the 1261 date on Coppo's *Madonna* is not alone sufficient proof) one cannot
really tell how, when, and where (if at all) one artist influenced the other. It is
just as likely, given the highly abstract formal properties of the 1261 *Madonna*
by Coppo, that Guido influenced Coppo as much as Coppo influenced Guido.
In all likelihood, both these artists—who worked in the same general Tuscan style
—influenced each other.

7. Guido da Siena. *Transfiguration, Entry into Jerusalem, Raising of Lazarus.*
Siena, Pinacoteca Nazionale.

The full range of Guido's more mature style is seen in three scenes painted
on linen in the Pinacoteca, Siena: *The Transfiguration, The Entry into Jerusalem,*
and the *Raising of Lazarus* [7]. In the *Entry,* the first narrative Sienese painting
we have seen, Guido introduces a plethora of images arranged before, within and
behind a range of pink and blue mountains which sweep diagonally across the
lower half of the picture. These curving, complicated masses give the surface a
spirited animation. Also full of energy are the sinuous trees and bushes which

spring up everywhere, their branches and leaves wonderfully silhouetted against the background of gold and mountains. All the natural elements in this picture impart a fantastic, unreal quality to the work and there is, throughout all three of these paintings, a very conscious and careful cultivation of unreality. This is interesting, for one of the major characteristics of early Sienese painting is the appearance of a refined, beautiful world lying somewhere just outside of the viewer's experience. It is noteworthy that one of the earliest surviving narratives depicts the story of the Entry into Jerusalem in these terms.

Also characteristically Sienese is Guido's color. The toylike city at the upper right, with its pink walls and blue, pink, green and yellow buildings, reminds one of an artist's palette covered with blobs of paint. The cascading, multicolored mountains form two large color areas interspersed by the reds, pinks, blues, purples and browns of the figures' robes. In the upper left corner, the gold of the background is broken only by the gently twisting trees. Here, certainly, is the work of a skilled and experienced colorist; one wonders where Guido learned to use color and with whom he studied during those mysterious years around the middle of the Duecento.

Each of the figures is endowed with a springy vivacity that recalls earlier Sienese pictures—the 1215 Pinacoteca dossal, for example. Everywhere one sees crisp gestures as the figures bless, point to something or simply bubble over with enthusiasm. Their long faces, prominent features and inquiring eyes lend further interest to the picture.

A supple, free brush has built up the picture's surface. The figures and landscape are constructed with considerable breadth, and the extensive use of white highlighting gives the objects volume and palpability.

This same broad conception of form appears in Guido's *Madonna and Child with Four Saints* (Pinacoteca, Siena) [8]. In the arrangement of this damaged picture's figures (it is missing one saint to each side) one sees another of the characteristics which will become a fundamental part of Sienese paintings: the subtle disposition of the figures. The interval between each figure is carefully calculated. Space flows around each of the bodies and the gold is pressed into shapes of exquisite, abstract beauty. The frame above also echoes the rounded contours of the saints. There is a refinement of composition in Guido's panel (which, on the basis of a damaged inscription, can be dated to the 1270s) that will be shared by many of his artistic heirs. In this altarpiece, as in his three scenes from the life of Christ, Guido was a pioneer. A number of his works exhibit, sometimes in embryonic form, the traits that will distinguish the art of Siena for

8. Guido da Siena. *Madonna and Child with Four Saints.* Siena, Pinacoteca Nazionale.

over a century.

The sprightly palette of the *Entry* is also seen in the Madonna and the saints surrounding her. This picture, like many others of Guido and his close circle, is compellingly colored. Its bright, variegated hues form an exciting display of original and sophisticated color. The Madonna wears a dark red tunic striated with gold, and a dark mantle (probably originally blue) covered with a circular pattern. The forceful opposition of these two colors is matched by the contrast of the Child's pink robe with his clear blue sash. This last color is repeated (now interspersed with white) in the scarf the Virgin wears around her hair. There is throughout these images of mother and Child the insistent contraposition of large, unmodulated areas of contrasting colors.

Much the same is true of the rest of the painting. Red (on the cloaks of the two St. Johns to either side of the Madonna, the Magdalen's robe and St. Francis's book) is the color note which ties this broad altarpiece together. Browns, light purples and gold also appear frequently.

Guido's expressive, plastic faces are tinged with the melancholy so often encountered in later Sienese painting. The gently inclined head of the pensive Madonna imparts an air of sadness to the picture. Christ's intelligent, alert face stares in the direction of his blessing. The expressive side figures look out at the viewer with a mixture of worry and reflection.

Although it is dated 1221, Guido's Palazzo Pubblico *Madonna and Child* (his most famous painting) [9] must come from around the time of the Pinacoteca

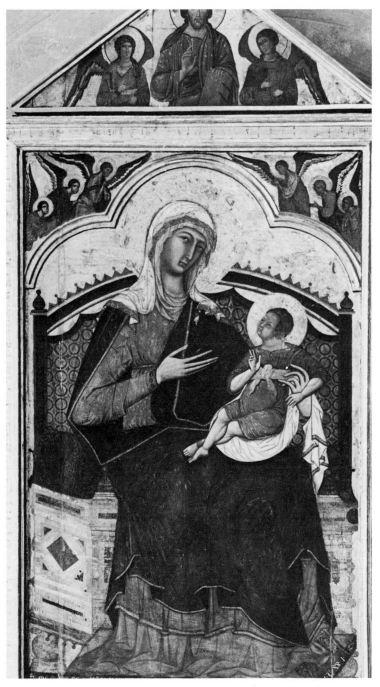

9. Guido da Siena. *Madonna and Child.* Siena, Palazzo Pubblico.

Madonna and Child with Four Saints. For years those who longed to see Siena as the first of the Tuscan schools of painting accepted the 1221 date as original. However, more recent scholarship on early Sienese painting has made clear that such an early date is impossible, and critics have concluded that the date—which is a later addition—must refer to something other than the year in which the picture was painted.[11]

Guido's Palazzo Pubblico *Madonna,* almost 4 meters tall, is one of several huge altarpieces painted during the last decades of the Duecento, a period which saw the commissioning of some of the largest pictures in the entire history of Italian art. The sheer size of Guido's great work must have made it the focal point of San Domenico, Siena, where it rested above the high altar.

Unfortunately, the picture suffered an extensive repainting (or, one should say, modernization) in the early years of the Trecento. Recent restoration has removed a great deal of this overpaint, but the original faces were scraped off before the repainting. A similar fate was suffered by a number of other pictures (Coppo's 1261 *Madonna del Bordone,* for example). This remodeling reveals that the Sienese of the early fourteenth century wanted to modernize certain of their older images, a desire that was no doubt provoked by the stunning stylistic innovation of Duccio from the 1280s onward.[12]

Perhaps the most impressive feature of Guido's Palazzo Pubblico *Madonna and Child* is its color. Red, seen in abundance in the *Madonna and Child with Four Saints,* also plays a predominant role here: it appears on the Madonna's tunic (shot through with gold striations), on the wide back of the throne, and in several other smaller areas throughout the picture. This red makes strong contrast with the Madonna's black robe, the green of the Child's robes and the touches of blue in the throne's decoration. White, on the Madonna's scarf and the robe held under the Child, sweeps across the center of the painting. Especially beautiful are the angels who occupy the spandrels. Their robes of different colors (blue, green, red, brown, purple) direct the eye in a series of smooth but persistent moves across the upper part of the picture. Each robe is painted with subtle, delicate and highly original hues. The Palazzo Pubblico *Madonna* demonstrates Guido's complete control of his palette and anticipates the genius of Duccio's color by nearly a decade.

Probably among Guido's last works, the Palazzo Pubblico *Madonna* reveals that the artist was becoming increasingly confident in the placement of figures and objects in space. From the Child to the Madonna and then to the throne back, one senses a real progression into depth. Each object is endowed with a corporeal

form which gives it substance and helps to define its location. This is very different from the much more jumbled conception of Coppo's 1261 *Madonna,* where space is developed up and down the picture plane. Guido's space is more unified and coherent; Coppo's is episodic.

With his increasing mastery of painted space, Guido grew more skilled in the realistic depiction of objects. Around the Madonna's head and under the Child, the drapery now has a weight and softness not seen in Guido's earlier work. The gold striations on the figures' tunics move in the direction of the fall and twist of the cloth. No longer stiff decorative patterns, as on the robes of Coppo's *Madonna,* the striations now act almost like flickering highlights across the surfaces of the cloth. This remarkable change clearly indicates a major shift in the conceptualization of objects from abstract to realistic.

Exactly how these substantial modifications in the depiction of space and the objects that occupy it came about is unclear. It is possible that Cimabue, the important Florentine artist who began to work around the seventies, may have been an influence on Guido.[13] His paintings (several will be discussed shortly) are of a powerful, monumental nature that in many ways anticipates Giotto. The solidity and broadness of Guido's large Madonna is in some ways related to Cimabue, but both idioms arose out of (and were part of) a style that had not yet become decidedly regional. It was, generally speaking, still a style shared—with some clear differences—by artists who worked all over central Tuscany.

It was also around the same time (the seventies to mid-eighties) that the single most powerful force in Sienese painting, Duccio, began his career as an independent artist.[14] Undoubtedly Duccio's style owes much to Guido—he may even have trained in Guido's shop—but there is a good possibility that the older artist was influenced by the work of the young genius. In the Palazzo Pubblico painting, the swinging folds of the white cloth framing the Madonna's face and beneath the Child, and the gold hem which slowly wends its way around the mantle of the Virgin, might well be Guido's interpretations of some of Duccio's early motifs. But one simply does not know in what order things occurred. All these artists—Guido, Cimabue and Duccio—were contemporaries for a number of years and their influence was probably reciprocal.

The idiom of Duccio was to become the major force in early Sienese painting, but before its influence swamped that of Guido, there appears to have been a short-lived, unified group of painters who followed Guido's style closely. This group seems to have constituted the first real stylistic circle in Siena. One of the best and most representative of this circle is an artist referred to as the Master

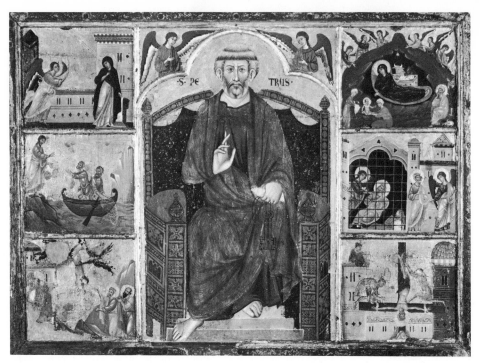

10. Master of the St. Peter Dossal. *St. Peter and Six Scenes.* Dossal. Siena, Pinacoteca Nazionale.

of the St. Peter Dossal, after his picture of around the mid-eighties now in the Siena Pinacoteca [10].[15] This splendid painting of the enthroned St. Peter surrounded by six scenes follows a Duecento format popular since the 1215 dossal in the same gallery.

The majestic figure of Peter is a powerful, arresting image. Placed firmly on his great throne (note how the armrests recede on either side), he pulls the spectator into his physical and psychological orbit with his fixed stare and the gesture of his right hand. The artist has been especially careful to extend the saint's body across the throne, and in this he is following the lead of Guido, who in works like the Palazzo Pubblico *Madonna* strove to make his figures occupy a considerable lateral space.

Peter is slightly more volumetric than Guido's Madonna. The bulk of his body is seen through his robes at the right arm and the knees. His large feet extend from beneath the cloth down the steps of the throne. He is indeed an extraordinary presence—not like the majestic, removed Christ of the 1215 dossal or the *Madonna degli Occhi Grossi,* but a more palpable and immediate being. The change between these figures mirrors the profound difference between the early

and the late Duecento.

At the upper left corner of the St. Peter panel is the *Annunciation*. Before a low wall bounded on either side by two towers, the angel sweeps in to make its sacred pronouncement. Its movement is echoed by the tall tower at the left set at an angle to the picture plane, so that the sides recede rapidly. Conversely, the Virgin's more static, self-contained pose is mirrored by the large structure behind her, which makes a note of stability and geometric calm. The flight of the wall across the surface of the painting seems to carry the message from the angel's outstretched arm toward the Virgin. All this careful composing reminds one of Guido's *Entry into Jerusalem,* where architecture and landscape work to activate the spectator's eye. Perhaps the apex of this type of composing will be seen only several decades later in Duccio's *Maestà.*

Both Virgin and angel in this *Annunciation* are extremely expressive figures. The diagonal of the angel's body, the network of diagonal brushstrokes on its robe and wing, and the urgency of its gesture all endow the figure with vivacity and quickness. Much more contained both in pose and expression, the Virgin inclines her head to receive the message, yet she seems to want to move not toward, but away from the angel. This twisting of the body's axis wonderfully expresses the controlled but real conflict which the artist intuits in the Virgin's plight. Such complex emotional interchanges were rapidly to become part and parcel of Sienese painting.

Characteristically Guidesque is the palette of the St. Peter Master's dossal. The overall impression of this panel is a riot of color and gold. The vivid red of Peter's robe is matched in brightness and intensity by numerous other colors in the surrounding panels. Reds, pinks, greens, blues and yellows appear everywhere. In the *Annunciation* one sees the use of color reminiscent of Guido's work, especially the *Madonna and Child with Four Saints.* Although not quite as subtle or original as Guido's, the combination of hues is nonetheless often remarkable. Like the rest of the panel, the *Annunciation* is, in terms of color, a bright and joyful scene, where the artist has given his fantasy full rein in the pink and yellow buildings and in the exquisite pinks and blues of the figures' clothes.

An even more exciting palette is seen in the work of another anonymous master who also seems to have been a contemporary of Guido da Siena. Termed the Master of the St. John the Baptist Dossal, after his only known picture (now in the Siena Pinacoteca), he is an enigmatic painter who has long puzzled those interested in Sienese art.[16] One of the most fascinating aspects of this dossal (which, like the St. Peter Master's, consists of a saint seated in the center sur-

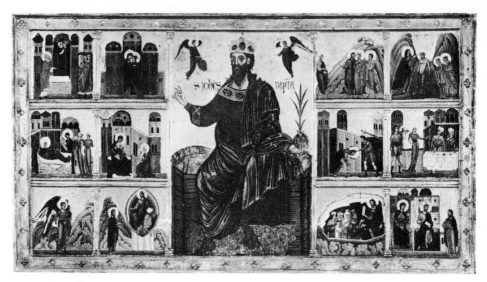

11. Master of the St. John the Baptist Dossal. *St. John and Twelve Scenes*. Dossal.
Siena, Pinacoteca Nazionale.

rounded by scenes from his legend) is the elusive quality of its style [11]. While
his figures seem to have some relation to the style of Guido, the visual syntax of
his narratives and his architectural and landscape settings are difficult to locate in
the work of any other Sienese painter. It has been suggested that he was a
Byzantine master (perhaps from Greece or some eastern European country) who
may have settled in Siena.

During the second half of the Duecento there was some influence from
Byzantine art on the artists of central Italy, although the exact nature of this
influence or the sources from which it sprang are hard to determine with preci-
sion.[17] Artists may have turned to the Byzantine style because it was more
illusionistic than the art of their own recent past and because they could learn from
it certain realistic conventions.

Byzantine art contained, so to speak, the fossilized remains of the illusionistic
painting of the ancient world. The relief-making play of light and shadow on the
robes of classical figures was schematized into a network of gold striations, just as
the realistic facial features and unified bodies were shaped into the graceful but
unreal forms of Byzantine painting. Sienese painters, along with those in other
Tuscan centers, realized the potential inherent in these conventions of realistic
representation and they began, during the later part of the Duecento, to revivify
them. How, exactly, this took place and what models the Italian painters used are
not known. There are, as in the St. John the Baptist dossal, certain resemblances

in figure type and architectural form between Byzantine pictures and Italian thirteenth-century art, but these are generic rather than specific in nature.

Interestingly enough, the palette of the St. John the Baptist dossal seems much closer to contemporary Sienese painting than to anything produced in Byzantium. This is not to say that the colors of this panel are exactly like those of Guido's or the St. Peter Master's, for they are not. In the first place, they are used in a more abstract manner. Many small areas of unmodulated color are placed next to each other. Squares or rectangles of red, blue, green and gold appear in the landscape, while fantastically shaped mountains of red and green loom up behind the figures. Obviously the painter has taken much pleasure in the simple interplay of these wonderful fields of color. The hue, its intensity and variety in every narrative, and its skillful combination indicate that here was a talent of the highest quality and originality. Certainly a panel such as this, along with the remarkable palette of Guido's paintings, had a major influence on the artists who began to work in the very late Duecento.

One such artist was responsible for a *Crucifix* in the Museo Civico of San Gimignano [12]. Probably painted during the late eighties or early nineties, this fine work reflects the state of Sienese painting on the eve of the Trecento. Svelte, graceful and sinuously attenuated, the body of Christ flows across the cross. We have already seen similar tendencies toward refinement and visual finesse in the works of Guido, his followers, and the St. John the Baptist Master.

The sentiment expressed by this picture is one of exquisite delicacy. The pathetic, dead Christ, sagging on the cross, and the grief-filled but highly stylized figures of John the Evangelist and Mary in the terminals, impart an air of wistful sadness not unlike that communicated by the melancholic saints and Virgin from Guido's altarpiece in the Siena Pinacoteca. One senses the powerful self-control exercised by the figures in this San Gimignano cross, as though deep feelings are demonstrated through ritualized attitudes and gestures. On the surface all is in order, but underneath strong forces rage. This kind of sentiment will be one of the hallmarks of Sienese painting for the next century and a half, and it will distance certain Sienese artists and their pictures from anything else produced in the Italian peninsula.

Especially remarkable is the line which defines the body of the San Gimignano Christ and delineates its musculature and skeletal structure. Although this swelling, melodious line may show the influence of Duccio's first works, such formal virtuosity and refinement are already found in the works of earlier Sienese artists—Guido, the St. Peter Master, and several others. This feeling for line was

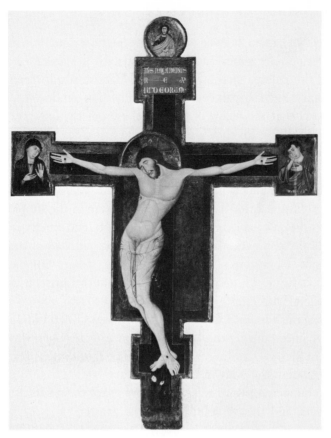

12. Sienese. *Crucifix.* San Gimignano, Museo Civico.

to be the inheritance of the painters of the next century.

A very limited but striking range of colors—bright red, black, blue and the almost ivory flesh tones of Christ—is skillfully combined to make this cross brilliantly colored. Such skillful use of color was, by the end of the Duecento, one of the principal distinguishing features of Sienese painting. Of course, such a tendency toward lively and subtle color seems to have existed in Sienese painting from an early time, but it is only at the end of the Duecento that the sustained development of one of the happiest traits of the art of Siena occurs.

But the San Gimignano *Crucifix* is also related to another current of artistic development during the late Duecento: the rise of Florentine art. Before the middle of the thirteenth century there was very little artistic activity in Florence, even though the city seems to have reached a rather high level of urban development. As at Siena, the first stirrings of what can be called a school of artists did

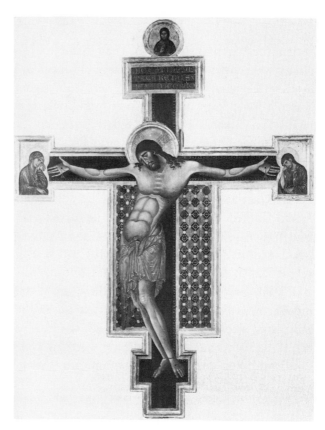

13. Cimabue. *Crucifix*. Arezzo, San Domenico.

not take place until after mid-century. Coppo, the first Florentine artist known by name, was a contemporary of Guido da Siena and, like Guido, one of the progenitors of his city's style. But the most important figure of the closing decades of the Duecento was Cimabue, a Florentine painter who seems to have started his career around 1270.[18]

Cimabue, partly on the basis of Coppo's style, developed a monumental idiom which was to be influential everywhere in Tuscany. Building on the foundation of a style shared by artists all over the region, Cimabue forged a vision of remarkable power and majesty, a vision destined strongly to influence the most revolutionary of all Florentine artists, Giotto.

One of Cimabue's earliest works is the large *Crucifix* in the church of San Domenico, Arezzo [13]. It is difficult to date this work with precision, but it seems to come from around the middle to the end of the seventies, just slightly before the Sienese cross at San Gimignano. Even a quick comparison of the two shows

certain fundamental similarities: the broad chest, the thick neck, the fully developed abdomen and the muscular legs of Christ in the Sienese cross seem to be based on Cimabue's earlier work. There is throughout the San Gimignano Christ a search for monumentality, never found, which appears to be motivated by a model like Cimabue's Arezzo cross.

Another foreign artist, Giovanni Pisano, was also responsible for strongly influencing the course of Sienese art.[19] The son of Nicola Pisano, Giovanni is first recorded working with his father on the pulpit completed in 1268 for the Duomo. He returned to Siena in 1284, where he was employed as architect and sculptor for the Cathedral. For over a decade he carved a series of nearly life-sized statues which were placed on the facade of the church [14]. Now in the Cathedral Museum, these were seen daily by the artists of Siena, and their influence on subsequent Sienese art cannot be underestimated.

Bold, powerful and expressive, these splendid animals, sibyls and Old Testament figures engaged in a spirited dialogue across the Duomo's facade. Each body, articulated along several axes, is a vivid, forceful being endowed with a presence not to be seen again until the early works of Donatello. Angular and twisting, Giovanni's men and women communicate their innermost thoughts through a masterful arrangement of form.

When these statues were placed on the facade, they must have been exciting and bewildering. Never in the history of the city had such expressively realistic figures been seen. From them the painters would learn much about the construction of the body, the use of gesture, the employment of facial expression and the shaping of drapery. In short, they could serve as models for the increasingly realistic and personal images that were the dreams of many painters of the late Duecento. But more than that, they furnished an example of a highly individual and dramatic mode alien to Sienese art. In its form and content, Giovanni's art was both foreign and instructive; it was certainly studied carefully by a young artist destined to play a major role in the development of Sienese painting: Duccio di Buoninsegna.

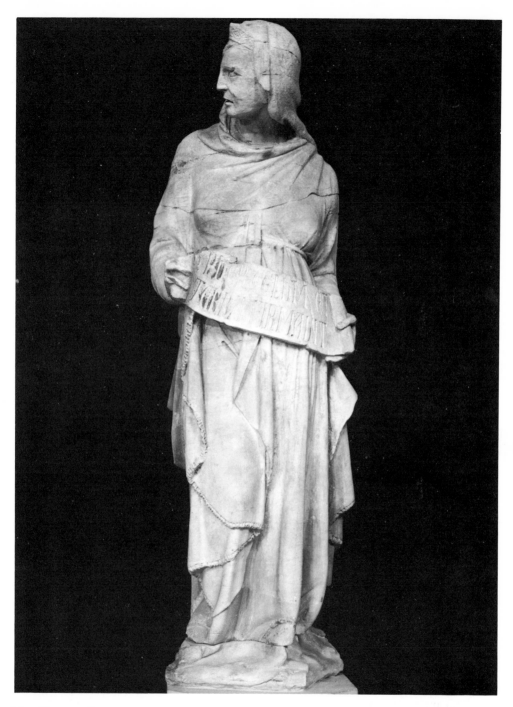

14. Giovanni Pisano. *Mary, Sister of Moses(?)*. Facade Statue. Siena, Museo dell'Opera del Duomo.

II

DUCCIO AND HIS SCHOOL

Probably painted in the 1270s or early 1280s, a remarkable *Madonna and Child* in the Museo dell'Opera del Duomo of Siena [15] is the first and perhaps most revealing evidence of Duccio's amazing career.[1] The documents which record this career say, as is often the case, little about works of art. Payments of 1278 and 1279 record a Duccio at work painting chests and book covers for the Biccherna, the powerful fiscal branch of the Sienese government which commissioned numerous artists to decorate its ledgers, offices and chapels. Scores of the handsome book covers still exist, although they have not been extensively studied, and it is likely that their decoration was entrusted to many important Sienese artists.[2] Yet one cannot say for certain that the Duccio di Buoninsegna, the artist of the *Madonna and Child* in the Museo dell'Opera del Duomo who is first mentioned in 1280, is in fact the Duccio who worked for the Biccherna from the 1270s to 1295. Quite possibly these were one and the same man, but this is far from certain. In any case, no surviving Biccherna covers can be connected with his hand.

Unfortunately the records do not reveal Duccio's birth date. Because he is fined in a document dated 1280, we can surmise that by that year he was legally an adult; thus it seems fair to assume that he was at least in his early twenties. His birth date would therefore have been no later than c.1260.

The date of Duccio's death can be fixed with greater accuracy. In 1319 his children (he and his wife Taviana seem to have had eight: seven boys—several of whom appear to have been painters—and a daughter) renounced their inheritance from their father, a sure sign Duccio was already dead. Thus the records tell us

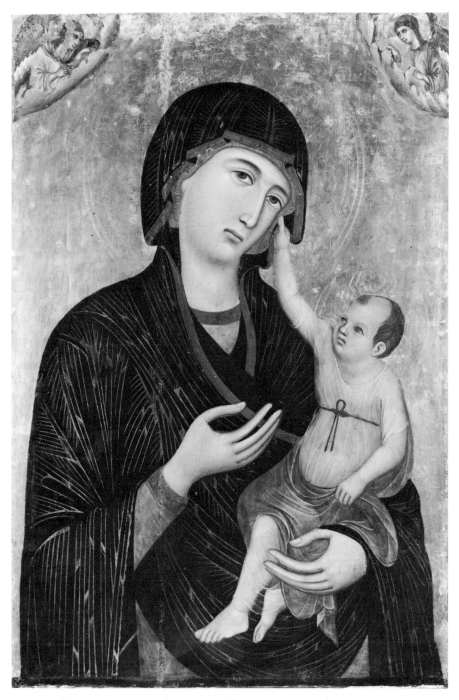

15. Duccio. *Crevole Madonna*. Siena, Museo dell'Opera del Duomo.

that Duccio was active for nearly forty years: from 1280 to 1319. Of course, there is a strong possibility that he was at work as an independent master a few years before he is first mentioned in 1280.

The 1280 document records a fine of 100 *lire* levied against the painter. For what offense Duccio was fined this considerable sum (one of his most important paintings, a now lost *Maestà* of twenty-two years later, cost 34 *lire*) is unknown. In the records mentioning Duccio one finds several fines. Although the exact nature of each transgression is not always known, at least three of the recorded infractions are of interest. For some unknown reason Duccio refused to obey certain ordinances of the city of Siena in 1299; for this he was fined 10 *soldi*. In 1302 he was fined for refusing to join the citizen militia raised to fight in the Maremma, a Tuscan region southwest of Siena. During the same year he was again brought to justice and made to pay 5 *soldi*. Since this fine was handed down by the office concerned with sorcery, it has been suggested that he was accused of practicing witchcraft.

In any case, the fines scattered among the surviving documents give a rare glimpse of the activities of an early Italian artist, a glimpse which suggests that Duccio was less than a diligent, patient and law-abiding citizen. But one must guard against reading too much into these records. Town life in the thirteenth and fourteenth centuries was usually troubled, sometimes violent, and always bound by a tangle of tradition and law. The judicial records are often the best source of information on many artists' lives. But just because their names appear in these ledgers, one cannot automatically assume that they were habitual criminals in the present-day sense of the term.[3]

Like many other artists, Duccio owned some property. A document of 1292 lists his house in the area of Camporegio, Siena. Ten years later (1302) he is cited as the owner of a vineyard at Castagneto near Siena. Although artists of the Trecento were by no means wealthy, they often managed to have a house in town and a place in the country. Along with numerous other city dwellers they were thus able to obtain fresh country products cheaply and with ease. By the last decade of his life Duccio had changed residences, and lived in a house quite close to the Duomo, where he also had his workshop.

Aside from the documents for the now lost *Maestà* of c.1302, there are a few records linking Duccio's name with works of art. On 15 April 1285, a contract was made between Duccio and the confraternity of the Laudesi of the church of Santa Maria Novella, Florence, for a picture. This large *Madonna and Child* enthroned surrounded by six angels still survives [16]. Ten years later (1295) a Duccio *pictor,*

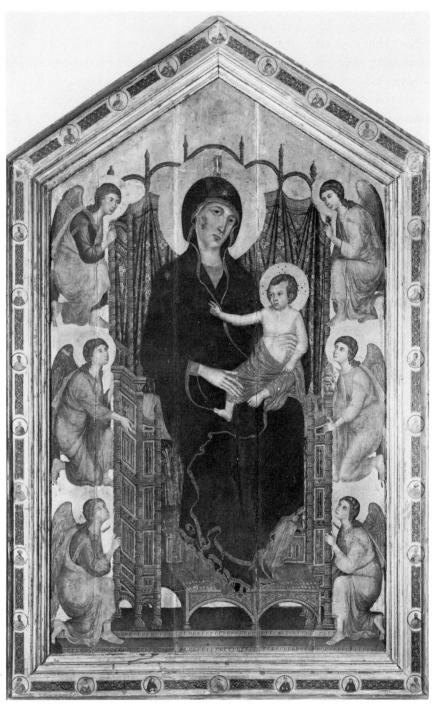

16. Duccio. *Rucellai Madonna*. Florence, Uffizi.

presumably Duccio di Buoninsegna, was a member of a committee formed to choose the site for a new fountain. This document is of some interest because it reveals that another committee member was the sculptor Giovanni Pisano, whose works were to have considerable influence on Duccio and on Sienese art. In 1308 Duccio swore on the Gospel that he would paint by himself, and without delay, the *Maestà* for the high altar of the Sienese Duomo. And on 9 June 1311 this picture, one of the cornerstones of Tuscan art of the Trecento, was carried in procession from the artist's studio in Via di Stalloreggi to the Cathedral.

Of the several pictures attributed to Duccio, only two can be documented: the Florentine *Madonna* of 1285 [16], now in the Uffizi, and the *Maestà* of 1308–11 [20–21]. Fortunately they seem to be among the artist's most important commissions. Because one dates from relatively early in his career and the other is a fairly late work, they furnish a picture—albeit incomplete—of Duccio's stylistic evolution. The remainder of his panels, however, are undocumented and undated.

The *Madonna* in the Museo dell'Opera del Duomo (known as the *Crevole Madonna* because it was at one time in the church of Santa Cecilia at Crevole near Siena) seems to be among the first of these undocumented pictures [15]. Although it appears to date from the early years of Duccio's activity, it is the work of an already masterful painter. The polished performance evident throughout indicates clearly that there must lie behind it a considerable body of work by Duccio.

In type, the panel seems to belong to a group of large rectangular Madonna pictures made throughout the Italian Duecento. Most likely they were single units, never meant to serve as parts of diptychs or multi-paneled altarpieces. These Madonnas were probably devotional images commissioned to be placed upon an altar in a church or religious house. In fact, the *Crevole Madonna* was first recorded in the Hermitage of Montespecchio close to Siena, the location for which it may well have been commissioned originally. The simple image of Madonna and Child and two small angels creates an air of intimacy, while the gesture of the Madonna's right hand invites the spectator to comtemplate the Child-god she cradles in her arm: an uplifting and comforting image for the eyes of a solitary monk used to long hours of devotional meditation. It is a work which, by its very nature, inspires reflection.

Very little is known about the history of the type of the *Crevole Madonna* but, interestingly enough, its choice seems to have dictated that Duccio use, perhaps grudgingly, the tiny angels placed in an indeterminate spatial position at

the upper corners of the picture. These small figures seem to have been almost entirely abandoned by the 1270s. Quite conceivably, Duccio considered them old-fashioned, but the necessity to replicate carefully the major features of an older, and perhaps very holy, type probably dictated their inclusion.

Looking at the Crevole panel for the first time, the observer is struck by the awesome beauty of its forms. The shape described by the line enclosing the Madonna's body is graceful and measured. The contrast between the shimmering gold and the silhouette of the Virgin is both forceful and sophisticated. One sees, especially in the passages around the Madonna's arms, how the artist has thought first of the overall composition as a visual dialogue between solid and void, between figure and space. The gold is activated and enlivened by the subtle shapes into which it is formed by the line surrounding the bodies, taking on a life of its own as important as anything else in the picture.

To see how skillfully wrought the *Crevole Madonna* is, one may compare it with Guido da Siena's *Madonna and Child with Four Saints* from the altarpiece in the Pinacoteca, Siena [8]. The very nature of the line is quite different in the two works. In Duccio's picture it is taut, tense, the describer of exquisite shapes. Line in Guido's work serves a much more descriptive function, not only in the center panel but everywhere; it is less alive, more placid.

A comparison between the two pictures also demonstrates that part of Duccio's art sprang from foundations in Guido's style. Some of the most important and fundamental characteristics of the *Crevole Madonna* are close to the Siena altarpiece: the proportion and features of the head and face, the shape of the neck, the form of the headdress, the way the lower frame stops the Madonna's body, and the carriage and attitude of the figures. In both pictures there is also much attention paid to the overall decorative effects of line and pattern. More difficult to describe are the gentle, almost hesitating demureness of the Madonna and the seriousness of her young son common to the two panels.

It cannot be proved that Duccio—who most probably began to paint around the 1270s—was directly influenced by Guido's Pinacoteca polyptych of that decade, but it does seem most probable when one considers the marked similarities between their work. Guido must have been one of the principal painters of late Duecento Siena. If Duccio did not serve as an apprentice in his shop, then surely he must have seen and admired Guido's work, which was an important part of the contemporary art of the closing years of the thirteenth century.

There were, of course, other artists working in Siena. Some of these, such as the Master of the St. John the Baptist Dossal and the other anonymous

followers of Guido (the St. Peter Master, for example), quite likely had a powerful effect on the formation of Duccio's style. Possibly there were also a number of influences on him from artists working outside Siena. It would be a mistake to assume that Duccio, even though he must have served a long apprenticeship with one painter, would have been influenced by only a single style. Artists of his caliber are alert to an astounding range of visual phenomena; but even with all the influences that must have helped shape his early style, one sees clearly the personal idiom of Duccio throughout the *Crevole Madonna.*

Perhaps the most interesting trait of this style is its inventiveness. In this early work he has continued and even accelerated the movement toward illusionism begun in the second half of the Duecento. The soft, subtly modeled face of the *Crevole Madonna,* when compared to the Madonna in Guido's Pinacoteca polyptych, shows a greater illusionism. There is less abstraction in the nose, eyes and brows. The shape of the face, the construction of the neck, and the patterns on scarf and robe are all more convincing. Perhaps the best example of this change is to be seen in a comparison of the clothes of the Child. In Guido's picture they are stiff, their fall and weight indicated only by the often confusing network of line. In the panel by Duccio they seem much more natural. The Child wears a gauzy cloth (visible around his feet) over his robes; in the late Duecento the ability to portray specific materials was no mean feat.

Also new, and of fundamental importance, is the delicacy of Duccio's panel. The lithe line, the sweeping, carefully placed robe striations, and the fluidity of the forms, together with the handsome, slightly withdrawn Madonna, who gestures with shapely, long hands, endow the painting with a new fineness and grace that will become one of the most characteristic features of Sienese painting. One senses in the picture a quiet, restrained elegance that is both Duccio's invention and one of his contributions to the art of his city.

The differences between Duccio's and Guido's *Madonnas* are not radical, but they are substantial, especially when one considers the imitative nature of artistic training in the thirteenth century. In the *Crevole Madonna,* Duccio has gone beyond Guido—and all of his contemporaries—and has produced an illusionism equal to that of Cimabue's Arezzo *Crucifix* [13], a work most likely painted within a few years of the *Crevole Madonna.* Whether he was in contact with any of Cimabue's works before he painted the panel is unknown, but even if he was, one cannot easily gauge their influence on him. Here again, as with the Coppo-Guido question, one does not know which way the influence went, or if there was influence at all.

In quite a different key from the *Crevole Madonna*, but certainly from the same time, is the *Madonna of the Franciscans* (Siena Pinacoteca), one of Duccio's most fascinating works [17]. This tiny panel, about the size of this book, may have formed part of a diptych whose other panel was, perhaps, a now lost *Crucifixion*.

If Duccio did indeed work for the Biccherna painting the covers of ledgers, then that experience would have stood him in good stead for this small picture. The *Madonna of the Franciscans*, more accomplished than any extant book cover, is, however, definitely not the work of a miniaturist. There is a grandness and amplitude about it which belies its small size. This is partly due to the monumental Madonna, who towers over the three kneeling figures at her feet. The graceful expansion of her body and the blue and red robes covering it occupy nearly three-quarters of the picture's surface: she is at once the picture's physical and psychological center. But Duccio took pains to make sure this large shape would be fluid instead of static. The slow, carefully controlled extension of the Madonna's right side creates a vital diagonal which moves the picture slightly off balance while leading the eye back into space. This same diagonal also helps carry the spectator's glance up from the three monks to the Virgin's face and then to her son's blessing hand. Throughout the composition is a lively asymmetry which demonstrates Duccio's desire constantly to enliven and energize his work.

Unique is the green and white cloth of honor hung over the throne. The small squares filled with crosses and the embroidered gold borders create a flat, space-denying surface, against which play the sinuous lines of the Madonna's body and the forms of the angels. There is a richness of pattern, gold, shape and line in the upper part of this painting seldom matched in the entire history of Sienese art.

The shape and subject of this picture must have been pleasing to Duccio, for they allowed him to explore spatial possibilities in a way that the format of the *Crevole Madonna* did not. The small, spatially ambiguous angels of that panel have been replaced by four larger angels, who seem to exist behind the cloth of honor. In fact, this small picture is built up of a number of well-defined planes. There is a steady progression into space from the three figures in the foreground to the Madonna and Child and then back toward the angels. To our eyes there is nothing unusual about the construction; but for the late thirteenth century the unity and boldness of Duccio's conception of space was innovative and striking indeed.

At every stage of his career, Duccio was fascinated by the representation of complicated objects in space. In the *Madonna of the Franciscans* this tendency

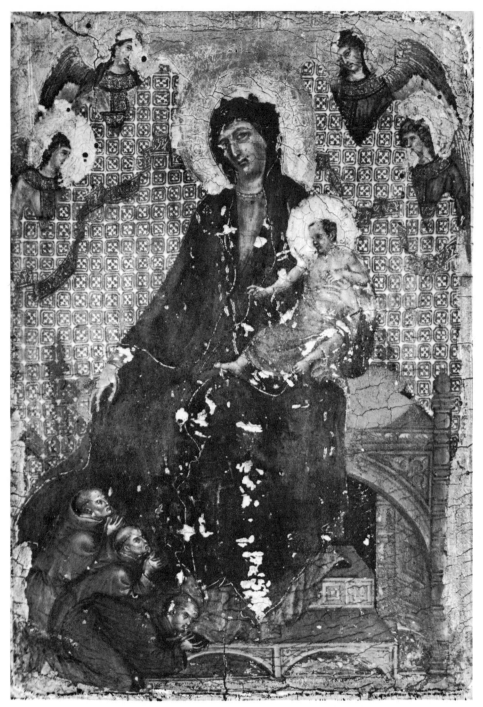

17. Duccio. *Madonna of the Franciscans*. Siena, Pinacoteca Nazionale.

is seen most clearly in the throne, which Duccio makes a complex architectural structure seen from numerous points of view: above, below and from the side. The spectator is invited to look under the throne and to observe its side and double-tiered footrest. There can be little doubt that Duccio found such architectural complexity both pleasing and problematic.

In the *Crevole Madonna* Duccio's palette is limited, probably because the painting was closely following a prototype. Black, grey, touches of red and green are the few colors that make up the balanced but sober palette of that work. Duccio's innate genius for the use of varied, original color was not, however, so restricted in the *Madonna of the Franciscans.* Like the freedom of form and line found everywhere, the color creates interest while enlivening the picture. Here the palette is composed of about six colors, which work across the surface of the picture to make this one of the most skillfully colored paintings of the late Duecento.

It is not only the striking and unusual juxtapositions of color—the blue of the Madonna's robe against the green and white cloth, the red pillow next to the brown throne, or the violet of the Child's clothes placed next to his mother's blue garment—but the nature of color that is so novel. It is the particular character and originality of the blue-purple cloak of the highest angel to the right, for instance, or the reddish purple of the Madonna's tunic, which sets this panel apart from previous Sienese painting. Before Duccio began to work, there was a love for highly decorative and sophisticated color in Siena. However, not even such a fine colorist as the Master of the St. John the Baptist Dossal can come near the exquisite, subtle beauty of the coloring of this early work by Duccio. Duccio built on the tradition of Sienese color and certainly he owes a great deal to it. Yet this quite remarkable, extremely beautiful use of color can be credited only to him.

The power of the *Madonna of the Franciscans* lies not only in its color and form but also in the way both combine to produce an image filled with spiritual tension. The three Franciscans (who perhaps commissioned this picture) kneel in the lower left-hand corner, a location symbolic of their humility and expressive of their relation to the monumental Virgin who towers above them. Their small, bony heads are poised on necks craned fervently forward. The upper two friars, with hands clasped and imploring eyes, seem to strain toward the Child, who bestows his blessing upon the three tiny figures. The third monk does not look upward, but tenderly embraces the Madonna's foot as he prepares to kiss it, a sign of his love and respect. It is as though these three tiny men worship at some great shrine.

Interestingly, the action of the three figures is nearly cinematic, almost as if they represent the various motions of one man moving rapidly from an upright kneeling position to a posture where his back is virtually parallel to the ground. One can almost sense that in their humility each monk is about to hug the earth.

The *Madonna of the Franciscans* is a marvel of integration. There is a fine yet very lively unity of form, color, line and pattern that is matched by the spiritual and physical integration of the figures. It is, moreover, a work of great delicacy and feeling. The yearning of the Franciscans and the beautiful but restrained Virgin and Child are clearly from the hand of a master painter endowed with an extraordinary degree of sensitivity. Like the *Crevole Madonna,* there must already lie behind this picture a considerable amount of artistic activity.

It is extremely difficult to date the *Madonna of the Franciscans* precisely. There seems to be little doubt that it belongs to the period of the *Crevole Madonna,* and since that work most likely dates from around 1280, a nearby date seems most reasonable for the *Madonna of the Franciscans.* Yet the lessened abstraction in the facial features and the slightly more confident handling of line may indicate that it is several years after the *Crevole Madonna.* One can say that it is rather far removed from anything by Guido or by any other contemporary Sienese painter, and this alone makes it a singular work. In it one glimpses, for the first time, the power and grandeur of Duccio's art so evident in his major Florentine commission of 1285.

Why the confraternity of the Laudesi of the church of Santa Maria Novella, Florence, commissioned Duccio to paint the altarpiece [16] for their chapel is not known. He was, after all, a foreign artist and a relatively young one at that. Yet he must have already done at least one important work that the Laudesi knew and admired. To receive such a prestigious commission was not only an honor for Duccio but a sure recognition of his growing reputation.

The panel (450 × 290 cm.) is one of a number of large gabled rectangular pictures painted during the last decades of the Florentine Duecento: it seems, in fact, to be among the earliest. Perhaps the type was originally Sienese—one thinks of Guido's earlier Palazzo Pubblico *Madonna.* In any case, since the Laudesi sang before the Virgin's image, it is not surprising that the panel depicts her. Several notable altarpieces of a similar type, including those by Cimabue and Giotto, followed in the wake of Duccio's commission.[4]

On 15 April 1285, the confraternity of the Laudesi contracted with Duccio to make a panel of the Virgin, Christ and other figures. The picture was to cost 85 florins and could, if not satisfactory, be refused: the latter did not turn out to

be the case. Now in the Uffizi, it is often called the *Rucellai Madonna* after the family to whose chapel it was moved, possibly in the early 1500s.[5]

One way of coming to grips with Duccio's huge panel is to ascertain its position in Florentine art around 1285. The decades of the seventies and eighties saw the emergence of an independent Florentine school. Little art was produced in Florence during the early Duecento, and those few surviving panels which do date from before the last decades of the thirteenth century reveal that the city was under the more precocious stylistic sway of western Tuscany. Interestingly enough, it is not until the 1260s that a Florentine painter, Coppo, is known by name. Although not the first recognizable Florentine artist (other anonymous painters are known through their works), Coppo certainly was one of the founders of his city's style.

Coppo exerted, either personally as teacher or by his art, a strong influence on Cimabue (active c.1270–1301). This great figure of the Florentine Duecento, a contemporary of Duccio, was approaching the peak of his considerable artistic powers during the eighties. Working on the basis of Coppo's style, he had developed the heroic and monumental idiom (seen in his Arezzo *Crucifix*) which was to be a characteristic of Florentine art for the next two centuries.

It was into this formative period of early Florentine art that Duccio moved in 1285. The destruction of works of art over the centuries makes it impossible to ascertain with accuracy the nature and extent of the pictures in the various Florentine churches of the late Duecento (the huge new structures of Santa Croce and the Duomo were not yet begun), but one can speculate that they were neither numerous nor the creations of a homogeneous school. There was, in short, not yet a strong artistic tradition in the city. This is important because any major work, such as Duccio's *Rucellai Madonna,* painted at a seminal moment in the history of style may have an influence which it might not at more settled times. So, most likely, the Florentines who looked at Duccio's panel were mightily impressed, for it was remarkably different from anything else in their native city.

On a throne of spatial and architectural intricacy, the huge Madonna regards the spectator with a wistful, detached air. Like some great empress she sits enthroned among costly brocades, adored by the six angels who flank her, surrounded by luxurious stuff, rare color and shimmering gold. Everything is in the service of this heavenly being to whom all pay homage—which, when one considers that this was the Laudesi's image, is exactly as it should be.

There is an elegance to this work unmatched in the entire history of Florentine Duecento painting. A characteristic of Duccio and, to a certain extent, the

entire early Sienese school, this refined grace may have been the reason Duccio received the commission. To see it, one has only to note the beautiful elongation of the Madonna's carefully controlled shape or the slow, sinuous, fascinating path of the golden hem moving down her robes to the bottom of her dress, where it cascades into a series of intricate rivulets.

The angels are also models of elegance. With their shapely necks and beautifully curved bodies with long, painted wings, they are graceful, svelte creatures. Especially Duccesque are the attenuated hands, which touch the throne with respectful restraint, as though it too were holy. These wonderful hands, so characteristic of Duccio's vision, are the descendants of those seen in the *Crevole Madonna* and the *Madonna of the Franciscans*.

As in those earlier masterpieces, Duccio once again reveals his consuming interest in line and pattern. The variety of shapes and their interrelation is striking: the vertical of the throne's base, the arches of the footrest and the latticework of the back, the diagonal of the folds of the cloth of honor, the zigzag of the golden hem, the loops and swirls of the angels' bodies and robes, and the intricate design of carpentry and fabric all combine to create an image of imaginative design.

In the *Rucellai Madonna* color is also varied and highly decorative. Once again Duccio, with strikingly original hues, has shown his intense interest in the use of color. At the center is the strong alternation of the dark blue (probably originally lighter) of the Madonna's robes with the red of her tunic. This simple opposition is surrounded by the gold-striated orange-brown and white of the Child's clothes and by the brown throne interspersed with red and blue. Behind the Madonna hangs the gorgeous grey cloth of honor, covered with red and gold brocade.

The angels to the sides not only act as compositional brackets framing the central images; they serve as a halo of color as well. The darker figures of Madonna and Child are encircled by the lighter and more variegated angels; moreover, the spectator's eye is constantly drawn around the picture by the repetition of certain colors in several of the angels' robes. For instance, the blue of the robes worn by the top and bottom angels on the right side is echoed in the blue of the sleeve of the angel at the lower left. The pink of the angel's robe at the upper left is seen again in two of the angels at the right. Other related shades of green and purple are also woven around the panel.

In this picture Duccio emerges for the first time as a truly extraordinary colorist. Not only does he use color to give balance and variety but he employs colors of the most marvelous and subtle nature. Look, for example, at the stunning

combination of deep green and pink on the angel at the upper left, or at the subtle matching of light green and purple on the clothes of the middle right angel. Light pinks, green-blues and pale purples float before the onlooker's eyes. These colors, and their combinations, are unheralded in previous Tuscan painting; they must have enthralled and enchanted the Florentines, who had never seen such marvelous hues.

The evolution of Duccio's style from the *Crevole Madonna* to the *Madonna of the Franciscans* is most apparent in the heightened realism of the figures. The strongly geometricized face and the pattern-like arrangement of hands and striations of the *Crevole Madonna* are indebted to Guido da Siena and, perhaps, other artists of his generation. The *Madonna of the Franciscans* seems somewhat more mature. In it one sees for the first time the graceful, refined Duccio who endows his figures with vibrant personalities. Here also Duccio's sense of color and decoration, already glimpsed in the *Crevole Madonna,* is given full play. By the time of the *Rucellai Madonna,* he is already a mature artist. In this large picture he gave full vent to his vision and produced a masterpiece filled with the most subtle visual and spiritual language. The wonderfully colored angels, the wistful, majestic Virgin and the overall decorative unity of the *Rucellai Madonna* combine to make it a picture of considerable importance in Tuscan Duecento painting. A model of grace, restraint and taste, it is one of the landmarks in the history of Sienese art.

The Florentine artists seem also to have been impressed by this painting for the Laudesi.[6] There can be little doubt that Cimabue, who may have influenced both Guido da Siena and Duccio, was in turn impressed by the *Rucellai Madonna.* This influence is not yet noticeable in his famous *Santa Trinita Madonna* (c.1285), which is still a powerful, if complex, frontal image full of the heroic and complicated monumentality so characteristic of his idiom [18]. Yet in several works which seem to have originated in his shop one clearly sees the impact of Duccio's *Rucellai Madonna.*

This is especially evident in an altarpiece depicting a Madonna and Child with six angels from Cimabue's shop and now in the Louvre [19]. In the throne type and its diagonal placement, Duccio's influence is apparent. But it is even stronger and more fundamental in the newfound delicacy and grace of the angels. In this picture (and in others from around the same time) one sees the first of the several waves of Sienese influence which were periodically to sweep over Florence during the Trecento. It is interesting to note a fact seldom admitted by historians of Florentine art: aside from Cimabue and Giotto, there are no exam-

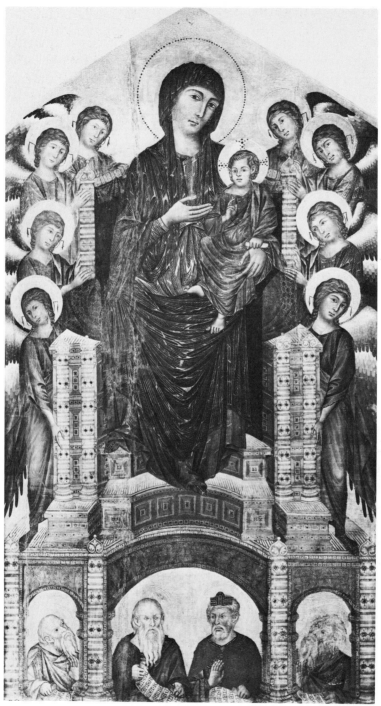

18. Cimabue. *Santa Trinita Madonna*. Florence, Uffizi.

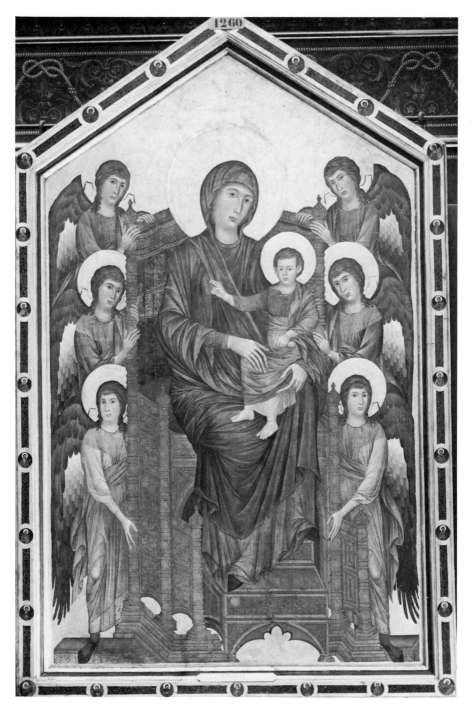

19. Cimabue's Shop. *Madonna and Child with Angels.* Paris, Louvre.

ples of the converse—a Florentine influence on Sienese painting.

After the completion of the *Rucellai Madonna* sometime around the middle of the eighties, almost nothing is known about Duccio's work until the contract for the *Maestà* of 1308. He seems to have been a resident of Siena during those years. Documents reveal that he was on a committee formed to give advice for the location of a fountain, and that he was paid for a now lost *Maestà* for the Chapel of the Nove in the Palazzo Pubblico. But the developments in his style and the influences to which he was exposed in this period remain only partly elucidated by the great *Maestà,* his most famous painting [20–21].

First mentioned in the commissioning documents of October 1308, Duccio was to paint his masterpiece [20] for the high altar of the Duomo, the most important location in the most important of Siena's churches. The artist, who was to be paid by the day, was to be supplied with all the necessary materials by the

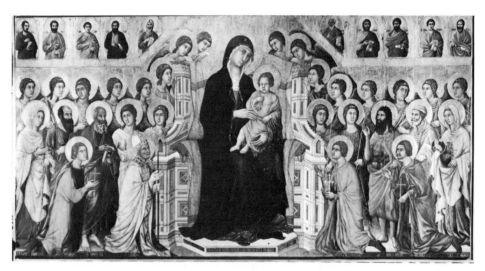

20. Duccio. Front of the *Maestà.* Siena, Museo dell'Opera del Duomo.

Duomo authorities. The large multi-paneled altarpiece was to be painted by Duccio's hand only—the commissioners were obviously worried by the thought of too much shop intervention—and he was to accept no other commissions until it was finished. A later record indicates that the painter contracted to paint a series of scenes for the back of the altarpiece as well [21]. For his work, which was completed in 1311 when the altarpiece was carried in procession from his shop, Duccio made the considerable sum of about 200 florins.[7] The awarding of such

21. Duccio. Back of the *Maestà*. Siena, Museo dell'Opera del Duomo.

a profitable and prestigious commission indicates that Duccio was the foremost painter in his native city, and thus one of the most well known artists of Tuscany.

Of course, the high altar of the Sienese Duomo was not without an altarpiece before Duccio's *Maestà,* for on this sacred location had stood a very famous miracleworking panel (the *Madonna degli Occhi Grossi*) which, the Sienese believed, had saved the city from the Florentines at the Battle of Montaperti in 1260 in which Coppo di Marcovaldo was taken prisoner.[8] The very fact that Duccio's new painting replaced the old, highly venerated miracleworking image [5] testifies to the desire of the Sienese to have up-to-date altarpieces. It also demonstrates that they must have been quite conscious of the differences between the older style of the earlier *Madonna* and Duccio's modern idiom. This awareness was responsible too for the modernization of both Coppo's and Guido's *Madonnas* around 1300. All this indicates that Duccio's fellow citizens must have seen in his art something quite new, perhaps even revolutionary.

We today do not see the *Maestà* in the same way that the Sienese of the early Trecento saw it. In the early sixteenth century the painting was removed from its original location. There followed a number of barbarous attacks on it—including the separation of the back scenes from the front—which resulted in the disfigurement of the work and the detachment of some of its small panels. Several of these are now in collections outside of Siena, while others are lost or, most likely, destroyed.

There has been much debate over exactly how the *Maestà* appeared in Duccio's time. This is a key problem because it seems that the original order of

the panels has been disturbed. However, because there is not unanimous agree-
ment on any of the reconstructions proposed by scholars, the question is still very
much in the air.[9] In this chapter, consequently, we shall concentrate on the overall
stylistic and narrative characteristics of the work rather than attempt to recon-
struct it.

When one sees the *Maestà* in the Museo dell'Opera del Duomo (it is
displayed with its front and back panels still separated), one is struck first by the
jewel-like quality of this large (over 214 × 422 cm.) work. Complete with all its
panels and pinnacles on the high altar of the Duomo, this glowing, gold-encrusted
painting must have been even more dazzling. Resplendent with marvelous, varied
color, Duccio's picture—which prominently bears his signature on the step of the
throne—must have been a powerful aid to religious devotion and to the liturgy
performed before it.

This type of *Maestà*, which seems to be found principally in Siena, may well
be Duccio's invention. Documents reveal that the artist had already been paid for
a *Maestà* for the Chapel of the Nove (c.1302), but we have no idea what it looked
like. In any case, there seem to be no extant altarpieces of the Duomo *Maestà*
type which predate Duccio's.

On the front of the *Maestà* are the Virgin and Child enthroned, surrounded
by ranks of standing angels and saints [20]. In the foreground kneel four of Siena's
patron saints: Ansanus, Sabinus, Crescentius and Victor.[10] Other prominent
saints include Catherine and Agnes (wearing nearly identical gold embroidered
mantles), who stand at the far ends of the picture, and John the Evangelist and
John the Baptist.

The inclusion of four patrons of Siena and the wording of the inscription—
HOLY MOTHER OF GOD BESTOW PEACE ON SIENA AND SALVATION ON DUCCIO WHO
PAINTED THEE—reveal that the *Maestà* has an overt reference to the commune.
The Virgin, Siena's protector, is implored by the kneeling patron saints and by
the inscription to help not only the worshipper but the worshipper's city. Similar
paintings are to be found in the period immediately following the completion of
the *Maestà*, but their location is limited only to Siena and its territories. There
was in Siena a particular melding of religious and communal iconography not
found in Florence or in many other Tuscan centers.

To us this blending of symbolism seems strange because in our world there
are rather clear boundaries between the religious and political spheres; but that
was not the case in the thirteenth and fourteenth centuries, when there was no
such clear separation. The Sienese Duomo was partially financed by the commune,

and the city's Palazzo Pubblico contained several chapels complete with religious decoration, including the now lost *Maestà* of 1302 by Duccio. In every aspect of life, the lines between the sacred and the secular were blurred or nonexistent.[11] The images of Christ, the Virgin and the saints were placed on coins, while the banners of private families and the commune were hung in churches. It is in this context that we should view Duccio's painting—as both an altarpiece and as Siena's offering to the Virgin.

Despite the original complexity of the panel, with predella below and small panels with angels and saints above, the spectator's eyes continually return to the physical and spiritual center of the altarpiece: the Virgin. The huge marble throne, decorated with multicolored stone inlay, firmly anchors the Virgin's body in space. This throne is very different from those seen in Duccio's earlier panels. It sits firmly on the ground and is a convincing and palpable architectural unit: the uncertainty of the earlier thrones is gone and in its place is a massive four-square structure. The sides and armrests swing out, forming a definable space for the Virgin. In creating this complex and sophisticated structure, Duccio demonstrates a grasp on pictorial illusionism which is a quantum jump from his immediate forerunners.

Much the same is true of the Madonna and Child who, while they have all the fluidity and grace of the earlier figures by Duccio, now possess a solidity and volume unheralded in previous Sienese painting, including Duccio's own. The sheer bulk of the Virgin, the space-creating turn of her body, and the revealed volume of her mighty knees below the mantle's heavy woolen material describe a figure of majesty.

Certainly the tendency toward a more illusionistic representation is evident in the progression from the *Crevole* to the *Rucellai Madonna,* but even with this in mind, the Virgin from the *Maestà* still surprises us. Perhaps if we were able to trace the complete evolution of Duccio's style and to fill in the gaps between the *Rucellai Madonna* and the *Maestà,* we would be less surprised. But not even this would tell the whole story, for Duccio's art must have undergone the influence of the revolutionary Florentine artist Giotto. When and where this took place is unclear. The shock waves of Giotto's style spread throughout Italy after 1300, and if Duccio knew no work by Giotto—which seems unlikely—then certainly he was aware of his style as transmitted through the scores of artists who transformed their style into a Giottesque idiom.[12]

The best comparison between the work of Giotto and Duccio is found by looking at the *Maestà* and the *Ognissanti Madonna* (in the Uffizi, Florence),

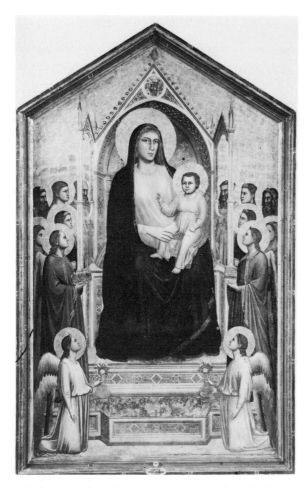

22. Giotto. *Ognissanti Madonna.*
Florence, Uffizi.

which must date from a few years earlier [22].[13] In Giotto's picture, one sees and senses a powerful physical and psychological presence unlike anything known in previous Italian painting. The serious figures act and interact with drama and dignity around a Madonna of remarkable corporeal and spiritual power. In this painting Giotto broke forever the old iconic bonds of the earlier, more aloof and geometricized style of Tuscany, a style shared by Cimabue and Guido da Siena. His illusionistic depiction of forms and their convincing location in space was, as his contemporaries noted, nothing short of miraculous.

If, in the *Maestà,* one looks at the movement of form from the step of the throne back to the angels who stand behind it, a coherent and logical system of interlocking units is seen. This kind of composing is one lesson Duccio learned from Giotto's style. Another is the volumetric articulation of broad, abstract forms. To see this influence in Duccio's work, one need only note the way the

body of the Madonna, especially the knees, is seen through the weighty robe or examine the construction of the great throne. There is an amplitude and breadth in the *Maestà* Madonna and saints which seems to come from Giotto, either directly or indirectly. Yet, although Duccio appears to have learned much from Giotto about form and space, he remains very much his own man, endowed with his own style. This is especially true in his interpretation of holy drama which, as we shall see, is very different from Giotto's.

When the spectator turns from the central figures of Madonna and Child to the surrounding saints and angels, he becomes aware of a variety of types. There are the numerous angels, all young, full-faced and blond, dressed in robes with golden collars and equipped with splendid feathery wings. Unlike the *Ognissanti Madonna,* there is here no overwhelming concentration on the Madonna and her Child. Four angels lean languorously on the throne, their heads resting on their slender hands. Others, who turn and gaze at one another, compose the uppermost row. Four more, among the most beautiful of them all, stand guard around the lower parts of the throne. There is a gentle variation among these heavenly creatures: some turn leftward, others rightward; heads are slightly raised or lowered; some hands gesture while others hold staffs. The large patterns of the rows of shining halo disks sliding across the picture are gently relieved by the subtle, graceful movements of the angels and saints.

More individualized, of course, than the angels, the saints are of varied types: the old John and Peter, the middle-aged Paul, the youthful, comely, long-necked Catherine, and Agnes, who reveals Duccio's concept of ideal feminine beauty. These saints seem quite aware of the Madonna and, almost as though they were in the wings of a polyptych, they gesture and look toward the large central figures towering above them. Their adoration is matched by the kneeling saints, worthy of Giotto, who both present and worship the Virgin.

Within the rows of angels and saints a rather limited number of colors is repeated across the surface of the panel. Duccio has aimed to carefully regulate color, to use it to help keep this large panel in check. Orange, red, pink, grey, small areas of green and some blue are the predominant colors. They range across the picture surface, reoccurring at uneven intervals. Hues extend from the warm orange of Ansanus's tunic to the cool grey of the angel standing next to St. John the Evangelist.

Yet the central section of the *Maestà* impresses not by color itself but rather by the way the particular colors work so well with the tall, elegant Madonna, saints, and angels covered with swinging, pleated robes. Color, design, line, solid

23. Duccio. *Prophets*. Siena, Museo dell'Opera del Duomo.

and void are all remarkably integrated. The overall appearance of this part of the altarpiece is like that of some glittering golden icon, overwhelming in its size, expense and religious power. Within the picture Duccio is employing concepts that are up to date, yet the totality of the central section is unreal, otherworldly and heavenly. And because of this, it was perfectly suited for the high altar of the

Duomo, a location demanding an altarpiece with the splendor and iconic quality of the *Maestà*.

Originally, a predella made up of scenes of the infancy of Christ alternating with images of prophets was attached to the *Maestà*. These *Prophets* [23] are clearly influenced by Giovanni Pisano's statues for the facade of the Sienese Duomo [14]. Duccio must have studied these at length, for he has caught not only their tense, vigorous movement but also something of the powerfully expressive personality radiating from each of the marble figures. There seems to be little doubt that Giovanni's example, like Giotto's, helped Duccio to energize his compositions and figures.

At the top of the *Maestà* are small panels of saints. Initially, these were surmounted by six pictures of the legend of the Virgin after Christ's Ascension. These panels were, in turn, topped by half-length angels. Thus the central panel of Madonna, Child, angels and saints was framed by narratives and by individual images of prophets, saints and angels. When the whole complex was together, these ancillary panels with their brighter, more varied and different colors must have acted like a frame enclosing and setting off the golden crowd of the central scene. In terms of color as well as composition, the front of the *Maestà* was planned as a whole, a unit formed of separate but interrelated parts.

The beginning of the *Maestà*'s narrative drama is found in the predella's *Annunciation* [24], where one sees the subtle opposition of two color masses: the grey of the arches to the right and the salmon of the background wall and left arcade. These smooth, unmodulated areas of color are at once wonderful abstract shapes and devices which direct the spectator's eye across the picture's surface.

Punctuating the two major colors are the light blue, red and pink of the angel's robes and the red and dark blue of the Virgin's clothes. There are touches of other colors—brown, gold and yellow—but the overall impression is of just several colors of great beauty and originality. Yet it is not only the colors that strike the onlooker, it is also their refined combination. The placing of the pink of the angel's cloak next to the blue tunic, or the combination of these with the orange of the wall and arches, is daring, successful, and characteristically Duccesque. In his use of color one sees Duccio's relentless, unerring sense for the decorative possibilities of each pictorial component.

One should, however, not let Duccio's skill as a colorist obscure the fact that he was also interested in exploring the spatial possibilities of any image or scene. This is not so evident on the central panel of the *Maestà*, where he has consciously restricted the figures' development in space to achieve an overall uniformity

24. Duccio. *Annunciation.* London, National Gallery.

(relieved by the considerable variety of the individual figures, postures and gestures) in a large and complex composition. But this interest in space is evident in almost every other part of the altarpiece, including the *Annunciation,* where Duccio comes to grips with a number of problems. It is clear that there are several distinct units of space in the picture. An area of void exists near the picture plane, but the eye is lead inward into a sort of intermediary space occupied by the figures. The Virgin's robe bridges both spatial units by extending to the picture's foreground. The figures' locations in space are emphasized by the columns and walls which overlap their bodies, indicating that they are actually behind these architectural elements.

Duccio is also anxious to give the spectator several viewpoints: one sees out

past the arches, is given a glimpse of the coffered roof over the Virgin's head, looks into the space beyond the open door, and down upon the ledge where the vase of flowers sits. When he is able, Duccio sets his figures in an environment of some spatial complexity.

In the *Maestà,* for the first and only time, one sees the full range of Duccio's mature narrative style. Svelte, elongated figures move with rhythm and grace in each of the altarpiece's stories. The lithe beauty of these figures (unlike any others of the late Duecento or early Trecento) is one of the splendors of Duccio's fertile pictorial imagination.

Another fine example of this is found in one of the several larger panels on the back of the *Maestà,* where the scenes illustrating the Passion of Christ appear. The *Entry into Jerusalem* [Plate 2] gives us our first glimpse of how Duccio handles numerous figures in a landscape. At first glance one can see that, although this is a highly decorative composition, it is not like any of the landscape narratives by Duccio's Sienese forerunners. Compared to Guido's *Entry into Jerusalem* [7], Duccio's panel is a marvel of realism. The geometric, decorative quality of that earlier work is nearly gone, and in its stead is a much more complex, ambitious and differently conceived narrative. There has been an appreciable shift from the idea of a picture as a network of highly stylized forms to one which depicts a story that is much more closely related to the observer's world.

Yet the panels by Duccio and Guido, although they are quite different, are both still readily identifiable as Sienese. In their spirited, careful use of color, in the quickness of their alert, comely figures, and in the interest in the decorative possibilities of each pictorial unit, they share certain characteristics that must be classified as Sienese. One can see that Duccio studied the works of Guido and his followers (he was certainly trained by one of them) and that from them he learned the love of decorative color and shape, just as he learned to solve problems of form and space by studying the art of Giotto and Giovanni Pisano.

Like the *Annunciation,* the *Entry*'s space is divided into a number of compartments: the foreground bounded by the first wall, the area in which Christ and the crowd are placed, another unit where the boys climb the tree and, finally, the city looming behind the wall. Although these areas are clearly demarcated by walls, passage between them is possible through the open door in the lower right corner and the city gate, just as access from one spatial unit to another in the *Annunciation* is furnished by arches and doors.

Each of these spatial compartments is populated by crowds that comfortably exist with the architectural structures surrounding them. Here Duccio has done

away with the toylike symbolic architecture of past Sienese painting, and his figures exist in a much more realistic atmosphere.

The city gate and buildings behind form one of the first in a long series of notable townscapes found in Sienese paintings during the next decades. In the several edifices Duccio has distilled the essence of the city: the town walls, one of the most visible features of any urban center; the multifaceted baptistry, where the infant became both Christian and citizen; the gabled church with campanile; and the tower of the Palazzo Comunale, the symbol of the commune's strength and power. Only the upper parts of the buildings appear over the wall; it is up to the onlooker to fill in the remainder of the structures and to imagine the teeming life of the city swirling around them.

Some of the citizens have just spilled out of the large arched gate which, in a characteristic Duccesque spatial experiment, is seen from the side and from below. With its crenelated top, splayed arches, and moldings, this pink structure is a complicated delight. Through it is visible part of a house with a window occupied by a woman. Here, as in the open door at the lower left, Duccio wants to suggest the flow of space throughout the picture. This is most appropriate in such a narrative of procession. By allowing the frame of the picture to overlap the leftmost of Christ's followers, Duccio demonstrates that the train has not yet completely entered the picture's space. The tightly packed group, all looking straight ahead, directs our attention toward the noble figure of Christ astride the donkey. Christ, however, is slightly in front of the group, more isolated and outstanding. Just to the right the rhythm changes again and there appears a large void separating the townspeople from the holy group. This empty spot at the center of the composition both allows our eyes to move up into space and serves as an interlude between procession and reception: Christ, in other words, is just about to be received by his believers.

As they wend their way out of the gate, the citizens are as unruly as the apostles are orderly. Figures turn this way and that, gesture wildly, move back and forth, and are generally in a confused and highly agitated state. Once again Duccio has used the basic intervals of figural placement to make a point: he has opposed the turbulent secular world of the city with the order and quietude of the holy group. And at the heart of all this turbulence appears the calm, composed figure of Christ.

It is evident from this, and from many other of the *Maestà*'s panels, that Duccio was fascinated by all the anecdotal and peripheral episodes attendant on any act of religious drama. Not only does one see the boys climbing the trees (part

of the standard iconography of the story), but one sees that the trees are oaks. Each leaf and branch is carefully articulated. Light playing on the outer leaves models the foliage, making it thick and dense. There are, in fact, several types of trees and bushes in the picture, including the spiky, dead tree that rises just behind Christ's head, perhaps an allusion to the crown of thorns he is soon to wear.

The scene is filled with different figural types engaged in numerous small, separate actions. Gawking men lean over the city wall, a woman looks out of the loggia behind the gate, boys hold palms, some citizens turn back toward Jerusalem while others chat. Among the crowd are greybeards, middle-aged men, and boys. Each is dressed distinctively and many make emphatic, individual gestures. One is aware that the Entry is not the only action and that it is not the focus of all attention. Duccio, unlike his contemporaries in Florence, opened wide his pictorial world and let in a range of anecdote which enriched his narrative and made it more human and accessible. One of his great strengths, this narrative conception seems to have originated with earlier Sienese artists such as the Master of the St. John the Baptist Dossal, but it was brought to fruition by Duccio.

The *Entry* provided Duccio with a splendid vehicle for color, and in it he used blues, greens, reds, pinks, violets and browns in the most striking, varied and original combinations. The crowd before the gate, for instance, can be read as a number of people or as a fantastic display of some of the most refined and delicate color ever painted. Color acts partly in the service of form, but its most brilliant function is as decoration.

An equally exciting use of color is found in the *Pact of Judas,* also from the back of the *Maestà* [25]. In front of a pavilion is a semicircle of men, their attention riveted on the exchange of money between Judas and the High Priest. Here again are the greens, blues and purples of the *Entry,* but now they are severely controlled to create harmonious transitions across the group's surface. Incredibly subtle hues are placed one next to the other: purple with orange, pink with blue, green with red-orange, pink with tan. Several colors—green, red, blue —appear throughout the crowd, giving the group unity. The arrangement of colors is of great formal beauty both in terms of the figures which it helps to describe and in the purely abstract joy of one color set beside another.

The conspirators in the *Pact* are very different from the knots of men in the *Entry.* In the *Pact,* Duccio wants to fix our attention on the act which was soon to have such great consequence. There arises from the tightly packed group a sense of conspiracy and stealth, accentuated by the grasping gestures of Judas and the High Priest. This is quite different from the confused multitude at the Gate of

25. Duccio. *Pact of Judas*. Siena, Museo dell'Opera del Duomo.

Jerusalem or the regular rows of the apostles. Like all good artists, Duccio is here manipulating the basic formal elements of style to produce certain psychological reactions in the spectator.

Also of considerable formal interest is the juxtaposition of the solid group of figures with the open, airy loggia in the back. This structure acts as an elegant foil for the men in front of it, while its arches provide a geometric complement to the human semicircle. The restrained pale yellow of the building—the arches and roof are orange and the vaults black—provides a neutral background for the display of color across the robes. There is, in fact, a decided absence of competing color throughout this panel: the buildings to the sides of the loggia and the floor are also yellow. Surely Duccio wished the delicately colored group in the foreground to stand out like a rainbow against grey clouds.

The gemlike *Pact of Judas* serves as a good example of Duccio's narrative

style in the *Maestà*. Carefully wrought, beautifully painted, it narrates its story with wondrous grace. One feels that here Duccio's idiom is near its apex. But much has been carefully excluded from Duccio's work. In the *Pact*, there has been a very conscious choice not to emphasize the story's drama. One senses that this is a conspiracy between evil men, but one is so spellbound by the play of color and form, and by the soft light falling over the picture's surface, that the horrible act is pushed into the mind's background. It is as though one is watching some ballet in which costumed dancers perform with consummate skill. The heart of the drama—often the main concern of the Florentines—and the dramatic clash between strong personalities are not of great importance to Duccio. For him, sacred drama takes place in a measured, carefully balanced milieu where the charged moment, when it does occur, is only one aspect of a much larger vision.

This same vision is especially evident in the double panel of the *Denial of Peter and Christ Before Annas* [26]. Found in Mark XIV, 66–72, this story begins as Christ is being interrogated by the High Priest Caiaphas. Duccio has here used two panels to illustrate a single story while maintaining the division between the panels, a division formed by the edge of the floor between the two interrelated scenes.

Throughout the *Maestà* Duccio constructed constant and consistent spatial settings. Thus the *Washing of the Feet*, the *Last Supper* and *Christ's Discourse to the Apostles* all take place in the same green room pierced by two doors and roofed by a coffered ceiling. Other scenes, such as *Christ Before Pilate* or *Christ Before Caiaphas*, also occur in the identical setting, regardless of their location on the back of the *Maestà*. This is not surprising to modern eyes, but such spatial, and therefore narrative, continuity was revolutionary in Duccio's time. Duccio was one of the first Tuscan artists (perhaps the first) to set down religious drama as though it were history. He was interested in specific and recurring locations which gave the stories a believability and logic unlike that of any previous Sienese painting.

The logic of the *Denial of Peter and Christ Before Annas* is apparent immediately. Just above Peter stands the bound Christ surrounded by his captors and questioned by Annas. In the lower room, connected by the staircase, Peter raises his hand in a gesture of denial as the maid points an accusing finger at him. There is a beautiful contrast between the passive, resigned Christ surrounded by his tormentors and the belligerent, lying Peter warming himself at the fire. Above unfolds an early act of a great tragedy, while below a group of men huddle around a fire built in a courtyard, thinking only of getting warm.

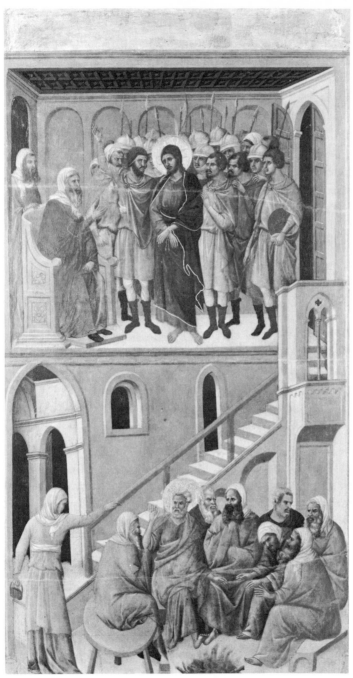

26. Duccio. *Denial of Peter and Christ Before Annas.*
Siena, Museo dell'Opera del Duomo.

But, as in almost every scene of high drama from the *Maestà*, the tension is lessened by Duccio's form and color. The small but intense figures of the men around Peter are graceful and varied. The maid, who probably was inspired by a statue by Giovanni Pisano, is supplely articulated. She is of course the counterpart of Annas above, but one is as taken by her pink robe as by her role in the story.

Again, Duccio's innate sense for color is at work. The greens, orange-reds and blues are played against the neutral tan of the architecture. Notes of color concentrated in the figures' robes direct the spectator's attention to the narrative action; everywhere color is the equal of any other dramatic or compositional element.

All Duccio's compositional skill was marshaled for the panel of the *Crucifixion* which forms the physical center of the back of the *Maestà* [27]. About twice as large as all the other back narratives (with the exception of the *Entry into Jerusalem*), this scene represents the climax of the Passion stories and the beginning of the supernatural events which took place after Christ's death. It is, therefore, not only the back's physical center but its narrative heart as well.

Christ's cross rises in isolation in the void between the groups of his enemies and his followers. The frail, solitary figure is delicately suspended on the cross, a pathetic image high above the sorrowing and gesticulating crowds below. The upper part of the composition is hushed; even the grieving angels seem restrained and muted. But below, the air is filled with shouts, wails and curses. Yet Duccio never lets things get out of control; there is always an overall restraint. Every gesture, no matter how full of passion, is measured and weighed. This balance is, of course, one of Duccio's most wonderful and distinctive traits.

Below the good thief (to Christ's right) stand the faithful. Mary, who looks up at her son, has fallen into the arms of the woman in green behind her. Desperately, Mary clutches St. John for support, their intertwining arms and hands forming one of the picture's most poignant passages. Heads are turned in all directions: the Magdalen looks inquiringly into Mary's face; John, with his back to the cross, seems dazed; to the far left a woman dressed in pink touches her face with a covered hand in a gesture of sorrow; other heads turn toward Christ. The soldier to the right in this group (Longinus?) holds a tense, defiant pose that reminds us of Donatello's *David* of a century later. Alert and rigid, he forms a strong contrast to the swaying, turning women to his right. Strange and spectral, Christ's followers demonstrate Duccio's uncanny ability to portray the deepest human emotions with ethereal beauty.

At the right one sees a disorganized group of figures similar to that in the *Entry into Jerusalem*. All is in action as figures turn toward Christ (one daringly

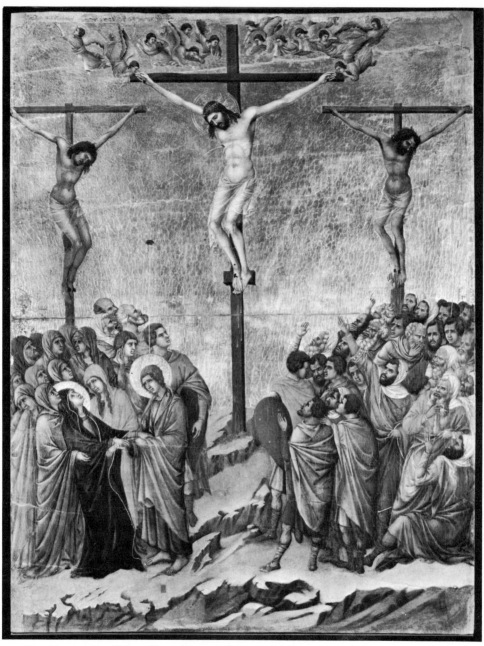

27. Duccio. *Crucifixion*. Siena, Museo dell'Opera del Duomo.

placed with his back to the spectator) or to the onlooker, away from the crucified figures. Hands fly out, beards are pulled in anger and heads uplifted in amazement. Here emotions and feelings are piled into a chaotic heap. Duccio has formed a remarkable contrast between the agitated group and the still, frail body of Christ surrounded by shimmering gold. Christ's cross is set further forward than those of the the two thieves and he is more strongly illuminated then they are: the one to the left receives some light, but the bad thief (to the right) is completely in shadow. Duccio has used light to pick out the physical and psychological center of the composition, to bring it forward, and to hold the spectator's attention.

Generally speaking, the back narratives of the *Maestà* are illuminated from the left by a gentle, soft light, which helps to define the figures without disturbing the flow of space and form from one side of the narrative to the other. By. the sheer splendor of its colors (green, pink, blue and red predominate), and the expanse of its gold ground, the *Crucifixion* becomes the formal focus of the narratives on the altarpiece's back. Duccio's picture was to have a strong effect on the scores of painters who came to admire and learn from the *Maestà.*

Another panel which had considerable influence on younger artists was the *Entombment* [28], in which Duccio has really combined two separate stories: the *Lamentation over the Body of Christ* and the *Burial of Christ.* In a solitary and barren landscape, Christ is lowered into the sarcophagus. Mary, with a pathetic and touching gesture which derives from the *Lamentation,* embraces her son. The blue of her robe and the quietude of her gesture are in strong contrast to the red-cloaked Magdalen, who raises her arms in horror and abandonment. Around the body other grieving friends help gently to lower the stiff and lifeless Christ. The supple bending of the bodies is of unmatched elegance.

The protective group around Christ is separated from the bleak brown mountains both by the fluidity of their bodies and by their brilliant colors. In this small group Duccio was free to paint large areas of uninterrupted color. Like a brilliant beacon against a dull sky, orange, red, blue, green and violet dance before the brown background as the ever-present gold of Duccio's exterior world shines above. A stunning color note is furnished by the light orange of the sarcophagus into which Christ is lowered. Although the figures are full of grief and passion, it is often hard for the spectator not to rejoice in the lucent and lively colors that help form this scene of human desolation.

One of the supreme masterpieces of Sienese painting, the *Maestà* was the product of the mature Duccio. While clearly indebted to the past, even for

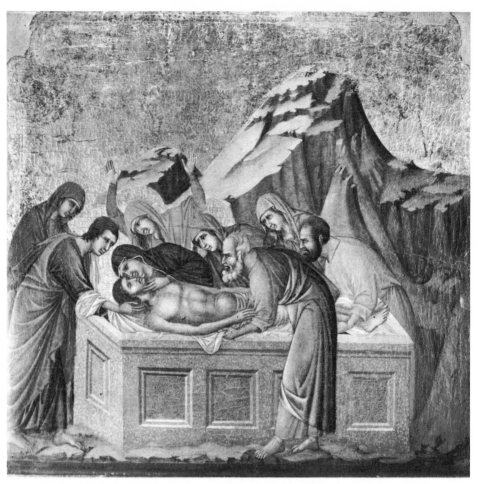

28. Duccio. *Entombment.* Siena, Museo dell'Opera del Duomo.

fundamental types and motifs, he was able to forge a personal and highly distinctive style; within the framework of tradition demanded by the workshop system of artistic education, he was a remarkable innovator. The complex, sophisticated spatial settings of his narratives were unprecedented in Tuscan painting; the powerfully restrained emotion of his figures, while certainly owing something to Giovanni Pisano's passionate actors, was also new to the Sienese scene; and his color, even in a city already so chromatically sensitive, was of the greatest originality. Nearly everything about the *Maestà*—its size, its location, its iconography, the prestige of its commission—must have made it, almost at once, one of the most famous altarpieces in Tuscany.

As the evidence of subsequent painting shows, the *Maestà* had a profound

effect on Sienese art for the next hundred years. In a sense, it was like a rich mine from which scores of artists, even the most inventive, took motifs, ideas and inspiration. But more than that, it was one of the incunabula of the Sienese school of painting. While there are certainly Sienese characteristics in the work of Guido da Siena, his followers and his contemporaries, these artists really belonged to a pan-Tuscan school which spoke the same artistic language, only with different accents. With the *Maestà* we find the first visual document—event might be a better word—of a new, innovative and independent school of painting.

Unfortunately we know very little about Duccio's painting between the completion of the *Maestà* in 1311 and his death by 1319. What he did or planned to do during those years remains a frustrating mystery. However, a *Madonna and Child* (once the center of a polyptych) in the Galleria Nazionale dell'Umbria at Perugia [29] does seem to date from a period slightly after the *Maestà*.

The Perugia *Madonna* seems slightly more resolved, broader and serious than any previous *Madonna* by Duccio. Firmly fixed in space, she appears to rise from the broad base furnished by the full sleeves falling from her extended arms. Turned slightly, her right shoulder seems closer to us than her left shoulder. There is a subtle integration of the various spatial planes. For instance, the Madonna's hands, her gently tilted head, the flow of her scarf, and the Child's carefully articulated body are all clearly demarcated steps back in the picture's space. There is a seamlessness about this picture which is different from the works before the *Maestà*, and which perhaps goes slightly beyond even that remarkable picture. The full, smooth face seems a bit more organic and integrated than that of the *Maestà* Virgin. The same seems true of the wonderfully drawn scarf and the robes of the two figures in the Perugia panel, even though the Madonna wears the old-fashioned striated robe absent from the *Rucellai Madonna* and the *Maestà*.

Quite restrained, the palette of the Perugia *Madonna* contains only blue, green, white and purple. The small angels above, who seem to lean on the frame and thus to enter the observer's space, are painted with just green, orange and purple. Overall, this is a subdued, rather serious picture, of a type that was to have considerable impact on several artists of the next generation.

Duccio was the teacher of many of the artists who succeeded him, and undoubtedly several of them spent a long time in his workshop. In fact, several panels of the *Maestà* seem foreign to Duccio's design and skill, in spite of the clause in the *Maestà*'s contract binding Duccio to do all the work with his own hand.[14]

A close follower of Duccio was responsible for a charming little diptych of

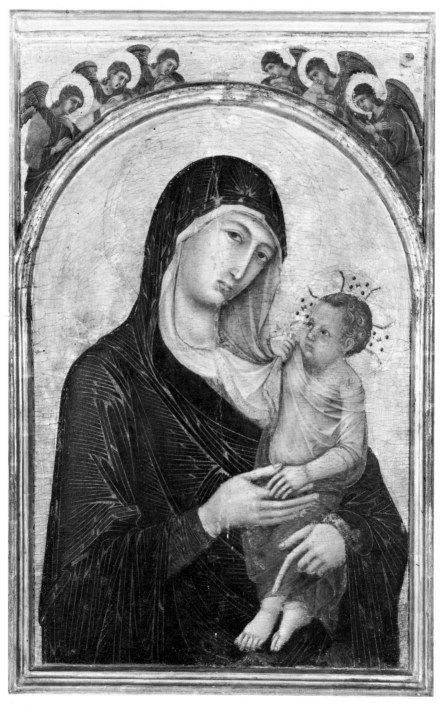

29. Duccio. *Madonna and Child.* Perugia, Galleria Nazionale dell'Umbria.

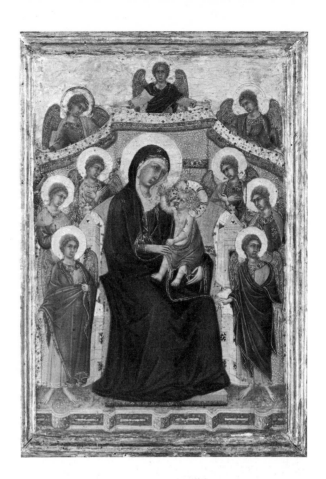

30.
Duccio's Shop. *Madonna and Child.* New York, Metropolitan Museum of Art. Lehman Collection.

the *Madonna and Child* enthroned with angels, and the *Crucifixion,* now in the Lehman Collection in the Metropolitan Museum of Art [30]. Both in form and spirit, this work is close to Duccio's style of the period somewhere between the *Madonna of the Franciscans* and the *Maestà.* It is even possible that this picture, along with several other works of quality, was commissioned from Duccio, who then handed the task over to a good pupil for design and execution. Perhaps Duccio was too busy with more important projects to handle this tiny diptych, which may have been meant for the saddlebag or purse of a merchant or monk.

The Lehman diptych differs from any of the secure works by Duccio in the basic elements of its composition. There is not the same feeling for rhythmic, exquisitely wrought form, nor the relation of shape to shape that one finds in all Duccio's works from the *Crevole Madonna* onward. Certain shapes, like the left side of the Madonna or the left side of the throne, are slightly awkward or unclear when compared to similar passages by Duccio. But, on the whole, the delicate and

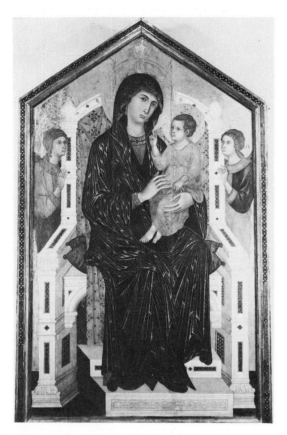

31.
Master of Badia a Isola. *Madonna and Child with Angels.* Badia a Isola, SS. Salvatore e Cirino.

intimate diptych is quite representative of the high quality achieved by the several talented pupils who made Duccio's stylistic principles their own.

Another class of Duccio follower is represented by an altarpiece in the church of SS. Salvatore e Cirino at Badia a Isola, near Siena. The author of this wonderful *Madonna and Child with Angels* [31], known as the Master of Badia a Isola, appears to have been one of the first notable imitators of Duccio.[15] The traces of geometric stylization still seen in the Madonna's noble face and in the Child's robes suggest that the artist was a contemporary of Duccio who, after training with someone such as Guido da Siena, adopted Duccio's idiom. Duccio's style did not make a sudden, total break with the past, but it was decidedly different from that which had preceded it, and it appears that a number of men, the Master of Badia a Isola included, were quick to recognize exactly what Duccio had done.

The highly plastic, curvilinear face of the Badia a Isola Madonna, her massive throne, the curly-haired angels who gently touch the throne, and the intent Christ Child, all are very reminiscent of the *Rucellai Madonna.* So, what we see in the

Badia a Isola altarpiece is one of the first artistic responses to the maturing and increasingly innovative painting of Duccio. More eloquent than any written record, this picture describes the early reception of what was to become the major stylistic movement of all Sienese art.

But the painting at Badia a Isola is more than just a record of momentous events; it is also a fine work of art, conceived with sensitivity and executed with a highly refined technique. The expansive, blocky, space-creating throne is the architectural center of this stable composition. It has been suggested that the Master of Badia a Isola was influenced by Cimabue, and this may indeed be the case. There is something solid and monumental about the work which recalls his style. But the beautifully controlled line and inherent grace of the figures are derived from the Duccio of the *Rucellai Madonna* (c.1285).

Thus far we have discussed only Duccio's pupils or contemporaries. There is, however, another group of artists indebted to Duccio which is of a slightly different order. One of these artists was Segna di Bonaventura, who painted a *Madonna and Child with Saints and Angels* for the Collegiata di San Giuliano at Castiglione Fiorentino [32]. Segna, active between 1298 and 1326, appears to have been Duccio's nephew.[16]

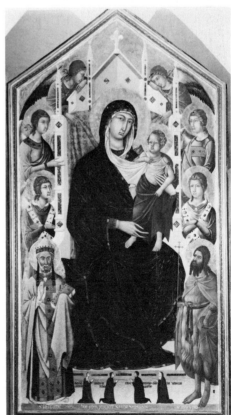

32.
Segna di Bonaventura. *Madonna and Child with Saints and Angels.* Castiglione Fiorentino, Collegiata di San Giuliano.

Segna's *Madonna* is a larger, more complicated version of the altarpiece at Badia a Isola. Like that earlier work, it clearly demonstrates that its artist was steeped in the fundamentals of Duccio's style; but there are several basic differences between the way each worked. The Master of Badia a Isola was a fine painter, who consciously strove to make his style like that of Duccio. Segna, on the other hand, was a less talented artist, who seems to have grown up with Ducco's style as his native idiom. Yet in parts of the Castiglione Fiorentino panel, Segna seems almost to be trying to move away from Duccio's influence.

Throughout there is a movement away from the elegant, svelte proportions seen in Duccio's works. One sees a broadness in the Madonna, and a squatness in the two standing saints at the lower left and right, which signals a different approach to the construction of figures. Also, Segna does not understand or does not care to follow Duccio's sophisticated spatial construction. In Segna's work all the figures, except the two angels behind the throne, are close to the picture plane; the major compositional rhythms are up and down the surface rather than back into space. Possibly this is a reversion to older, Duecento ideas, where the surface of the picture was always activated to form an overall decorative pattern.

There is also a different emotional atmosphere about Segna's altarpiece, an atmosphere that it shares with other works produced by his contemporaries. Some of the figures—the Madonna, the two saints and several of the angels—seem lost in their personal thoughts. They do not make contact with each other. Such lack of unity is never seen in Duccio's psychologically integrated pictures.

Segna, like a number of other Duccio followers, was influenced by several famous Sienese artists who began to work shortly after the completion of the *Maestà*. The four topmost angels in his picture, for example, reflect some of the grace and poise of Simone Martini's figures. In fact, Segna and some of the later followers of Duccio are quite eclectic. They graft (often uncomfortably) some of the stylistic motifs of their more inventive contemporaries onto their own basically Duccesque art. They are very interesting artists, for their work frequently reveals much about the prevailing idioms and painters of their times.

Another of these followers of Duccio was Ugolino di Nerio, sometimes called Ugolino da Siena, who was active between 1317 and 1327.[17] Ugolino's only known signed work is a large altarpiece, once on the high altar of Santa Croce in Florence. This painting of c.1320, now in a fragmentary condition, is important because it clearly demonstrates that, even during the time of Giotto's greatest popularity, modern Sienese works were highly appreciated in Florence. Santa Croce was one of the major churches of the city, and the commission for its high

altarpiece would have been one of the most sought after by all painters.[18] It is thus noteworthy that it was awarded to a Sienese follower of Duccio. This fact may well indicate something about the popularity of the *Maestà* and suggests that the patrons of Ugolino's Santa Croce altarpiece were anxious to get an artist who would work in Duccio's style. One does not know exactly what the finished altarpiece looked like, but early descriptions and the existing fragments demonstrate that it was a grand affair, which had a rather strong structural resemblance to the *Maestà*.

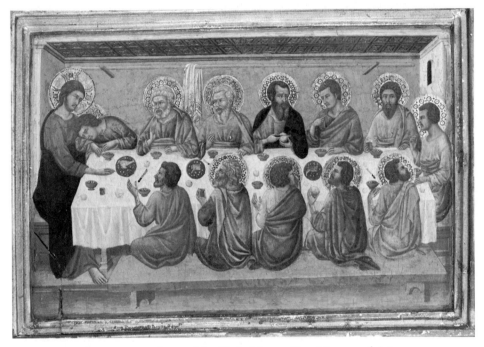

33. Ugolino di Nerio. *Last Supper.* New York, Metropolitan Museum of Art. Lehman Collection.

One of the fragments from Ugolino's Santa Croce altarpiece, now preserved in New York, is the predella panel of the *Last Supper* [33]. Obviously inspired by the picture [34] of the same subject from the *Maestà* (a work which Ugolino must have known well), it is clearly in the Duccesque idiom. Like Segna's altarpiece in Castiglione Fiorentino, it owes its stylistic vocabulary and narrative vision to Duccio; the space of the room, the gestures, facial types and almost everything else in the work can be traced back to the *Maestà*.

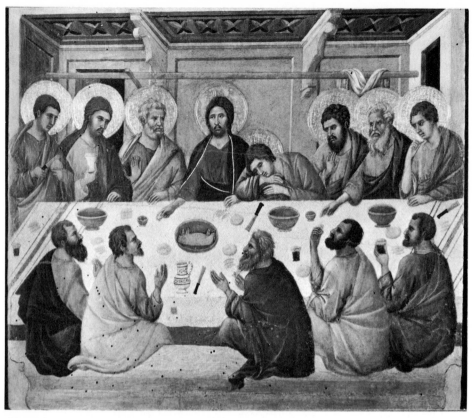

34. Duccio. *Last Supper.* Siena, Museo dell'Opera del Duomo.

Yet no one would mistake this picture for a Duccio, any more than one would suppose that Segna's altarpiece were by Duccio. The narrative scheme of Ugolino's picture differs greatly from that of Duccio's. Duccio has placed Christ in the center of the table, surrounded and fronted by small groups of apostles. He is the center of all attention; the moving force of the drama. In Ugolino's picture, Christ occupies the end of the table. Neither he nor anything else is, in fact, the center of the composition. The apostles are not the carefully planned and unified audience that they were in Duccio's predella. Instead, they talk to each other, make silent gestures, eat or drink. Ugolino was interested, as this comparison reveals, in a much more episodic and anecdotal type of painting. He, Segna, and a number of other artists painted many pictures in this vein, but these artists were not anti-Duccio. Rather, they either did not understand him or did not want to utilize much of what was most inventive in his idiom.

There is a particularization of the surface, a fussiness of detail and execution,

which is also characteristic of these later followers of Duccio. Note, for instance, the sharpness of robes and facial feature or the love of the minutiae seen in the objects covering the table. One feels that here there is an obsession for detail alien to Duccio.

Also based on Duccio, but very different from him, is the palette. In the works of both Duccio and Ugolino there is a love of the contrasts and juxtapositions of color. But where Duccio's color is soft, subtle and wonderfully modeled with white, Ugolino's is sharp, harsh and used in combinations foreign to the painting of the subtler Duccio. Perhaps this is to be expected, for Duccio's palette —perhaps his greatest invention—was never to be duplicated or even approached in Trecento Siena. He was a born colorist, with a genius for the invention and combination of color seldom matched in European art. Yet Ugolino's manner of breaking up the surfaces into rather distinct areas of strident color seems well suited to the generally more fragmented vision of Duccio's close followers.

Thus far we have glimpsed two groups of artists strongly influenced by Duccio: those anonymous painters who worked in his shop or followed his style with little modification; and those painters, perhaps slightly younger than the first group, who worked in a Duccesque style heavily modified by their personal tastes. There remain several other artists trained in the shadow of Duccio who, although deeply indebted to his style and pictorial inventions, were to become his equals. Simone Martini, the subject of the next chapter, was one of these.

III

SIMONE MARTINI

THE PROBLEMS OF SIMONE'S ORIGINS, stylistic development and chronology are numerous.[1] No known documentation exists to fix his birth date, although it can be reasonably assumed that it was in the eighties or early nineties of the Duecento.[2] His first extant dated work (1315) is the frescoed *Maestà* [35] in the Sienese Palazzo Pubblico, a commission which would not have been given to an inexperienced artist. If it is assumed that Simone was already an established young painter by the mid-teens of the fourteenth century, then it seems logical to suggest that his artistic education was received in the shop of a contemporary of Duccio, or perhaps with Duccio himself. In any case Simone appears to have been, like Segna di Bonaventura and Ugolino da Siena, a member of the new generation which came to the fore during Duccio's last years.

In 1317 there is a record in Naples of an annual pension of gold to be paid to one Simone Martini *Milite.* It has often been assumed that this knight Simone Martini was Simone Martini the painter from Siena. The artist Simone was certainly in the employ of King Robert of Naples, the same man who ordered the pension, but there is absolutely no certainty that the Simone mentioned in the 1317 document and the artist are one and the same person. Both Simone and Martini were rather common names and without more specific evidence it seems imprudent simply to assume—as has been done—that Simone the painter was in Naples in 1317.

The records do show, however, that by 1319 Simone was receiving commissions outside Siena. In that year, his large altarpiece—commissioned by one Fra Pietro—was installed in the church of the convent of Santa Caterina, Pisa. And

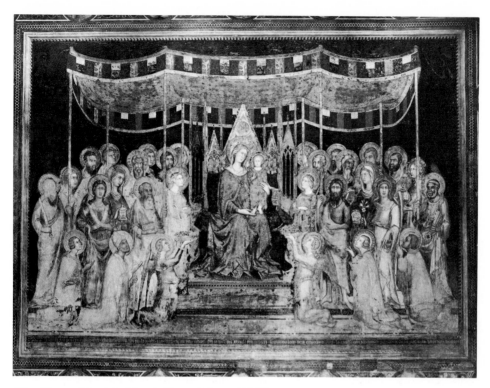

35. Simone Martini. *Maestà.* Siena, Palazzo Pubblico.

in the twenties (perhaps in 1320) he signed a polyptych destined for the Duomo of Orvieto. Both notable foreign commissions testify to his growing fame.

Between 1321 and 1323 Simone did a number of paintings for the Palazzo Pubblico, Siena. During the first of these years he seems to have retouched various damaged parts of his 1315 *Maestà,* and to have painted a *Crucifix* for a chapel in the building. In 1322 and 1323 he was paid for paintings which have either been destroyed or are not yet identified.

A glimpse into Simone's personal life is afforded by a document of 1324 which records his purchase of a house from Memmo di Filippuccio, who was soon to become his father-in-law. Memmo's son Lippo Memmi (who was, like his father, an artist) appears to have had some sort of professional connection with Simone after the latter's marriage to Lippo's sister Giovanna. This purchase document is a vivid reminder of just how tightly knit were the artistic clans of the Trecento. We have already seen that Segna di Bonaventura was Duccio's nephew, and this is just one of many cases where artists were related. In fact, there seems to have been a rather large network of marital ties which bound artists

together and, more important, probably acted to exclude outsiders from the trade.³

Throughout the second half of the twenties, documents record paintings (mostly lost or destroyed) by Simone. In 1331, he spent a week in the vicinity of Arcidosso, Castel del Piano, and Scansano (towns to the south of Siena) in the service of the commune of Siena. This is very interesting because at the end of 1330 he was paid for painting frescoes of the castles of Arcidosso and Castel del Piano in the Palazzo Pubblico's Sala del Mappamondo. There appear to have been a number of portraits of various castles and towns owned by the Sienese in the Palazzo. In Simone's case, at least, it seems clear that the commune wanted an accurate rendering of the places which were to be painted.

In 1340, according to a document, Simone bought a house in Siena. Sometime shortly after that year he appears to have moved to Avignon, the seat of the papacy and the Curia and an important commercial center.⁴ Simone obviously went to Avignon for commissions, but aside from the remains of a fresco, very little work by him can be securely traced back to that city. We have already seen that he executed a number of paintings for locations outside of Siena, and it may have been that his fame had already spread as far as France. Unfortunately, Simone's activity in Avignon—where he met and worked for Petrarch, who admired him—was to be short, for in 1344 he died in that city.

Several Simone works are dated on their frames and others can be dated by documents. But there remain a number of pictures, some central to any understanding of Simone as an artist, that defy any attempt to assign a firm date. Given the present state of knowledge about the artist, any suggestions concerning the chronology of these paintings, and thus the evolution of Simone's style, can be only of a highly tentative nature. There are simply too many unsolved problems for any definitive answers.

We do know, however, that Simone's *Maestà* of 1315 appears to be an early work [35]. It derives its basic composition from Duccio's Duomo *Maestà*, completed only four years earlier. Duccio's picture must have been the most famous modern work of art in Siena; it certainly made a deep and lasting impression on the young Simone Martini.

But the function of the two *Maestà*s is different. Duccio's was, so to speak, the centerpiece of the great Cathedral, a cult image and an aid to religious devotion and ritual. Simone's, on the other hand, was in a government building, and one of its primary functions was didactic.⁵ Its inscription urges those who govern Siena to be wise and just; it was an image which was seen daily by the rulers

of the city. Of course, Duccio's *Maestà* is not free from civic ties, but it is not so consciously didactic and exhortatory.

A number of figures surrounding Simone's Virgin seem aware of the on-looker's presence, and although they do not gesture to him, their glance and body movements indicate a certain self-consciousness. The Child and His mother also seem to make contact with the spectator, and Christ bestows an alert blessing on those standing before the fresco.

The scene is surrounded by an elaborate border, containing roundels filled with a series of busts. But while this frames the picture, it does not interfere with the spectator's easy access into it. One is invited to approach the Virgin's throne through the wide void in front of it. Further movement toward the Virgin is created by the uplifted, proffering hands of the kneeling angels.

It is apparent at once that Duccio's *Maestà* is the model from which Simone worked. What is surprising is how Simone—who must have been painting one of his earliest major works—daringly modified Duccio's famous composition. He has, in the first place, almost done away with the defined rows of saints and angels, replacing them with a more integrated, varied and coherent crowd. In fact, this is much more like the well-wrought groups that one sees on the back of Duccio's *Maestà*, in the *Entry into Jerusalem* or the *Pact of Judas,* for example. It is, of course, quite likely that Simone was inspired by these marvelous massings of people and learned much from them.

Yet there is a more solid, more convincing, more articulate treatment of space at work in Simone's picture. One feels that the overlapping figures are real solids standing before, behind and next to each other. One also senses that they really move back into space and not up the picture plane. The relation of figure to figure and their positions in space are of a different order. These new qualities seem to come from Simone's study of Giottesque composition, either from pictures by Giotto or by one of his many followers who were producing numerous works by 1315. We have already seen what appears to be Giotto's influence on the front of Duccio's *Maestà,* where there is an amplitude and monumentality probably stemming from a work like the *Ognissanti Madonna* [22].

But in Simone's *Maestà* the influence is deeper, more pervasive. The figures, for instance, are more volumetric and therefore have a palpability that is closer to Giotto's monumental inventions. There even seem to be some motifs taken directly from the *Ognissanti Madonna:* the profile faces looking through the sides of the throne and the two angels offering flowers are quite close to similar figures from Giotto's painting, which Simone could have seen in Florence or known

through a copy. This is not to say that Simone is here a Giottesque painter, for he is far from that. The easy elegance of his figures, the remarkable suppleness of their gestures, and their comely beauty are directly in the tradition of Duccio's earlier *Maestà*. Even the spatially complex intertwining of the group around the poles holding the splendid canopy emblazoned with the Sienese coat of arms would not seem out of place in a work by Duccio.

But one would not, for a moment, confuse Simone's work with that of Duccio, any more than one would mistake it for Giotto's. For Simone, like several Sienese painters of his generation, was an artist of considerable invention. The shining, relaxed countenances of his saints and angels invite the spectator into a world of languid, melancholic beauty unmatched in the entire history of Trecento painting.

These characteristics are seen in a rather small *Crucifix* by Simone in the church of the Misericordia in San Casciano in Val di Pesa near Florence [36]. Nothing is known about the history of the painting before the twentieth century, but the church was built in the 1330s—Simone's picture certainly antedates this —by the Dominicans of Santa Maria Novella in Florence.[6] This is fascinating because Simone's work is modeled on Giotto's revolutionary *Crucifix* in that Florentine church [37].

Giotto was the first to depict the pathetic dead Christ in a straightforward, highly realistic manner. His Santa Maria Novella *Crucifix* of around 1290 destroyed the much more abstract and stylized Christ type which had reached its most developed state during Giotto's youth. Even minor provincial artists felt the shock waves emanating from Giotto's painting, so it is not unnatural that a man as sensitive as Simone was also impressed by it.[7]

The articulation of Simone's Christ (note the extended arms or the tilt and fall of the head) are inspired by Giotto's earlier painting. Simone has carefully observed the way Giotto's Christ is positioned in space, and has studied how the hips bump back against the cross as the head and knees move forward. The pronounced interaction of the body with the space surrounding it is a notable feature of both crosses. Undoubtedly, Simone was looking at Giotto's remarkable work for guidance on how to make volumetric figures stand or hang in space.

Simone has also borrowed a number of individual motifs from Giotto. One of the most obvious is a shock of the red hair (Giotto's Christ also has this red hair) which hangs to the chest. The musculature of the thin, stretched arms is also alike in the two pictures. In Simone's, the arms and the rest of the body are modeled by a subtle, highly realistic interplay of shadow and highlight which

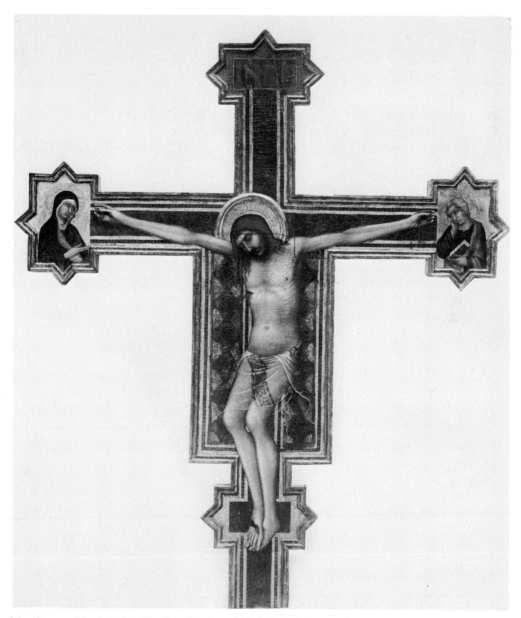

36. Simone Martini. *Crucifix.* San Casciano, Val di Pesa, Misericordia.

originated in the Santa Maria Novella *Crucifix.*

But there is a finesse and delicacy about the San Casciano *Crucifix* which mark it both as Simone's and as Sienese. The sweep and tautness of line, the beauty of the figures in the terminals, and the careful attention to detail in the

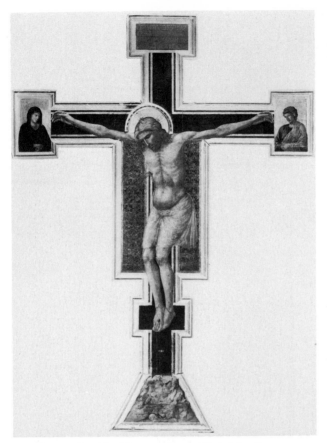

37. Giotto. *Crucifix.* Florence, Santa Maria Novella.

apron's pattern and on the filmy loin cloth all demonstrate Simone's love of decoration. While not ablaze with color, the green, orange and red palette reveals a strong interest in the use of subtle color for decorative effects.

It is impossible to assign a precise date to the cross. However, there is a tentative, almost hesitating quality about it which would seem to indicate that it comes from early in Simone's career, somewhere around the Palazzo Pubblico *Maestà.* If, as is possible, it was brought by the Dominicans to San Casciano from the church of Santa Maria Novella, it might have been commissioned in Florence.

Another work by Simone which also appears to be rather early is the *St. Louis of Toulouse,* now in the Capodimonte Museum in Naples [38]. The provenance of this altarpiece is not clear, but in all likelihood it was commissioned for the church of the Franciscan convent of San Lorenzo Maggiore, Naples. It is usually associated with the 1317 document mentioning the knight Simone, an association which is less than certain.

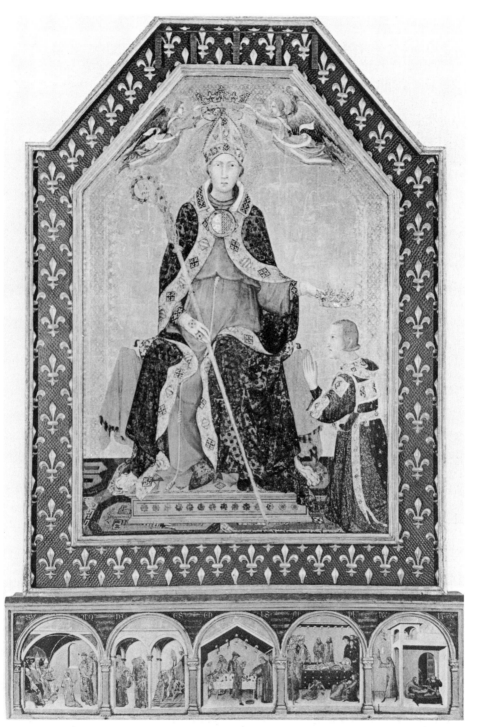

38. Simone Martini. *St. Louis of Toulouse.* Naples, Museo di Capodimonte.

In many ways, this is one of the most complicated and interesting works of the entire Trecento. Its design and iconography reveal that Simone was an intelligent and sophisticated artist who could easily paint images quite beyond the grasp of most fourteenth-century artists.

The shape of the picture is most unusual; in fact, it appears to be unique. Carried on a predella of five scenes, the major image is contained in a rectangular panel with a truncated gable. Similar rectangular panels containing the images of standing or seated saints were common during the first three-quarters of the Duecento, but by the early Trecento they were long out of fashion. Simone, it is quite clear, has consciously revived an old type for his painting. He did this, it seems, because he wished his image to share in the holiness which must have surrounded this old and venerated type. Such archaism is not uncommon in the history of art and occurs in many cultures. But in this particular case, it signals both that Simone was aware of the distance between himself and the older type (a type which belonged, at the latest, to the world of his artistic grandfathers), and that he was using the ancient image to make a point.[8]

The point was a dynastic one, for in 1296 Louis of Toulouse abdicated the throne of Naples to become a Franciscan. He was succeeded by his brother Robert, who kneels in Simone's painting. The single message of this altarpiece deals with the succession and its legitimacy: as Louis is crowned by angels, he places the crown of Naples on his brother's head. There can be no doubt about what is happening or about its holy rightness—everything is clear, divinely ordered. Such a quasi-secular subject is, to say the least, not common in early Italian painting, and it seems surprising that it is on an altarpiece. Of course, there are a number of other altarpieces depicting the images and miracles of saints, but seldom do they serve such obviously dynastic and partisan goals. In fact the throne, the coat of arms on Louis's brooch, and the golden lilies on the frame make this picture as much an Angevin coat of arms as an altarpiece.[9]

It is interesting to observe that except for the figure of Robert, Simone has kept the picture quite symmetrical. This, combined with the fully frontal, enthroned image of the staring Louis, again recalls iconic images of the early Duecento. Standing in front of the picture, one is always aware of the power and majesty of the aloof saint who, like the frontal Christ of a *Last Judgment,* seems to look past, or through, the awestruck spectator.

Even though Simone has been extremely careful to revive the format, motifs and postures of older types, he has not in any way abandoned his own personal style. The impressive figures with their full, voluminous robes made of heavy,

fantastically folded material recall the saints and angels who flank the Palazzo Pubblico *Maestà* Madonna. The regal milieu of the Neapolitan court, seen in the costly brocades, furniture, gold, rugs and jewelry of Simone's picture, is similar to the *Maestà*'s glory.

The palette of the *St. Louis of Toulouse* is restrained, dignified, yet splendid. The reddish purple of Louis's robe—which is left open to expose the humble Franciscan habit—is edged with a wide gold border covered with heraldic devices. Robert's greenish robe is gold-encrusted and Louis's miter, staff and the crowns are gold as well. Glittering in the candle and lamplight which originally illuminated it, this must have been an awesome image.

The architecture of each of the five predella scenes is so constructed that the spectator's eye is led in from the outer panels toward the frontal and symmetrical central scene. Simone, in short, has conceived the predella as a unified whole rather than as a series of disconnected narratives. Small and intimate, the predella scenes are still heavily indebted to Duccio, and this may indicate that the panel is indeed from the earlier part of Simone's career, probably around the time of the Palazzo Pubblico *Maestà* and the San Casciano *Crucifix.* Duccio's influence is apparent in the panel of *St. Louis Resurrecting a Boy.* [10] In an intricate and spatially interesting setting of a porch, tower, door and crenelated walls, the boy is brought back to life by St. Louis (who appears in the upper left-hand corner) after his father has prayed to an image of the saint which he still holds in his uplifted hands. The love of intricate spatial settings with multiple viewpoints clearly derives from Duccio: note, for instance, the half-opened door or the vaults of the tower. The placement of the reds and browns of the boy and his family against the cooler grey-green of the architecture is also characteristic of Duccio.

However, in the narration, Simone demonstrates his independence from Duccio. There is in the younger man's work a rigidly controlled but almost enervating drama. One sees this in the grieving figure who pulls her hair or in the boy who slumps against the doorway behind. There is an emotional tension about many of these predella figures that is Simone's invention.

Simone's considerable talent for the unification of the various parts of a work of art is seen nowhere better than in his two polyptychs: one for the Pisan convent church of Santa Caterina of 1319 [39], and the other for the Duomo of Orvieto from the twenties [40]. The skillful painting of a polyptych composed of half-lengths demands that the artist integrate the space, position, gesture and color of each figure with its neighbor and with all the other figures in the painting. This Simone has done with consummate skill. The gently swaying saints occupy their

39. Simone Martini. Polyptych. Pisa, Museo Nazionale di San Matteo.

40. Simone Martini. Polyptych. Orvieto, Museo dell'Opera del Duomo.

panels in a unique manner. There is an extremely sophisticated relation between their bodies and the areas of gold which surround them, indicative of Simone's (and the entire Sienese school's) feeling for the beauty of abstract shape. The eye is led gently from one porcelain-complexioned figure to another and thus from each side toward the Madonnas. There is a remarkable interplay of solid and void, which unifies and enlivens the work.

Each of the individual figures—especially those from the Orvieto polyptych—is of a very high order. Described by a slow, sensitive line, they are models of grace and decorum. Simone's is a very individual type of beauty. Each of his figures is miraculously invested with an air of quiet melancholy. Elegant and refined, they appear lost in disquieting thought. The germ of these physical and psychological types comes, of course, from Duccio, but Simone has changed it and made it his own. The elongated, narrow eyes, the arched brows, long noses and sensuous lips again recall Duccio, but they have been modified and personalized.

Simone's palette in these polyptychs is, however, quite different from Duccio's. There is a decided preference (seen best in the less damaged Orvieto altarpiece) for saturated, clear and enamel-like color. This is most evident in the red of the Magdalen's robe or in Paul's blue tunic. In the larger painting in Pisa there is a splendid show of color—black, blue, gold, red, yellow and white—across the surface of the work. Simone does not appear overly interested in the more subtle and exotic hues of Duccio, yet his polyptychs are themselves wonderful displays of remarkably integrated and balanced color.

Simone's debt to previous Sienese painters is also apparent in the type and shape of his polyptychs. But throughout his career he was an innovative designer of panels, as is clearly seen in the unusual and daring *St. Louis of Toulouse.* The Pisa polyptych, while springing from a type found in Duccio's workshop, is an uncommonly rich and complex work. There is a harmonious integration of the many component parts which parallels the unity of Simone's painted design. Much the same is true of the surviving parts of the smaller Orvieto painting, and in both paintings the arches and molding around the panels are also of considerable beauty.[11]

The dated (1328) equestrian portrait *Guidoriccio da Fogliano,* Simone's next extant work, comes from about a decade after the Pisa polyptych [41]. It is a huge fresco (340 × 968 cm.) in the Palazzo Pubblico's Sala del Mappamondo, painted directly across from Simone's *Maestà.* Like many of Simone's works, the *Guidoriccio* is hard to classify by type, a sure indication of the artist's inventiveness. Equestrian portraits of famous men were known in antiquity, but there appears

41. Simone Martini. *Guidoriccio da Fogliano.* Siena, Palazzo Pubblico.

to have been no tradition of them in Tuscany; Simone's portrait of this well-known soldier is the first in a line of such images destined to extend down to the twentieth century.

While Simone's fresco is often said to be a portrait of Guidoriccio riding before the recently conquered towns of Montemassi and Sassoforte, there is no concrete evidence that this is exactly what is portrayed. Of the identity of Guidoriccio there can be no doubt, but the exact purpose of the picture and the circumstances surrounding its commission are not entirely clear.[12] There seem to have been a number of portraits of cities in the Sienese territory on the walls of the Palazzo Pubblico. Simone himself, as we have seen, traveled to two towns before he painted them in the Palazzo. The Guidoriccio is, in all likelihood, part of this tradition. The two towns were conquered in 1328, and Simone received some payment for the fresco in 1330.

But if the relation between the rider and mount and the background is analyzed, one sees a rather startling disparity: the horse strides on the edge of the painted border. Neither steed nor rider is spatially integrated into the fresco. This is, of course, surprising from an artist as sensitive to the unity of a picture as Simone. The lack of integration can be explained only by postulating that the work was done in two separate stages. In the first, Simone painted the background with its two cities. When finished, this fresco probably looked very much like some of the other portraits of towns which graced the walls of the Palazzo Pubblico. Then, at some later date, it was decided to add the figure of Guidoriccio. This Simone did, but without the potential for spatial harmony possible had he been able to design the entire fresco from scratch.

Yet, like a number of other talented artists, Simone turned a disadvantage

to his favor. By placing the magnificently clad horse and rider (who both wear the diamonds of Guidoriccio's coat of arms) so close to the picture plane, he has not only made them the center of attention but has also brought them quite close to the spectator. They gain a majesty which could not have been attained had they been located farther back.

Guidoriccio is marvelously isolated as he rides across the fresco. Behind him lie the two towns and the military encampment of his soldiers, yet he is the only figure seen. Soldiers are suggested by the many flags and spears, but they do not appear. The solitary Guidoriccio, baton in hand, rules the empty landscape. Of course, part of this may be due to the fact that the fresco originally contained only the two towns and no figures. If this is true, it would be another example of the artist's ability to capitalize on difficult circumstances.

Whatever the exact genesis of the work, Simone has created a powerful and striking image. Here is the Trecento's ideal of the military hero, the soldier of fortune so essential to the commune. What Simone has chosen to emphasize about Guidoriccio is his power. United by their drapery, horse and rider glide effortlessly across the deserted, conquered countryside. Like some unstoppable machine, they dominate the flinty world around them. This is in many ways a chilling visual concept, but it is one that remains in the memory, and certainly Simone's vast work must have had an influence on the equestrian portraits which were later to commemorate other *condottieri.*

Around the time of the *Guidoriccio,* Simone finished what is perhaps his most well known picture, the Uffizi *Annunciation* of 1333 [42]. Originally in the Sienese Duomo, it entered the Uffizi in the nineteenth century with a heavy new frame which overpowers it and masks its original shape; but from photographs made before the new frame was put on, it appears that the *Annunciation* panel is square. The wings with St. Ansanus and an unidentified female saint are not Simone's, but by the hand of his brother-in-law Lippo Memmi. In fact, the work bears an inscription stating that it was painted by both artists.

But despite the dual signature, it seems unlikely that both artists collaborated on the work at the same time. The smaller, slighter side saints are not proportionately in balance with the center figures; the platforms on which they stand do not line up with the much more steeply inclined ground plane of the *Annunciation;* and both saints look off to the spectator's right, out toward some undefined location in space. They seem unaware of the Annunciation taking place between them.

Later copies indicate that the *Annunciation* was already flanked by the two

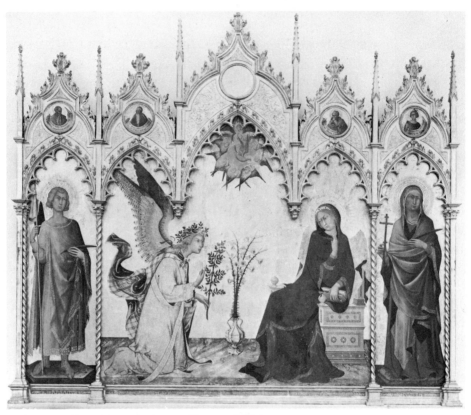

42. Simone Martini. *Annunciation.* Florence, Uffizi.

standing saints in the Trecento.[13] Yet careful observation of the panel suggests that they do not appear to have been planned with it. Possibly the two saints are what might be called a contemporary afterthought. Perhaps the patron felt that the *Annunciation* was itself not grand enough, or maybe he had some extra money to spend on the panel. It is possible that the saints were in Simone and Lippo's workshop (parts of an unfinished polyptych?) and that they were then attached to the *Annunciation.*[14]

Whatever the physical history of the picture, the *Annunciation* remains in relatively good condition and serves as a rare and important example of Simone's panel style of the 1330s. In comparison with his earlier works, here he seems to have reached a level of even greater opulence, grace and elegance. Both fantastically elongated figures are silhouetted by gently curving, slow-moving, tense lines. One need only look at the wings, billowing plaid cloak, or cascading hem of the angel to see Simone's obsession with graceful shape. The curvilinear outline of the

shrinking Virgin is, quite simply, one of the most remarkable forms in all Sienese Trecento painting.

This is a very sumptuous painting. Gold is everywhere: on the throne, in the angel's robe and wings and hem, on the haloes, and in the background. Various textures and materials are scattered throughout: marble, flowers (note the angel's headdress), brocade, plaid and feathers. All add to the richness of Simone's work.

In many ways, the *Annunciation* is like a vision. The ethereal quality of Virgin and angel set them apart from the spectator. Their lithe, swaying bodies, beautifully separated by the carefully shaped void, are in a perfect balance of measured action and reaction. Here is a stratospheric world, populated by protagonists of such refinement that each gesture, glance or breath seems a work of art. But, shot through the *Annunciation,* there is also a feeling of tension which one senses from the line, from the elongated shapes and even from the elegant but strangely stilted confrontation between angel and Madonna.

These handsome creatures (equaled only by Botticelli a century and a half later) represent Simone at his most gracious. Many of the basic components of this moment in Simone's career come from Duccio. The loving depiction of the location, the fascination with costly material and shining color (the angel's orange wings, brown plaid and golden brocade), and the careful attention to the peripheral objects, such as the branch held by the angel or the lilies at the Virgin's feet, all are foretold in Duccio's *Maestà*. The line, shape and drama can also be traced back to that earlier picture, but Simone's *Annunciation* is very different from anything Duccio ever painted. Certainly he has used the pictorial syntax invented by Duccio, but with it he has created his own idiom. And that, in a time when artists learned through copying their teachers, stands as testimony to his considerable powers of invention.

These same powers are also brilliantly evident in Simone's most extensive work, the fresco cycle in the chapel of St. Martin in the lower church at Assisi. Unfortunately there exist no contract or payment documents for this cycle, so its exact date is uncertain, as are the circumstances of its commission.[15] The frescoes narrate stories from the legend of St. Martin of Tours, a bishop saint of the fourth century whose acts of charity and humbleness were very like those of St. Francis.[16]

The onlooker is introduced to the cycle by a donor fresco *(St. Martin and Cardinal Montefiore)* which fills the inside of the chapel's entrance arch [43]. Before a balustrade is a ciborium (very like the structures designed by the late Duecento sculptor Arnolfo di Cambio) enclosing a donor, his red cardinal's hat placed on the rail, who kneels before St. Martin. This man has been identified

43. Simone Martini. *St. Martin and Cardinal Montefiore.* Assisi, San Francesco.

as Cardinal Gentile Portino da Montefiore, an important and powerful figure who supposedly dedicated this chapel in 1312.[17]

Like many of Simone's paintings, this fresco is strikingly inventive. The idea of placing these two figures far above the viewer's head (the stone baldachin is seen from below) and setting them before an extended balustrade seems to have been Simone's. There is a feeling of lonely, muted isolation surrounding the two men which is very close to the *Guidoriccio*. All attention is focused on the center of the ciborium; nothing is allowed to distract from the solemn action unfolding under its stone canopy.

It is, however, the relationship between saint and cardinal which makes this such a compelling painting. The rough oval formed by their bodies unites them, as does the steady locked gaze and the touch of their hands. The heavy cardinal, kneeling before the saint, places his right hand over his chest in a gesture of supplication as he looks hopefully toward his patron.

St. Martin, in turn, regards the cardinal with a seriousness and purpose expressed by his bent back and craning neck. His gloved hand firmly clasps the cardinal, and gently but surely pulls the weighty figure toward him. The yearning of the cardinal and the stability and grandeur of the saint are marvelously expressed by Martin's nearly erect figure and by the diagonal sweep of the donor's full robes. It is a riveting, indelible image.

St. Martin Sharing His Cloak with a Beggar is the story which begins the chapel's narrative cycle [Plate 3]. Here, in one of the most lilting and lovely scenes ever painted by Simone, the saint divides his cloak in order to cover the shivering beggar who is, in fact, Christ in earthly guise. The smooth and fluid sweep of horse, rider and beggar forms a masterful, seamless composition.

But a recently discovered underdrawing (sinopia) found when this fresco was detached from the wall indicates that the composition underwent several changes [44].[18] The sinopia also affords a rare glimpse into Simone's working method. In the underdrawing there is a large city gate at the right side that is absent from the fresco. This probably indicates that Simone had planned originally to have St. Martin ride out of the gate from right to left, instead of in the opposite direction seen in the painting today.

There are also several changes in the figures. In the preparatory drawing, the beggar is bent over further and both of his hands are outstretched and holding the cloak. Martin's body is more contorted and slightly more angular. This is interesting because it seems that the changes Simone made between sinopia and fresco were aimed at creating a smoother, less twisted articulation of the two bodies.

44. Simone Martini. *St. Martin Sharing His Cloak with a Beggar* (sinopia). Assisi, San Francesco.

Observation of the nature and placement of the lines of the sinopia reveals that Simone worked with great confidence and skill. The marks flow fluidly, easily describing each contour of body or architecture. Above all, it is an economical line: one sweep of the brush develops the contour of a leg, while another shapes the top of a head. There is no wasted effort as the single line almost magically creates form. Certainly the charcoal sketches beneath the tempera of Simone's panels must have resembled this exciting drawing.

St. Martin Sharing His Cloak with a Beggar is reminiscent of Simone's *Guidoriccio*. Seated on the magnificent horse, the saint's large body recalls the power of the soldier. The isolation of the rider set before the still city in a barren landscape is also similar. Like the *Guidoriccio,* there is everywhere a breathtaking sweep and elegance.

Overall, the palette of the frescoes of the St. Martin Chapel is bright and varied. In the *St. Martin Sharing His Cloak,* several colors predominate. The pink of the city gate and wall makes a subtle contrast with the green used for the beggar's tunic and some of the city's buildings. The pink and the green are then effectively foiled by the white of the horse and by St. Martin's gold halo. Originally blue, Martin's cloak would have created a dark swath across the picture contrasting strongly with the saint's horse and the pink city wall. Throughout the cycle, there are similar greens, pinks and golds along with white, blue and a subtle brick red.

One of the most accomplished palettes is found in *St. Martin Renouncing Arms,* a scene which illustrates Martin's decision to abandon his profession as a knight and, in the face of charges of cowardice, to confront the enemy armed only with a cross [45]. The action, which takes place in an army camp, affords Simone a chance to paint another landscape. The craggy hills (reminiscent of the *Guidoriccio*) separating Martin from the opposing army are a pale green, a color carried across the picture by a similar hue on the robes of several of the soldiers in Martin's camp. This light green not only brightens the entire narrative; it also imparts a sense of fantasy. Especially masterful is the coloring of the group around the seated emperor. Martin is dressed in a purplish robe, while the soldiers wear robes of extraordinary design and subtly varied colors: green, red, brown, gold and blue. Simone's colors, like those of Duccio, are extremely personal creations, and like that older master, he evidences a remarkable sensitivity to the juxtaposition of colors for decorative effect.

The *St. Martin Renouncing Arms* is filled with Simone's sense for rhythmic interval. Especially telling is the hiatus between the figure of Martin and the right

45. Simone Martini. *St. Martin Renouncing Arms.* Assisi, San Francesco.

edge of the picture plane. This considerable area of empty space takes up nearly a quarter of the composition and creates a significant gap between the group to the left and the picture's border at the right. Narratively significant, it demonstrates symbolically the void which Martin must enter after having renounced his career and secular life.

The white conical tents, the twisting peaks of the green hills (which make a striking outline against the blue sky), the fluttering banners, the network of lances and the shape of the figures are all carefully placed across the fresco's surface. There is a balance between solid and void and between the various forms which vividly reminds one of the way Simone sensitively arranged his figures on the Pisa and Orvieto polyptychs. This kind of composing is very appropriate for frescoes, where large areas of wall surface have not only to narrate holy stories but also to serve as chapel decoration. In the St. Martin cycle, Simone is keenly aware of this dual function, and he treads a fine line between pure decoration and narrative.

Simone is always interested in the details of costume; as with Duccio and his contemporaries the Lorenzetti brothers, what his figures wear is of utmost importance. The several scenes where Martin is a part of a court afforded Simone a rare opportunity to create a series of beautiful and fantastic costumes. One has only to observe the soldier behind Martin, who wears a green robe decorated with small red circles and an exotic conical hat of white, red, black and yellow, to see Simone's delight in the attire of his figures. Equally fascinating is the emperor's golden armor and the voluminous purple cloak worn by Martin.

Simone's painting is nowhere more suffused with his melancholic and wistful sentiment than in the *St. Martin Renouncing Arms.* Even in this dramatic moment when Martin defies the emperor and, unarmed, turns to the foe, one feels that some sad ballet is unfolding. The bewildered look of the emperor, the faraway gaze of the man accepting the money (a bounty for fighting in this particular campaign), or the wary glance of the soldier behind Martin, all seem to express doubt and worry. Like the beautiful but slightly disturbed figures of Simone's polyptychs, these protagonists express a sentiment hard to define, yet characteristic of Simone's fertile, complex mind.

The sway of another powerful artistic mind—that of Giotto—is apparent in several of the scenes in the St. Martin Chapel, but it is seen at its strongest in the *Death of St. Martin* [46]. One cannot know where Simone first encountered Giotto's work, nor determine how much of it he knew. It is possible that he visited Florence and perhaps, like a number of Sienese artists, worked there. In any case

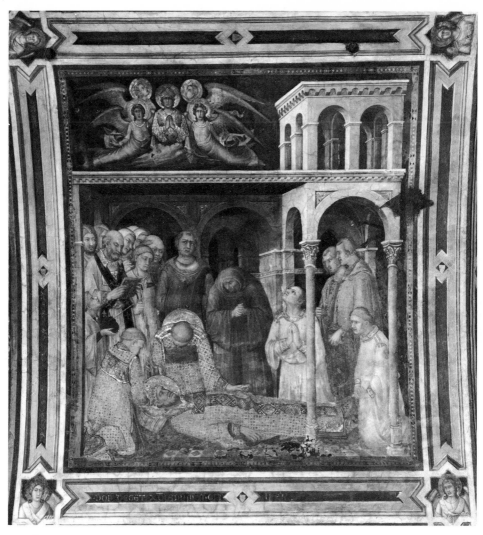

46. Simone Martini. *Death of St. Martin.* Assisi, San Francesco.

Giotto's influence, either through his own paintings or through the work of his early followers, was a strong force in the painting of the first decades of the Trecento. The hands of several of these followers are evident in the design and execution of the frescoes of the legend of St. Francis on the walls of the upper church of San Francesco, Assisi. Although we do not know when these were done, they were probably finished by the time Simone worked there.[19]

In the *Death of St. Martin* Giotto's influence, whatever way it was transferred, is apparent in the rather symmetrical grouping of the figures. This is very different from the asymmetrical figural placement of the two frescoes discussed so far. Groups of standing men bracket the figure of St. Martin, while two brothers kneel at each corner of the picture. This kind of Giottesque architectonic composing appears in two very similar scenes in the St. Francis legend in the upper church: the *Death of St. Francis* and the *Confirmation of the Stigmata*. But it is not necessary to postulate that Simone was inspired by these paintings (although he may well have been), for such Giottesque compositions were found in increasing number in the early Trecento.

Also clearly Giottesque, perhaps even more so than the figures from the St. Francis legend in the upper church, are several of the protagonists in Simone's *Death of St. Martin*. The hooded man with clasped hands, or the bending cleric, are bulky, monumental beings who clearly owe their existence to some Giottesque prototype. Among the onlookers, one also spots the full-faced stolid figures so often used by Giotto in crowd scenes.[20]

In the construction of architecture as well, one sees how the building is organized around the scene and how its various parts help to articulate and balance the drama's action. Here, Simone depicts only the essential elements of the courtyard and tower. He suggests the buildings rather than furnishing the on-looker with an overly detailed description.

One more detail recalls Giotto. Only two figures, the one at the far left and the other next to the bending figure with clasped hands, are aware of the heavenly apparition above the roof. While everyone else is absorbed in the earthly event, two of the minor figures are given the great privilege of witnessing a miracle. Such irony is something very close to Giotto's heart.[21]

The *Death of St. Martin* has provided Simone with another opportunity to display his love of splendid costume. The robes of gold brocade worn by Martin (a gift from angels) and the kneeling figure at the far left both attract attention and provide a rich, shimmering foundation for the rest of Simone's color. Interspersed among the white robes of the monks, brown, green and several shades of

pink and red appear. The quiet, meditative figures who wear these garments participate with a measured, dignified demeanor most appropriate to the solemn subject.

A number of full-length saints in painted niches provide ancillary decoration in the St. Martin Chapel. Two of these, the Magdalen and Catherine, are good examples of Simone's ideal of female beauty [47]. Tall, elegant, elongated, and clothed in splendid, heavy material, they modestly display their attributes of ointment jar and wheel. Especially striking are the Magdalen's robes, which cascade across and down the body in a series of large, sweeping folds. There is here a fluidity and ease reminiscent of the *St. Martin Sharing His Cloak* or the wonderful flow from figure to figure in the polyptychs. Like almost all of Simone's personages, both saints seem slightly self-conscious as they wistfully look away from the spectator toward something outside his space and understanding. Throughout his career, Simone was concerned with a type of refined and distant beauty best seen in these figures and in the 1333 *Annunciation.*

A date around this year would seem a strong possibility for the Assisi frescoes. Their figures are more volumetric and their compositions more spatially sophisticated than the *St. Louis of Toulouse* and the Palazzo Pubblico *Maestà,* and they exhibit less of the slightly contorted posing and expression found in either of these two paintings. The articulation of the bodies appears more secure (this may well be due to Simone's increasing study of Giotto) and daring than in any of Simone's works discussed so far, including the two polyptychs. In figure type and handling of composition, they seem closest to the 1333 Uffizi *Annunciation.*

The high quality of the Assisi frescoes seems to suggest that Simone had experience in the medium before he began to work in the St. Martin Chapel. In fact this cycle, a high point in the art of Siena, demonstrates without a doubt that he was a most accomplished fresco painter. It is interesting to note, however, that there is little compositional difference between his frescoes and panels.

It is possible that Simone's renown as a fresco painter might have been the reason he secured a commission at Avignon, the residence of the popes for a great part of the Trecento. This southern French city, a center of commercial and religious power and wealth, attracted merchants and artists from all over Europe. From it, as we shall see in the last chapter, radiated the influence not only of Simone's style but also of the idioms of several of his Sienese contemporaries.[22]

No documentation survives for the two frescoes on the portal of the church of Notre-Dames-des-Doms in Avignon, but because Simone died in Avignon around 1344, it seems logical to place them in the early part of that decade. In

47. Simone Martini. *Female Saints.* Assisi, San Francesco.

a ruinous state, both the *Madonna of Humility* and the *Blessing Christ Sur-rounded by Angels* have been detached, revealing a series of underdrawings which prove that Simone repeatedly changed his mind while designing the paintings.[23]

The sinopia for the *Madonna of Humility* affords a fascinating glimpse of Simone's drawing style [48]. Much sketchier than the fresco would have been, it shows a spontaneous and casual hand that contrasts with the rather polished, carefully calculated idiom of Simone's panels and frescoes. It is clear from the sinopia that he was interested in working out the fresco's plan of light and shade, and one can follow his brush across the surface as it defines areas of highlight and shadow. There is throughout the sinopia a kind of nervous energy which animates the Madonna and the angels. Here the process of artistic creation unfolds before our eyes.

48. Simone Martini. *Madonna of Humility* (sinopia). Avignon, Notre-Dames-des-Doms.

It seems certain that the Avignon frescoes were done near the end of Si-mone's life. Their sinopie, as one can see by looking at the *Madonna of Humility*, reveal that the polished world of Assisi is now even more full-blown. Perhaps most remarkable are the angels at either side of the Madonna. These creatures—descendants of the angels on Duccio's *Maestà*—epitomize Simone's elegant yet volumetric treatment of the figure. Convincingly foreshortened, their bodies ap-pear to fill the space surrounding the Madonna. All in all, this sinopia shows us

49.
Simone Martini. *Virgilian Allegory.*
Milan, Biblioteca Ambrosiana.

Simone at the height of his powers: confident, skillful, and in the possession of an influential and highly personal style. One wonders what direction his art would have taken had he lived longer.

Simone appears also to have been a painter of miniatures. A frontispiece (once owned by Petrarch and now in the Biblioteca Ambrosiana, Milan) depicting a Virgilian allegory has been attributed to his hand [49].[24] While the attribution is probably correct, one witnesses here a slackening of the fantastic power of compositional unity common to Simone's other paintings. This is perhaps due to the episodic nature of the scene, which contains many scattered figurative and landscape elements fragmented by several long titles placed almost directly in the center of the page. Although there are some beautiful details, such as the gesture of the pointing man, one feels that overall this work is not up to the quality of the other pictures by Simone discussed in this chapter. Certainly Simone was no stranger to the art of miniature painting, for it was extensively practiced in Siena. Like a number of other Sienese artists, he may have had some experience of painting Biccherna book covers, a task which often involved small figures. But this

only makes the rather uninteresting nature of the Virgil frontispiece less explicable. Perhaps Simone was simply not interested in the task.

Simone's brilliant style was to have a major impact on the history of Sienese painting for the next hundred or so years. The immediacy of his influence can be seen in four small panels depicting scenes from Christ's Passion, usually attributed to him but more likely works by one of his closest and best followers.[25] These powerful pictures—perhaps painted sometime during the 1340s—narrate their stories in a fierce, passionate and unrelenting manner. In all of them, but especially in the *Entombment* (now in the Staatliche Museen, Berlin) [50], there is an emphasis on the frenzied emotional reaction of the crowd to the suffering or dead Christ. There is here a spiritual agitation that is really quite foreign to the much more restrained and balanced world of Simone. Take, for instance, the attitudes of the actors in the *Entombment*.

Around Christ there occurs a fervent explosion of grief: hands reach out to touch the body; women tear their hair in sorrow; Mary Magdalen stands open-mouthed and dumbfounded; two embracing figures share their loss. The range of expression runs from the screaming women with outstretched hands at the right to a silent John the Evangelist who, in a stupor of mourning, hides his face with his robe. All this is set against a luxuriant landscape whose high horizon line towers above the figures' heads.

There is a cascading movement from left to right, as though the grieving women at the left were spilling down toward the pathetic figure of Christ. Everywhere is action, tumult and agitation. Expressive of this are the blues, reds, yellows and purples which fracture the surface and add notes of confusion and disorientation to the scene.

But as fine as this picture is, it is not characteristic of a work by Simone. His highly refined sense of decorum is absent. Nowhere does one find the wonderfully svelte, fashionable figures seen in every other composition by him. The palette is much too harsh and not in the service of a close-knit, carefully balanced composition. And finally, the description of the story in this emotionally unrestrained way is something alien to him.

There can, however, be no doubt that the *Entombment,* and the three other panels to which it has been linked, are strongly indebted to Simone's visual vocabulary; most likely their artist was trained by Simone himself, but was of a very different temperament. Of all Simone's known followers, the style is closest, in the rotund, sharp-featured faces, to that of Lippo Memmi, Simone's brother-in-law.

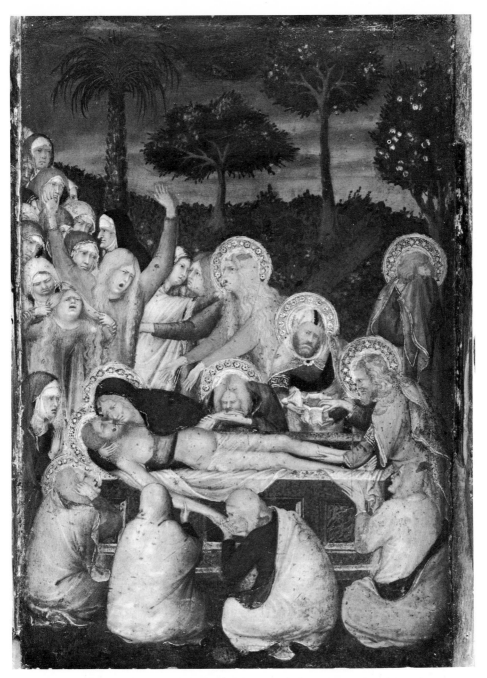

50. Close to Lippo Memmi. *Entombment.* Berlin, Staatliche Museen.

51. Lippo Memmi. *Maestà*. San Gimignano, Palazzo del Popolo.

Active between 1315 and 1356, Lippo was a productive artist whose adherence to Simone's stylistic principles was almost unwavering.[26] One of his first works is the large fresco of the *Maestà* [51] in the Palazzo del Popolo in San Gimignano, which dates from 1317, two years after Simone's in the Sienese Palazzo Pubblico. The fresco has been damaged by two doors set into the wall, and by the addition in the Quattrocento of the outermost figures at the left and right.

Obviously, Lippo's patron—the *podestà* (a high government official) Mino de'Tolomei, who kneels to the right of the Virgin—wanted the fresco based on Simone's *Maestà*. The basic arrangement of Madonna and Child surrounded by saints standing under a canopy supported on tall poles is similar, as are numerous details: the throne's shape, the step on which it is placed, and the standing angels, to name just three. But Lippo's conception of the scene is very different from Simone's. Instead of the brilliant grouping which both unites the figures and creates a backward movement, Lippo has utilized the rowlike construction of Duccio's *Maestà*. It is not that Lippo is returning to an older tradition, but rather that Simone's work is, in comparison, so innovative and spatially sophisticated. In

the figures Lippo has imitated Simone. Yet close inspection reveals that his saints and angels, while often of considerable beauty, lack the organic unity—both in the construction of the body and in the relationship of one body to another—found in the Palazzo Pubblico *Maestà*.

Part, but certainly not all, of the difference between the two pictures might be due to their varying functions. Simone's fresco of the Queen of Heaven surrounded by her court is didactic. It serves as a constant reminder that the Protector of Siena was watching over the decisions made by those who governed the city from the room on whose walls she was painted. Lippo's fresco shares this function (it is in the large council room of the Palazzo del Popolo), but it was also painted to commemorate the official who occupies an important place in its compositional scheme. Maybe this is why it seems, unlike Simone's fresco, to lack a central focus. But perhaps the overall difference between the frescoes resides ultimately in the varying levels of the two artists' creative ability.

There are times when Lippo comes very close to Simone: for example, in the splendid *Madonna and Child* in the Pinacoteca of Siena [52]. Probably derived

52. Lippo Memmi. *Madonna and Child*.
Siena, Pinacoteca Nazionale.

from a composition by Simone, the integration of arms, hands and robes is accomplished with a mellifluous sweep. From Simone, Lippo has taken the cascading hems and the beautifully elongated hands and fingers. Yet, for all its grace and sweetness, the quality of the picture does not come up to the level of Simone's Madonnas. There is a rather harsh precision about the facial features and a puffiness to the flesh never found in the work of Simone. The Child's head, perhaps the weakest part of the picture, lacks the suaveness and confidence of the Christs of the Pisa and Orvieto polyptychs.

Of more than passing interest is the Christ in the trefoil above the Madonna. He makes the gestures of blessing and damning almost always associated with the Christ of the Last Judgment. Certainly the Madonna was flanked by three-quarter-length saints, so Christ's gesture could not have referred to them. Perhaps there was a scene of Last Judgment in the predella below the Madonna, but this would have also been quite uncommon. In any case, Lippo certainly wished to make the gesture as emphatic as possible, for Christ's right hand actually extends beyond the trefoil, into the observer's space. This makes the gesture both more compelling and immediate. As we have already seen in Giovanni Pisano's statues from the Duomo facade and Duccio's *Denial of Peter and Christ Before Annas,* artists working in Siena were not afraid to occasionally break the boundaries of buildings or frames. Lippo's *Madonna* is a good example of how daring even a lesser Sienese artist could be in this respect.

Lippo's brilliant palette (the blue of the Madonna's robe, the white of her scarf, the striking red of her tunic, the Child's mantle and his cloak) is also a hallmark of almost every Sienese artist active during the entire Trecento.

An equally impressive array of varied colors (green, blue, red, orange, blue-green, gold) is found in a charming *Mystical Marriage of St. Catherine* also in the Pinacoteca at Siena [53], by the Master of the Palazzo Venezia Madonna (so-called after a work in the Palazzo Venezia, Rome), a contemporary of Lippo Memmi and a close follower of Simone Martini.[27]

This is a delicate work, filled with a soft and tender sentiment different from both Lippo and Simone. Especially moving is the network of glances established between the three figures: the slightly apprehensive look of the sweet Madonna, the serious countenance of the saint, and the shy, innocent gaze of the Child. Related through an interlocking series of diagonals—the sweep of the robes' folds and the intertwining of the hands—this is a painting which reveals a sense of unity worthy of Simone.

The Sienese sense for the decorative potential of form is apparent here. Each

53. Master of the Palazzo Venezia Madonna. *Mystical Marriage of St. Catherine.*
Siena, Pinacoteca Nazionale.

of the cusps of the frame works the gold into a shape echoed by the carefully placed haloes, and the overall shape of the frame is repeated roughly by the massing of the three figures. Whoever painted this picture was an artist of a remarkable sensitivity. In its own way it rivals even the best of Simone's compositions.

A number of Simone's followers, like the Master of the Palazzo Venezia Madonna, were artists of high quality who carried on the basic principles and aspirations of Simone's art. With the exception of the painter of the four Passion scenes, all of them helped to pass on Simone's refined, restrained, and always decorous sense of form and content. And each was an individual painter with a style which, although based on Simone's, was imbued with distinct personality.

Simone, while he lived, attracted a number of good followers; but after his death, his svelte, languorous and melancholic idiom attracted numerous other adherents who carried some of his major tenets (albeit in a modified way, sometimes verging on the edge of caricature) far into the next century. After Duccio, he was one of the major forces in the entire history of Sienese painting. In fact, his influence was matched only by Pietro and Ambrogio Lorenzetti, the subjects of the next two chapters.

IV

PIETRO LORENZETTI

I N THE STONY DARKNESS of the colonnaded Pieve di Santa Maria in Arezzo stands a large, complex and noteworthy polyptych commissioned in 1320 by the powerful Bishop Guido Tarlati [56]. It is the earliest dated painting by Pietro Lorenzetti.[1] By 1320, as the visual evidence of the Arezzo polyptych demonstrates, Pietro was already a fully formed artist with an individual, distinctive style; he must have also been rather well known to land such a considerable commission. Yet there are no known documents that shed light on what he did before 1320, how old he was in that year, or with whom he had trained.[2]

In 1326 his name appears again, this time in connection with some unidentified pictures probably for Siena Cathedral. Three years later he is documented as the artist of an altarpiece for Santa Maria del Carmine, the Carmelite church of Siena. This remarkable painting survives, although in a fragmentary state, as the earliest example of the artist's maturity.

The 1330s witnessed a number of important works by Pietro. In 1333, he painted a *Madonna* for the Sienese Duomo, and in 1335, he received payment for an altarpiece of the *Birth of the Virgin* for the chapel of San Savino in the same church. This work, now in the Museo dell'Opera del Duomo, was not finished until 1342. Connected with it is a fascinating document which authorizes payment to a certain Master Ciecho for translating the legend of St. Sabinus into Italian for the painter's use.[3] Obviously those in charge of the commission wanted to make sure that Pietro understood what he was to paint. By implication, the document also suggests that Pietro had a considerable part in the planning of the altarpiece's narrative: why else would the translation be made?

Both Pietro and his brother Ambrogio signed and dated the *Marriage of the Virgin* on the facade of the major hospital of Siena (Santa Maria della Scala) in 1335. This and the other facade frescoes, most likely destroyed in the early eighteenth century, were probably extremely influential. Certainly such an important commission testifies that by the mid-thirties Pietro was already a sought-after artist.

He was given permission to carry arms by the Sienese government in 1337, and in 1342 he bought some land on behalf of the children of the Sienese sculptor Tino di Camaino (d. 1337), who appear to have been his wards.[4] Another land transaction by Pietro and his wife, also involving Tino's children, occurred in 1344. This is the last known documentary mention of the artist, and like the rest of the records, casts little light. To understand something of Pietro's development, one must turn to the only reliable evidence—the pictures.

His first extant work is found in the lovely Tuscan hill town of Cortona to the southeast of Siena. A *Madonna and Child* enthroned with four angels [54], it is of a type, in part based on the Duomo *Maestà*, popular among a number of Duccio's followers. The style of the Cortona work is also closely tied to Duccio himself. Each of the full-faced angels around the throne finds its origins in his late works, as do the serious Madonna and the infant she holds.

The coloring of Pietro's Cortona *Madonna* is remarkably delicate and fresh. Light purple robes are worn by the uppermost angels; the lower two are dressed in green cloaks with red lining, and Christ's robes are a subtle red and green. A series of decorative red notes relieves the cool grey throne. Each color is telling, appropriate, and ultimately derived from the palette first perfected by Duccio.

Smaller things, such as the golden hem on the Madonna's robe, the spider-like hands, the fineness of the angels' wings, or the intense eyes with their large areas of white, also prove a rather direct Duccesque origin. Even the refined and restrained postures of the figures seem to be indebted to Duccio.

It is extremely difficult to date the Cortona panel with precision. On the basis of other similar types, it seems however to come from the late teens. This would indicate that by that date Pietro, who certainly seems to have been trained in the inner Duccio circle (if not with Duccio himself), was already an independent master.

Although the overwhelming debt of the Cortona panel is to Duccio, there appears in it a kind of seriousness and emotional expression not associated with that master. The intense, burning glance of the angels' deep-set eyes, or the charged, wordless communication between Child and mother, are new. This type

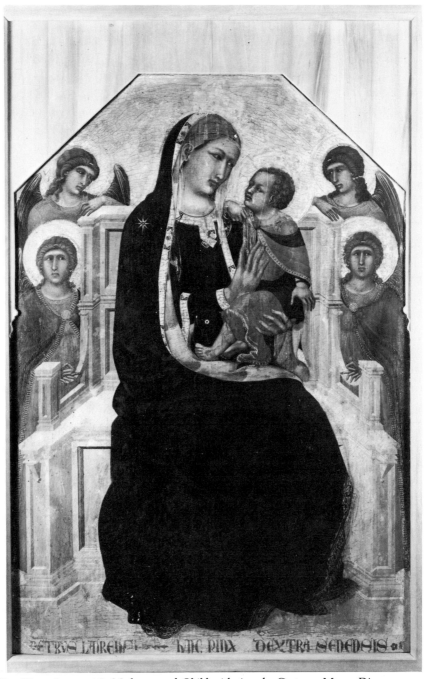

54. Pietro Lorenzetti. *Madonna and Child with Angels.* Cortona, Museo Diocesano.

of highly expressive single-mindedness will be one of the most important charac-
teristics of Pietro's idiom.

It appears again in a small Madonna panel from Castiglione d'Orcia, a town
in the Sienese territory [55]. Like the picture in Cortona, this *Madonna and Child*
is painted with a vibrancy and refinement that seems to have been a characteristic
of Pietro when he was still very close to Duccio. In fact, a good comparison with
this work is the late *Madonna and Child* by Duccio in Perugia [29]. Yet even in
the most basic compositional aspects, there is already a distance between Pietro
and Duccio. For instance, the great diagonal sweep of the Madonna's robe
(echoed, in part, by the curve of her neck) or the strong contours of the Child's
body and head in Pietro's picture, are harbingers of stylistic independence. Al-
ready in these early works Pietro manifests an uncommon individuality.

Recently restored and cleaned, the Castiglione d'Orcia panel displays a
wonderful and sensitive palette: the Madonna wears a blue robe with a red lining
over a pink tunic, the blond Child is dressed in yellow, orange and red. These few
but striking colors are arranged with skill, subtlety and unexpected daring.

Remarkable also is the great refinement of surface which characterizes this
panel and the Cortona *Madonna and Child.* The delicate hands, the hair, the
fringe on the Child's robe and the exquisite facial features are of a refinement
worthy of the best pupil of Duccio. These are, however, characteristics only of the
early works by Pietro and, as we shall see, are modified as his career progresses.

The same expressions found in the Cortona picture are also present here. The
questioning, slightly worried Child who gazes intently into the face of his sad and
wary mother could be an invention only of Pietro Lorenzetti. On the basis of these
two early panels, he seems to have been one of the most inventive and best
painters to emerge from the circle of Duccio.

Perhaps, as the important polyptych for the Pieve di Santa Maria of 1320
suggests, Pietro's talent was recognized early [56]. This large, impressive work
certainly was one of the prize Tuscan commissions of the first decades of the
Trecento. Physically intricate and iconographically complex, the Arezzo polyptych
is a type which seems to have originated in the workshop of Duccio. The tiers
of saints stacked over the three-quarter-length figures are characteristically Sie-
nese. Such visual diversity gave the artists of Siena splendid opportunities to create
rich dramas extending from panel to panel. Around the Madonna stand four
saints: Donatus (a patron of Arezzo), the two Johns, and Matthew. The pose of
each is different: Donatus stands almost frontally; John the Evangelist is frontal,
his head turned away from the Virgin at whom he gestures. The hair-shirted John

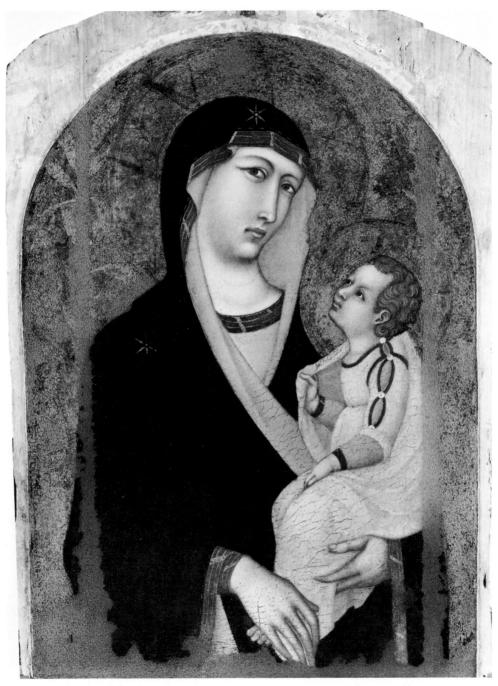

55. Pietro Lorenzetti. *Madonna and Child*. Castiglione d'Orcia, SS. Stefano e Degna.

the Baptist is turned toward the central panel, but his figure seems to be moving away from the Virgin. At the far right, the composition is closed by the nearly three-quarter profile of Matthew. There is across the surface of these panels a variety of pose, posture and gesture that enlivens the work. Yet an even greater variety of attitude is found in the smaller figures above: heads look up, down and out; bodies twist and turn; hands hold or gesture.

56. Pietro Lorenzetti. Polyptych. Arezzo, Pieve di Santa Maria.

This is very different from the smooth, measured pacing found on Simone's Pisa polyptych of the previous year. Instead of his unified, polished grace, there is an often gangling and purposely awkward construction and juxtaposition of figures. The gesture of the body is for Pietro an important aid to emotional expression: note the angular, serious figures, especially the two long-maned, worried greybeards or the gaunt Baptist. These charged, skillfully articulated beings introduce a highly emotional note into the history of Sienese painting. They are the first in a line of unforgettable figures Pietro was to create.

Cloaked in a white robe covered with blue-centered embroidered flowers and lined with ermine, the Arezzo Madonna is a splendid image. The decoration of her robe, the undulation of the golden hem, and the swing of the lining form a series of exciting patterns; surely this love of abstract design is Pietro's inheritance from Duccio.

The Madonna's face is also indebted to him. More volumetric and accomplished than the faces of the two earlier Madonnas, it is nevertheless strictly Duccesque in type. The lively, inquisitive Child also springs from Duccio's idiom, but the gentle twist of his body across—and slightly into—the picture's space signals a new interest.

Throughout the Arezzo polyptych, both in the movement of figures in space and in their angular, expressive quality, Pietro reveals debts to two other artists, Giotto and Giovanni Pisano. These debts, however, are not obvious, and like those incurred by all artists of considerable talent, they are not manifested as direct quotations, but rather are seen only after they have emerged reshaped by the subtle creativity of the borrower.

Exactly when and where Pietro came into contact with Giotto's art is unknown. Perhaps he knew works in Florence, or maybe he had seen some of the scores of paintings produced by Giotto's early imitators. In any case, that he had knowledge of Giottesque works is clear from the Arezzo polyptych where the bulky, foreshortened Madonna and Child reveal his fascination with the revolutionary Florentine style. In the overlapping of planes and in the dramatic foreshortening, Pietro reveals that he was one of the earliest to understand fully many of the stylistic ideas first set down by Giotto. The heightened realism of the Arezzo polyptych, with the increased volume and tangibility of its figures, demonstrates that by 1320 the study of Giotto's art had already caused certain important modifications in Pietro's interpretation of Duccio's idiom.

Along with Giotto's influence in the Arezzo polyptych, one also sees the powerful sway exerted by Giovanni Pisano. From Duccio onward, Sienese artists

were fascinated by Giovanni's sculpture, which they must have known from the Duomo facade since they were children. Giovanni's art, as well as Giotto's, must have taught painters much about the representation of solid objects in space.

But for Pietro, there was something else to be learned from Giovanni: the manipulation of the various parts of the body to form figures of remarkable emotional power. The tendency toward highly expressive images appears in Pietro's earliest pictures, but it is only with the influence of the twisted angularity of Giovanni's style into the Arezzo polyptych that his full ability to create sympathetic and moving figures is realized. Pietro must have looked with wonder at the works of Giovanni Pisano and Giotto, but he seems not to have forgotten that they were also tools which could help him forge his own intensely personal vision.

A precursor of Pietro's later style is the *Annunciation* [57] above the Madonna panel of the Arezzo polyptych. The story unfolds in a rather complicated architectural setting, consisting of several structures and levels. Pietro has divided the scene in half, marking the center of the composition with the small wooden column (now mistakenly removed) of the frame. This column is directly in front of a painted column; consequently, the spectator has some difficulty deciding where the paint ends and the wood begins. This merging of the fictive world of the picture with the real one of the frame is a device which Pietro, along with a number of other Sienese artists, would use throughout the first half of the Trecento. It is one of the first manifestations of a new, highly illusionistic tendency destined to reach its apex around the middle of the century in the *Annunciation* by Pietro's brother, Ambrogio.

Nine years after the Arezzo polyptych, Pietro was working on another large altarpiece [Plate 4], this time for the church of the Carmelites in Siena. Now dismembered, this painting was one of the grandest polyptychs of the early decades of the fourteenth century, and its commission to Pietro must be interpreted to mean that by 1329 he was one of the city's leading artists.

Originally flanked by panels of four saints, the panel with the Madonna, Child, Angels, St. Nicholas and the Prophet Elijah formed the center of this sizeable polyptych.[5] Bracketed by tall angels and addressed by two standing figures below her, the serious Madonna is the focal point of all interest. Enthroned in the center of a symmetrical composition, she is the physical and spiritual hub of this small universe. The relation between the hushed, unwavering adorers and the large Virgin reminds one of Giotto's *Ognissanti Madonna* [22], where saints and angels alike stand transfixed before Mother and Child.

In the Carmine painting, Pietro's style has entered a new phase. There is an

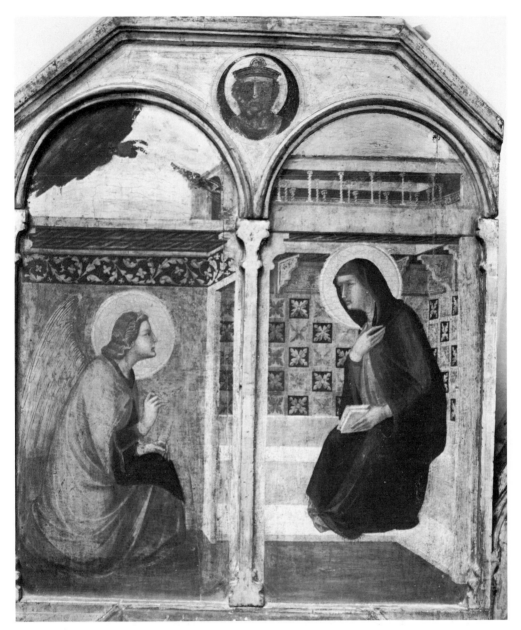

57. Pietro Lorenzetti. *Annunciation*. Arezzo, Pieve di Santa Maria.

increased confidence in the construction of the figures: the side saints and the
Madonna have become nearly monumental. The faces are even more volumetric,
the foreshortening of heads, torsos and objects is better integrated into the pic-

ture's space, and the drapery folds are broader and easier. All this makes for a very compelling and immediate image. The beholder now seems really to be in the presence of his heavenly queen and her saintly court. Pietro's fundamental seriousness is here combined with a newfound grandeur.

But still there remain connections with Duccio. Throughout the picture, there is a fascination with decorative detail seen in the embroidered cloth of honor, the costumes of the angels and St. Nicholas, the fringe on the gold border of the Madonna's robe, and the particularized nature of the crown, veils and crozier. A remarkable union of increasingly abstracted forms with typical Sienese decorative sense prevails.

Every panel of the altarpiece displays Pietro's well-conceived palette. In addition to the golden embroidery of the costly robes and the striking red of the cloth draped over the Madonna's throne, there are whites, greens (ranging from pale to highly saturated), browns, pinks, reds and blues. The *Consignment of the Rule,* the long predella under the Madonna, is the most varied[58]. Across its wide

58. Pietro Lorenzetti. *Consignment of the Rule.* Siena, Pinacoteca Nazionale.

surface Pietro has placed colors in a series of wonderfully spaced notes—the greens, whites, pale yellows, browns, bright reds, pinks and cool blues producing a surface of great coloristic beauty. This is not the ultra-refined, gradual movement of Duccio, but a series of sharper and bolder transitions from one color to another. Although poorly preserved, the predella and the Madonna panel above it still give an idea of what must have been the jewel-like brilliance of the central part of the Carmine polyptych.

The *Consignment* is divided into two halves. On the left, a procession emerges from the pink-walled city; the right side is occupied by a blue-grey church, a pink fountain, and a group of brown-clad Carmelites (the only slightly somber color in the picture) who accept the Rule of their order. Behind this screen of vigorous riders, brisk soldiers and kneeling friars unfolds a hilly, panoramic landscape filled with flowers, bushy trees and white-robed hermits, all bathed in a gentle light. This vast and beautiful countryside is unlike anything seen in Sienese painting before. Although it may owe its origins to Duccio's *Maestà*, it is more

59. Pietro Lorenzetti. *Sts. Agnes and Catherine.* Siena, Pinacoteca Nazionale.

PLATE 2. Duccio. *Entry into Jerusalem*. Siena, Museo dell'Opera del Duomo.

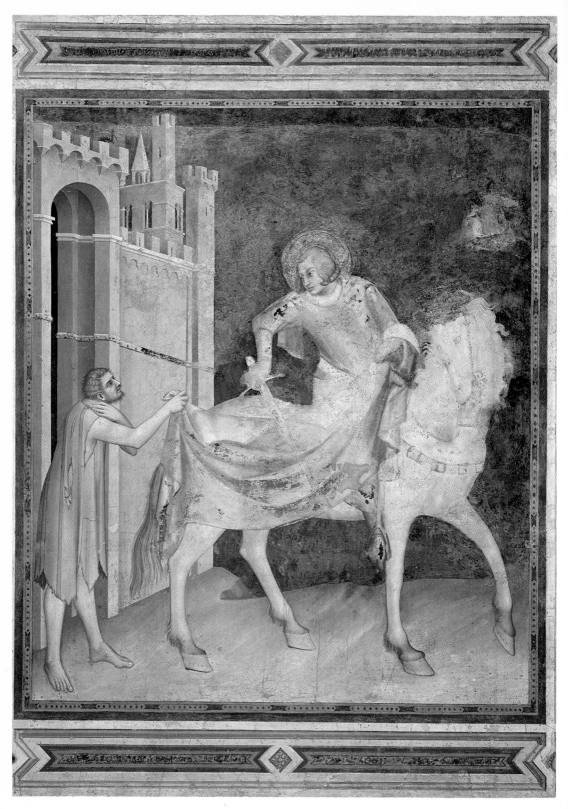

PLATE 3. Simone Martini. *St. Martin Sharing His Cloak with a Beggar.* Assisi, San Francesco.

PLATE 4. Pietro Lorenzetti. *Carmelite Altarpiece*. Siena, Pinacoteca Nazionale.

PLATE 5. Ambrogio Lorenzetti. *Rapolano Madonna*. Siena, Pinacoteca Nazionale.

panoramic and fantastic than any landscape in that earlier monument. Neither does it come from Giotto, whose landscapes and color were at this time much less evocative. The richly exotic, exciting feeling of this predella must be credited to Pietro's genius alone.

Each of the saints who originally flanked the central panel is a memorable image. Full-length, of great volume and dignity, these expressive creatures are uniquely Pietro's. Like the saints of the Arezzo polyptych, they turn within their niches, but here the movement is more pronounced. These beings, especially Agnes and Catherine, begin to deny the established boundaries of the frame [59]. The traditional space-confining role of the individual polyptych panel is here challenged by Pietro, who now starts to make space, action and drama move from panel to panel. Perhaps inspired by Giovanni Pisano's facade statues, he has taken a major step toward the unification of the multi-winged altarpiece. This development will be fully understood by Ambrogio Lorenzetti, who will carry it to its logical conclusion in the forties. These early attempts toward the unification of the polyptych are indicative of Pietro's increasing desire to make the holy figures more realistic and to bring them nearer the spectator.

Around the time of the Carmine Altarpiece, Pietro painted a small *Madonna and Child* (perhaps once the center of a polyptych) for the town of Monticchiello, set deep within the hills of the Sienese territory [60]. A comparison of this rare and moving picture with the Castiglione d'Orcia *Madonna and Child* [55] of about a decade before is revealing. The earlier *Madonna* still belongs to the world of the late Duccio. Close in form, if not in spirit, to works like Duccio's late Perugia *Madonna,* it reveals Pietro's origins and early adherence to the principles of picture-making created by that artist. But the first glance at the Monticchiello *Madonna* demonstrates the remarkable change undergone by Pietro's style. One is immediately impressed by the way the broad body of the Madonna fills up the lower part of the picture and serves as a sturdy and firm base for the figures. While the forms of the earlier *Madonna* tend to be delicate, those of the Monticchiello picture are blunter and fuller.

Both physically and psychologically, the Madonna and Child of the Castiglione d'Orcia panel are somewhat isolated; there exists between them a certain timidness characteristic of the early Pietro. Yet by the time of the Monticchiello painting, there is a formal and emotional integration seldom matched in the history of early Tuscan art. Especially touching is the Child, who stares intently and innocently into the face of his serious mother, his body forming one side of an arch that is continued and completed by her head and right side. The closeness

60. Pietro Lorenzetti. *Madonna and Child*. Monticchiello, SS. Leonardo e Cristoforo.

of the two figures and the skillful union of their bodies are remarkable, even more so when one considers how different this is from the Castiglione d'Orcia *Madonna* of just a decade or so before. In the Monticchiello panel, there is a monumentality of form and a tenderness of feeling characteristic of Pietro alone.

Coloristically, the Monticchiello *Madonna* is one of Pietro's finest works. Brilliant combinations of hue are found everywhere. The blond Child wears a yellow tunic with a brick red robe, while the Madonna is dressed in a blue robe lined in green. Each color is clear and strong, and the overall impression is one of restrained brightness and gaiety. There is a breadth and daring to the color which is in absolute harmony with the picture's form and emotional content. How very different this is from the much more controlled Duccio or the coolly graceful Simone.

The increasing boldness and breadth of Pietro's style appears again in a large *Crucifix* in the Museo Diocesano, Cortona [61], which seems to date from the late twenties, the same period as the Monticchiello *Madonna*. (Crosses of this type probably hung high in the apse of the church, so they had to be large to be seen from below.)[6] The greenish Christ of Pietro's painting hangs lifeless; it is clear that here he has chosen to emphasize Christ's intense suffering. The twisted body, contorted face and slack abdomen leave no doubt that the Crucifixion has taken a horrible toll. This is in many ways a new conception of the dead Christ. In the work of Duccio and Simone there was a much more stylized, almost ritualistic suffering; these were painful images indeed, but they avoided the blunt directness that is the major psychological motif of Pietro's cross.

This directness is achieved by style. Again, one sees Pietro using the large, integrated forms of his maturity to create a monumental figure convincingly articulated in space. The result of all this is that the Christ is a terrifying presence. John the Evangelist and Mary in the cross's terminals are also figures of expressive power. Self-contained, John holds himself in unspeakable grief as he averts his glance from Christ. His and Mary's sadness seems unbearable. Brilliantly and boldly composed, they are models of pictorial economy, closely related to Pietro's Monticchiello *Madonna*.

Much more somber than the picture from Monticchiello, the Cortona *Crucifix* is, nevertheless, finely colored. There is a striking opposition between the large areas of gold on the apron and frame and the black of the cross. Characteristically Sienese is the resulting decorative black-gold pattern which energizes the work. The greenish flesh tones of Christ and the thin white material of his loin cloth form the central focus, but other color notes also appear. The blue and red

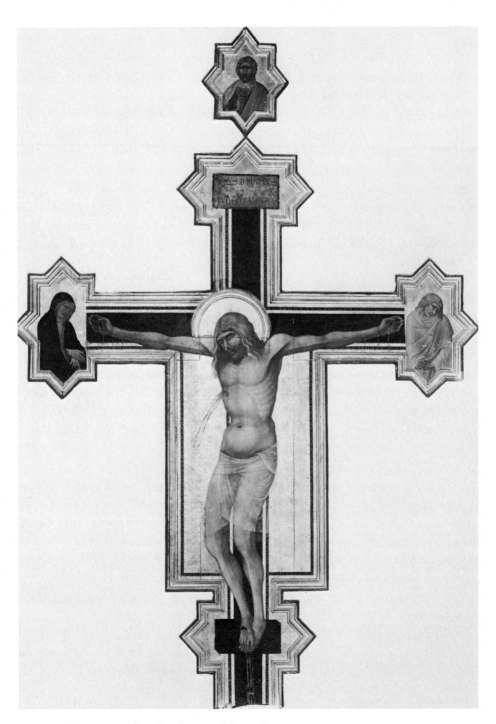

61. Pietro Lorenzetti. *Crucifix*. Cortona, Museo Diocesano.

of Mary's robes, the red of the *cimasa* Christ's mantle and, most vividly, the bright pink of John the Evangelist's clothes. These colors keep the spectator's eye constantly moving around the cross.

Another essay by Pietro on Christ's Crucifixion is found in a fresco in San Francesco, Siena [62]. Badly preserved (much of the color has fallen away), cut down on the bottom and probably on the sides, this magnificent wreck appears

62. Pietro Lorenzetti. *Crucifixion.* Siena, San Francesco.

to date from around the same time as the Cortona *Crucifix.*

As in the Cortona *Crucifix,* a grave and monumental feeling arises from the Siena *Crucifixion* fresco. Around the dead Christ hover mourning angels, whose wildly contorted poses and dramatic gestures express the depth of their feelings. The beating wings, wailing voices and twisted bodies of these creatures find their equals only in Giotto's remarkable *Crucifixion* in the Arena Chapel in Padua, a

work quite similar in spirit to Pietro's.[7]

Below Christ stand the Marys, St. John, and a group of soldiers, including the recently converted Longinus still holding his lance. Pietro has paid careful attention to the interval between these figures: the rhythmic disposition of the bodies varies from the tightly packed knot of women at the left to the isolated figure of St. John.

Especially touching is the figure of the Madonna at the lower left, whose face reveals an ineffable grief, mirrored wonderfully in the figures who support, surround and protect her. Most pitiful is the gesture of a woman with her back turned to us who places her hand over Mary's womb as Mary looks upward toward her son. Exactly the same type of pathos is found in the monumental, grieving St. John, who painfully reveals his isolated grief at the foot of the cross. The dramatic, pathetic quality of these figures makes the picture a landmark of early Italian art.

The same skillful ability to portray the deepest emotion in a convincing, heroic, and brilliantly economical fashion is seen throughout Pietro's frescoes in Assisi. Filling the entire left transept of the lower church, they stand among the largest, most noble examples of Sienese religious wall painting.

A lengthy debate has raged over the date and attribution of these paintings. Critics have placed them both early and late in Pietro's career and have seen in them various hands.[8] To fix these frescoes firmly in Pietro's chronology is indeed difficult, but the maturity of their compositional and narrative construction seems to indicate that they cannot come from an early stage in his career. Several of the scenes are, in fact, among the most splendid he ever painted, and the economy and power of their drama strongly suggests that they are the products of an older and experienced artist of genius.

There are a number of striking differences between the scenes on the vault and the frescoes on the walls below. The former are often crowded and marvelously off balance, while the latter are more calmly dramatic and grand. These differences have prompted some historians to suggest that the Assisi pictures were done in two campaigns. This may be true, given the considerable changes between the two sets of frescoes, but there are also enough similarities among all the paintings to make one hesitate to accept the idea too readily. The truth is that Pietro's Assisi frescoes are a stylistic puzzle. Perhaps some of the differences between wall and vault may have been caused by the intervention of assistants. Nevertheless, each of these paintings is a splendid example of Pietro's inventiveness and originality.

Nascent violence, rage and isolation are the emotional hallmarks of Pietro's

63. Pietro Lorenzetti. *Kiss of Judas*. Assisi, San Francesco.

Kiss of Judas [63]. Attention centers immediately on the large group occupying the central foreground. Guided by them, the eye comes to rest on the figure of Christ, who is about to be captured by his enemies. Surrounded by hostile, leering faces, he recoils from the hunched, animal-like Judas, but at the same moment he admonishes Peter for cutting off the ear of the High Priest's servant and performs the miracle which will replace it. The convincingly foreshortened bodies of Judas and the soldier with the shield create a rush of space toward Christ, who is trapped by walls of figures and stone. Escape is unthinkable.

In the solidity and volume of the bodies and in the directness of their gestures, Pietro demonstrates an understanding of Giotto's Arena Chapel style (c.1305). This is also evident in the way the architectonic landscape is integrated with the drama: the fleeing apostles pass through the rocky cliffs, and the action is contained by the tower of rock to the left and the flinty hill in the background. The brilliant and profound manipulation of the basic visual elements in the works of Pietro marks him as one of those rare artists who understood fully the nature of Giotto's remarkable style. It was, of course, not necessary for Pietro to have traveled to Padua to have drawn inspiration from Giotto's idiom: there were, in

all likelihood, other frescoes by him in Tuscany and many of his innovations were repeated (sometimes without much understanding) in the works of his numerous followers.

In the *Kiss of Judas,* and throughout the Assisi frescoes, Pietro shows a strong awareness of light. Set against a dark sky filled with stars, the *Kiss* is illuminated by torchlight. Although one must be careful when assessing the condition of the surface of Pietro's paintings, it does appear that in the *Kiss* and in another scene (the *Last Supper*), he has tried to capture the effects of artificial illumination. In both these paintings there is a pearly brightness; the figures and landscape exist in islands of light, surrounded by darkness. The colors, as well, seem under some strange illumination: the gold, yellows, pinks and blues appear dissolved by strong light. This pale, eerie palette adds a further disquieting note to the paintings.

Another Assisi fresco in the same key is the *Way to Calvary* [64]. The background is occupied by a magnificent cityscape. Houses, steeples, arcades, and loggias are piled one upon the other. The eye is assaulted by a multiplicity of form

64. Pietro Lorenzetti. *Way to Calvary.* Assisi, San Francesco.

and color (green, red, white, yellow). Buildings are set at various angles and their sharply foreshortened corners often rush toward the onlooker; they make a disquieting, disorienting jumble which acts as a perfect complement to the frightening narrative. Here Pietro shows himself to be remarkably accomplished at making abstract formal elements expressive of the drama.

Spilling out of the Gate of Jerusalem is the procession bound for Calvary and Christ's Crucifixion. Isolated between two soldiers, the tall, bearded, long-haired Christ shoulders his heavy cross. In the friezelike line of soldiers, condemned men, and followers of Christ, one sees a new emphasis on the horror and cruelty of this often painted story. To the left, the Virgin, Mary Magdalen, St. John, and the other faithful are pressed between the riders passing through the gate on their fierce horses and the soldiers who push the two Marys away from Christ. Everywhere in the holy group there are the most pitiful gestures and looks of despair. Like an animal, Christ is leashed. He is led by an evil-looking soldier dressed in dark blue who forms a bridge between the two bound thieves and Christ. The right side of the composition is closed by two other mounted figures: one astride a wonderfully foreshortened rearing horse, which leads the viewer's eye back toward the city, the other menacing Christ with a sword. The entire procession is placed upon a sharply tilted ground plane.

The overall impression of the *Way to Calvary* is disturbing. Seldom in the history of Trecento painting does one find such expressive figures caught in such powerful drama. And seldom does one see such graphic description of the cruelty of human to human, even in other scenes of the same subject. There is here a dizzying horror extending from the city itself to all of the figures who form the sad frieze moving across the picture plane. Later versions of the story, which also dwell on the more horrible aspects of the Passion, have often been linked to the plague of 1348, in which Pietro probably died. Yet here is an example done well before that cataclysmic event.[9] Why Pietro constructed his fresco in this manner is, of course, unknown; but the expressive charge of his earlier work certainly forecasts this powerful new treatment of narrative.

Rich, complex interpretation is found again in the large and tumultuous *Crucifixion* which covers an entire wall of the transept [65]. Although badly damaged, it remains a scene of extraordinary depth and brilliance. Towering over the crowd in magnificent isolation are the three crosses. Blunter, broader, and more monumental than the figure in Pietro's earlier Cortona *Crucifix*, the Assisi Christ hangs limply above the swirling crowd below. Surrounded by grieving angels, who again must owe their origins to Giotto, the pathetic figure is horribly dead.

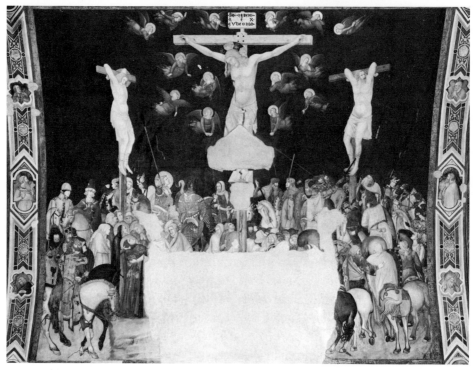

65. Pietro Lorenzetti. *Crucifixion.* Assisi, San Francesco.

The milling crowd below is one of the most vigorous and interesting in Sienese painting. Because of a large area of paint loss, it is impossible to know what was painted originally in the fresco's center. Perhaps at least part of this space was filled by the soldiers gambling for Christ's robe, a common motif in early Italian paintings.

Below the cross of the good thief, the small group of Christ's followers huddles. The swooning Virgin, supported by her friends, is the subject of the troubled stares of Mary Magdalen and John the Baptist. In this small vignette, the larger emphasis on the Crucifixion and its symbolic significance is subordinated to an overriding and immediate concern for the frail and tormented woman. It is a note of tenderness in an otherwise chaotic and dreadful scene.

The entire crowd is ringed by mounted figures: some guide their horses toward the crosses, others face the spectator and, at the lower left, several turn sideways. A number of these men, and some of the standing figures, look with awe upon the crosses. Several seem to be rapt in deep meditation on the significance of what has just taken place, and their quiet consideration of the event allows the spectator to catch his breath in the midst of the tumult, and to speculate on the

transcendental meaning of what he sees.

Pietro's desire to depict the crueler aspects of the Passion scenes is seen in this fresco. A group of soldiers break the bad thief's legs. Their raised arms and cruel smirks contrast vividly with the more sensitive and meditative faces of some of the other soldiers, who seem to demonstrate understanding and sympathy for the victims. Pietro's *Crucifixion* is a stunning mixture of unthinking violence and compassion.

Seldom are so many facial types seen in a *Crucifixion*. Especially characteristic of Pietro's art are the bearded figures (both old and young) with large, blunt facial features and wide, curving lips. Other types, such as the riders around the cross of the good thief, are clearly inspired by Simone Martini: there was, after all, hardly a better model for noble and knightly faces.

A comparison between the *Maestà Crucifixion* by Duccio [27] and Pietro's fresco demonstrates how far the latter's style has moved from the Duccesque idiom which permeated his early works. Perhaps the most striking difference is found in the artists' attitudes toward the subject. In Duccio's painting, almost all action centers around the crucified Christ; it is his death which holds the attention of spectator and painted figure alike. The two powerful emotions of grief and anger intermingle, giving the scene a compact emotional charge. In Pietro's work there is less concentration on Christ, who in fact seems more removed from the swirling mass of humanity below. Instead, there is more concern with individual reactions to the event. A wider gamut of emotions—ranging from anger to fear to indifference—is portrayed. In many ways, Pietro's is the more profound, richer interpretation of the scene.

Also extremely different is the treatment of the figure. Pietro's many monumental forms, often foreshortened and angular, are now quite independent of Duccio. The movements of his expressive figures and their relation one to the other are also of another order. His earlier interest in beautiful line, evident in certain passages in the Cortona and Castiglione d'Orcia *Madonna*s, has been replaced by an economical, concise and bold treatment of outline. In fact, his whole conception of beauty has undergone a considerable change. From the time of the Arezzo polyptych onward, he strove to depict highly expressive, psychologically energized figures in strong, dramatic action. Although formally satisfying, perhaps his earlier pictorial solutions lacked the power he desired. The very fact that his Assisi *Crucifixion* is so different from Duccio's famous and highly influential example certainly demonstrates Pietro's independence.

Yet, even with all this in mind, one still stands awestruck before Pietro's two

masterpieces on the adjacent walls at Assisi: the *Deposition from the Cross* and the *Entombment of Christ.* These two frescoes reach an emotional and dramatic peak never again equaled in the Trecento. They are without doubt Pietro's greatest works.

In the *Deposition* [Plate 1], Pietro has turned what could have been a problem into an advantage. The strangely shaped field of the fresco (it flanks an entrance to an adjoining chapel) was brilliantly utilized by Pietro, who, instead of trying to fill the awkwardly curving upper section, has compressed his figures into the lower left corner. This both concentrates the action into a tight, drama-filled knot and surrounds it with the lonely expanse of blue.

There is a masterful integration of the figures that makes them act as one, a very different emphasis from the large, heterogeneous crowd of the *Crucifixion.* The group around the cross takes on the shape of a low, irregular arch which springs from the two great bending figures at either end of Christ. The slow, decorous, painful movements of these people, together with the compressed figural grouping, instill a feeling of unfathomable sadness in the beholder's mind.

Of course, it is the body of Christ which binds and gives meaning to the entire fresco. In painting it, Pietro has allowed his expressive art to reach its full potential. Elongated and angular, almost to the point of caricature (note the left arm and the legs), this pathetic, broken figure rivets the spectator's attention. Once again the emphasis is on the pain, sorrow, and horror of the event. Around the pallid, attenuated corpse, the faithful stand in silent grief. In a gesture that piercingly recalls the Madonna and Child image, the Virgin presses her face to her son's and cradles his head. Stunned contemplation of the event clouds Joseph of Arimathaea's face, while St. John's mute and tender look reveals the enormity of what has just happened. This is a quiet scene. From it one does not hear the wails and shrieks of many other Trecento Depositions. It is intimate; the small group is alone as it performs its heart-wrenching task.

In this fresco Pietro's mind reaches its highest level, endowing his painting with remarkable dramatic power of directness and economy. The simple, volumetric figures are formed with a minimum of line. On the preserved drapery, one sees how the few broad folds are convincingly modeled with large areas of light and shade. The whole conception of the figure has become less linear and more sculptural. The weighty, plastic configuration of the bodies is echoed in their sturdy and purposeful gestures. Pietro has here reached a point in his stylistic evolution very distant from his early works.

Color plays an important role in the realization of the drama. Large color

fields move the spectator's eye slowly around the fresco. Unlike the *Crucifixion*, where there are varied and contrasting colors, one finds here carefully calculated areas of harmonious colors which both aid in the construction of form and help demarcate the figures. Originally, substantial parts of the fresco were covered by the rhythmic alternation of sober green, red, grey, purple, blue and yellow. The nature of Pietro's dignified palette is expressive of the fresco's content.

The *Deposition* is a work of paramount interest because it is unified on many levels. The composition of the work, the brilliant intertwining of the figures, the expressive potential of each body and the masterful palette are fused into a great whole. Filled with the deepest and most intense emotions, it elevates the narrative of the Deposition into something at once elemental and sublime. Its piercing and mature power must surely indicate that it was done toward the end of Pietro's career, and only after considerable meditation on the meaning of the story.

It is interesting to observe that Pietro seems to have turned to an older version of the Deposition for help, a panel [66] from the circle of Guido da Siena

66. Close to Guido da Siena. *Deposition from the Cross.* Siena, Pinacoteca Nazionale.

67. Pietro Lorenzetti. *Entombment of Christ.* Assisi, San Francesco.

(from c.1280) in the Siena Pinacoteca.[10] The attenuated, twisted body of the earlier Christ and the swaying figures around him, some very close to those of the Assisi fresco, must have influenced Pietro. Perhaps he turned to this picture because it presented the event in a highly pathetic and emotional manner, an approach somewhat different from Duccio's famous version of the scene.[11] It is, in any case, a noteworthy example of a Sienese artist borrowing from an older, eclipsed tradition.

 Next to the Assisi *Deposition,* Pietro painted the *Entombment of Christ,* the earthly parting of Christ and his disciples [67]. As in the *Deposition,* the action is compressed and isolated. In both the frescoes, the setting—a desolate, barren landscape—reflects the bleak emotional charge of the narratives.

 The grieving disciples from the *Deposition* reappear in the *Entombment.* The same unspeakable pathos grips the little group lowering Christ into the tomb. Each clear, unforgettable gesture is totally expressive of sadness and despair as the bent bodies strain to place the body in the sarcophagus.

 Several figures stand out from this remarkable fresco: the Virgin tenderly embracing her son, much as she does in countless Nativity scenes from the

Trecento; the mute St. John who holds the feet as he helps lower the body; the mourning woman with the scarf over her head who clasps both hands to her face as she wrestles with her emotions; the calm, reflective Joseph of Arimathea supporting the upper part of Christ. Their robes fall over bodies of great breadth and weight; each figure is formed in the most economical fashion. Each movement is slow, deliberate and expressive, and even where much paint has fallen away, the shape of the figures and the sketchy underdrawings still create monumental beings. Once again, Pietro has painted a moving, grief-filled drama very different from the more stylized and gracious narratives of Duccio. The only comparison to the direct power of this scene, outside of Pietro's own work, is found in the *Entombment* [50] attributed to Simone Martini discussed in the previous chapter. Both pictures are extremely unusual for their unbridled display of sorrow and emphasis on the human suffering of the disciples of Christ. Although stylistically different, they share a very similar treatment of the subject. Certainly both were inspired by the revolutionary vision of Giotto, but they are more deeply emotional and less restrained than anything from the hand of that Florentine artist.

While still indebted to many of the principles first formulated by Duccio, Pietro's frescoes exhibit a formal independence which entitles him to a position among the most creative and original minds of his time. But perhaps more importantly, they contain a new, expressive emphasis on the human pathos surrounding Christ's Passion and Crucifixion. The economy and directness with which the mourners communicate their grief to the spectator is masterful. The fully integrated, often wrenching, and always compassionate treatment of the Assisi narratives makes them extraordinary works of art.

Yet Pietro's personal progression did not end with the Assisi frescoes. Two other paintings, the Uffizi *Madonna and Child with Angels* and the *Birth of the Virgin* in the Museo dell'Opera del Duomo, Siena, contain a number of interesting and sometimes daring modifications of old themes. And, as both seem to date from the forties, they offer insight into the pictorial thoughts of Pietro during the last decade of his life.

The Uffizi *Madonna and Child with Angels* [68], which is signed and bears a damaged date, has been heavily overpainted and cut down at the top. Pietro's design, however, is still clear, and from it one can see that his conception of the. *Madonna* panel has undergone considerable change.[12] When compared to the 1329 Carmine *Madonna,* the Uffizi picture seems simpler, heavier, more massive and compact.

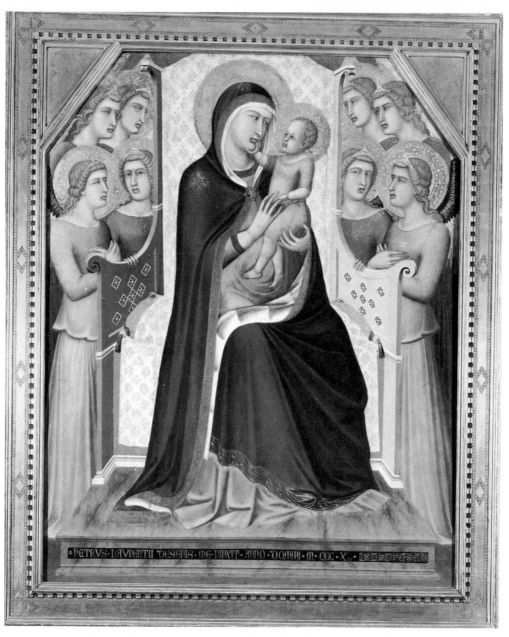

68. Pietro Lorenzetti. *Madonna and Child with Angels.* Florence, Uffizi.

Throughout the earlier picture, there is an orderly calm which does not appear in the later work. Certain passages in the Uffizi painting—the way the large angels are packed behind the throne or the considerable expanse of empty space

before it—are disturbing. This feeling is complemented by the apprehensive Madonna, looking sadly into the face of her Child. There is an air of uneasy sadness about this panel that is absent from the earlier picture.

A comparison of the Uffizi *Madonna* with the Cortona *Madonna,* Pietro's earliest essay on the subject, reveals the distance he has traveled by the late forties. In its massiveness, its simplification and its grandeur, the later painting belongs to a different stylistic and psychological world.

Pietro's *Birth of the Virgin* [69] seems to date around the same time as the

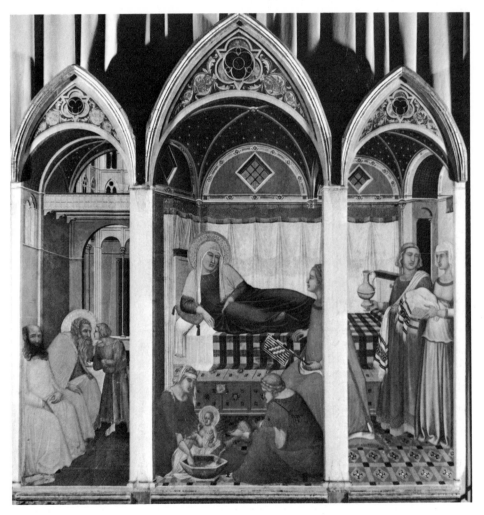

69. Pietro Lorenzetti. *Birth of the Virgin.* Siena, Museo dell'Opera del Duomo.

Uffizi *Madonna.* Payment for the *Birth of the Virgin* was first made to Pietro as early as 1335, but the picture is signed and dated 1342 and, on the basis of style, it appears that it was designed toward the latter date.[13] Originally the *Birth* was flanked by two standing saints, Bartholomew and Sabinus, the patron saints of the chapel in the Siena Cathedral for which the panel was destined. A similar arrangement of standing saints flanking a large central scene is found in Pietro's 1328 Carmelite picture and in Simone's 1333 Uffizi *Annunciation.*

A fascinating document of December 1335, one month after the first payment, states that a Master Ciecho was paid for translating into Italian the legend of St. Sabinus.[14] Sabinus was a patron saint of Siena and he appears in the front row of Duccio's *Maestà.* This record indicates that there must have been a predella containing stories from the saint's life and, in fact, a small painting in the National Gallery, London, may come from this part of the altarpiece.[15] The document also suggests that Pietro was to have a hand in designing the iconography of the panel and thus needed to know the stories to be illustrated.

Pietro has here utilized the multi-paneled altarpiece in a new way. Ignoring the traditional separation of the space and action of each compartment, he has unified the composition. The space of all three of the surviving panels seems to flow together behind the white pilasters (placed at the juncture of each panel), which act not as dividers but, rather, seem actually to support the vaults above. The wall behind the bed's headboard also seems to abut one of the pilasters. The vaults, with their red ribs and starry webs, appear to exist behind the pinnacles, as though each pinnacle were part of the architecture of the painted scene.

It is clear that in this panel Pietro is consciously manipulating the illusionistic elements of painting. This is not something new in his work—it appears as early as the *Annunciation* from the Arezzo polyptych—but never before has it been done so convincingly as in the *Birth of the Virgin.*

Here is a scene that seems to be taking place within the physical world, a story unfolding right behind the altarpiece's white pilasters. The old idea of the frame acting as the spatial and psychological boundary between the worshipper and a removed, obviously separate religious drama is challenged in Pietro's *Birth of the Virgin.* The worlds of worshipper and narrative drama have begun to mesh.

But inside the picture, there are further spatial complexities. The room occupied by the Virgin and the attendant women is of limited dimension. Roofed by two vaults which correspond to the pinnacles of the center and right panels, it recedes to a curtained wall directly behind the bed. Yet just to the left, in the room where Joachim sits, space is not at all circumscribed; the eye is carried ever

deeper through the open archway into a large courtyard flanked by tall pink buildings. In introducing this highly sophisticated spatial juxtaposition, Pietro is, of course, continuing the intense Sienese interest in the depiction of space first seen in the work of Duccio. From the Arezzo polyptych, through the Assisi frescoes, to the *Birth of the Virgin*, Pietro's fascination with the complexities of space is daring and unwavering.

Also part of Pietro's Sienese heritage, and prophetic of the next generation of Sienese painters, is the love of decorative pattern that appears almost everywhere in this altarpiece. One notes the plaid bedspread, the starry vaults with their red ribs, and the patterned fan held by the sitting woman whose body forms a transition from the right side to the center of the picture. Elsewhere striped towels, embroidered drapes, and patterned floor tiles (the latter, along with the plaid of the bedspread, forming a nearly perfect recession to a single vanishing point) testify to the artist's love of abstract decoration.

Once again, the substantial figure types appear. Close to those of the Uffizi and Assisi paintings, they are commanding. Slow-moving and majestic, they convincingly inhabit the picture's remarkable space. Especially noteworthy is Anne, who reminds one of sculpture, specifically Arnolfo di Cambio's great *Madonna* which was over a doorway of Florence Cathedral in Pietro's time. Pietro, like Giotto, by whom he was influenced, must have regarded the volumetric works of Arnolfo with the utmost respect.[16] The two figures sitting on the floor bathing Mary are wonderfully foreshortened; their broad bodies seem rooted to the earth as they turn in space. And in the figures of the boy speaking to Joachim and the two women entering Anne's room, there remains still the lingering influence of Giovanni Pisano.

This is also one of Pietro's most brilliantly colored works. The palette is original and varied. Large fields of color move the eye along the panel's surface and then back into space. Yellow, red, blue, green, black and white are among the lively and bright hues. Because of the power of his forms and the physical presence of his images, one tends to forget that Pietro was also an accomplished colorist.

Pietro's style did not find the sustained widespread following that Duccio's or Simone's did; perhaps this is because of its dramatic, serious and highly expressive nature. His, after all, was not an art of charm and grace but one of considerable drama and power. Yet, for a decade or so, artists came under his sway. The most derivative were several painters who seem to have come directly from his

shop. Sometimes their efforts are very close imitations of his, and it may be that he had a hand in many of their paintings. As they moved slowly away from Pietro, their work became cruder and often caricatured his idiom.[17]

A more interesting development is seen in the works of Niccolò di Segna, a rather minor master, active from at least the early thirties to the mid-forties.[18] His style was founded on that of Duccio and Duccio's earliest followers, and in

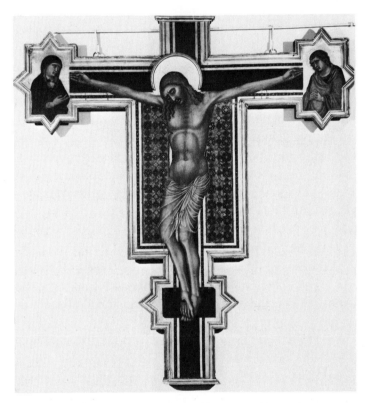

70. Niccolò di Segna. *Crucifix*. Siena, Pinacoteca Nazionale.

this idiom he produced a number of competent, conservative, and not very exciting panels. But by 1345, the year in which he signed and dated a large *Crucifix* [70] now in the Siena Pinacoteca, his primary source of inspiration no longer came from Duccio, but from Pietro Lorenzetti.

Impressed by the large fluid features of Pietro's figures, Niccolò tried to duplicate them in the Mary and John in the cross terminals; in these two one sees

the distant reflection of the pathos of Pietro's faces. The body of Christ, although Duccesque, is also strongly influenced by Pietro. No doubt, Niccolò had been looking at something very like Pietro's Cortona *Crucifix* (if not at that work itself) and from it he has captured part of the awkward, strained quality of Pietro's style. But it is as though he has grafted on to his own idiom a style basically alien to it to make his work more fashionable, and in so doing, has lost all the spirit and magnificence of the original conception.

This is definitely not the case with a talented painter known as the Ovile Master, after a *Madonna* in the Sienese church of San Pietro Ovile.[19] Perhaps a student of Pietro, he soon developed a highly personal style, seen in one of his most interesting works: a splendid *Assumption of the Virgin* of about 1350 in the Siena Pinacoteca [71]. The somber Madonna and contorted St. Thomas at the bottom of the picture are close to the style of Pietro. Also directly inspired by him are the prophets in the spandrels who observe the scene with considerable emotion. This painter is not a slavish follower, for on the basis of Pietro's style he has built his own personal visual language. He is, as one sees at first glance, immensely fond of gold; it surrounds the Virgin, covers her robe and headdress, and appears on each of the angels. Yet this is not unadorned gold, for each surface of the robes is worked with a pattern echoed by other patterns on the hems and belts. The resulting image is dazzling. The eye does not move back into space but is held near the picture's surface by the glittering metallic material, punctuated only by the figures' faces and the blue and violet robes of St. Thomas. Enclosed in a weightless golden mandorla relieved only by the bright red heads of the seraphs, the Virgin floats at the panel's center.

All this is very far from the much more profound, volumetric and spatially complex paintings of Pietro. The ethereal, almost eerie quality of this image, and the nature of its highly worked surface, seem to represent something quite foreign to his artistic aims. The direct, pathetic and often violent strain has been nearly suppressed, replaced by a weightless, sumptuous and less expressive ideation of form and content. This is revealing, because the direction taken by the Ovile Master was also followed by many painters working after the middle of the Trecento, the period from which the *Assumption* seems to date. Many artists— as we shall see—turned away from the human, accessible world of Pietro toward a more fantastic and svelte style heavily influenced by Simone Martini. Perhaps the artist closest in spirit to Pietro was not one of his students or followers, but his brother Ambrogio.

71. Ovile Master. *Assumption of the Virgin.* Siena, Pinacoteca Nazionale.

V

AMBROGIO LORENZETTI

Ambrogio Lorenzetti's vibrant *Madonna and Child* [72] from the provincial village of Vico l'Abate is dated 1319.[1] His first extant panel, it may have been painted in nearby Florence where he was enrolled in the *Arte dei Medici e Speziali* (the guild to which the painters belonged) sometime during the 1320s.[2] Because Ambrogio's earliest activity is documented in Florence, one wonders if his apprenticeship may have taken place there, but all the visual evidence of his youthful panels proves that he, like his brother Pietro, was trained by Duccio or someone from his immediate circle. In fact, Ambrogio was just one of a number of Sienese artists accepted into the Florentine *Medici e Speziali:* there was always an appreciation of Sienese art in Florence, both on the part of patrons and artists, but never was it more active than in the 1320s and 1330s during the height of Giotto's career. The intermingling of Sienese and Florentine idioms was an important factor in the styles of both cities.

By 1324 Ambrogio probably was back in Siena, for in that year his name appears on a document dealing with the sale of some land.[3] Many artists (Giotto, Duccio, Simone Martini and Pietro Lorenzetti among them) seem to have owned various pieces of land; perhaps real property was considered a good investment by men of their economic position.

The 1330s must have been a decade of intense work for Ambrogio. It is likely that some of this time was again spent in Florence. His altarpiece, of which fragments survive, for the Florentine church of San Procolo was signed and dated 1332. The year 1335 and the names of Ambrogio and Pietro (the inscription stated that they were brothers) once appeared under the destroyed *Marriage of the*

Virgin, painted on the facade of the Scala, Siena's famous hospital. Toward the end of the thirties Ambrogio began his most celebrated work, the frescoes of *Good and Bad Government* in the Sienese Palazzo Pubblico.

During the 1340s he produced a series of remarkably inventive and prophetic paintings. Two signed works, the 1342 Uffizi *Presentation* (begun in 1339) and the 1344 *Annunciation* in the Siena Pinacoteca, are the touchstones around which several other pictures from Ambrogio's last years may be grouped. Unfortunately some works of this decade are lost, including an altarpiece of San Crescenzio which, judging by the payment of 135 gold florins, must have been a major picture.

In 1347 Ambrogio was elected to the Sienese Consul of the Paciari before which, as the documents state, he gave a short speech. This is the last record of Ambrogio before his will of 1348; it was during the same year that he died, perhaps in the great plague then sweeping Tuscany.[4]

It is sometimes assumed, on the basis of the Scala inscription where Pietro's name came first, that Ambrogio was the younger of the brothers. There is no real evidence for this assumption, either in the documents or in the paintings, and both their birth dates remain unknown. The first dated works of each brother come from about the same time, Pietro's from 1320 and Ambrogio's from 1319, and the makeup of their early styles seems to place their training in the teens of the Trecento. It is likely that they were quite close in age and a birth date of around 1300 appears possible for both. Perhaps they were trained in the same shop. They may have shared commissions other than the Scala frescoes, although it is unlikely that they had a joint shop throughout their careers.

Ambrogio's 1319 *Vico l'Abate Madonna,* as it is called [72], is perplexing. This immobile, fully frontal Virgin seems to run counter to the entire development of the Madonna from the late Duecento onward. Starting with Coppo di Marcovaldo, Guido da Siena and Cimabue, there was a constant increase in the liveliness and the intimacy of the image. But Ambrogio's figure, at first glance, seems close to those iconic and aloof images—the *Madonna degli Occhi Grossi* [5], for example—that stare past the spectator in scores of paintings from around the middle of the Duecento. Consequently, his picture is quite different in feeling from that of the more accessible *Madonna*s painted by Duccio, Simone or Pietro.

In many respects the *Vico l'Abate Madonna* reminds one of Simone's *St. Louis of Toulouse* altarpiece in Naples [38]. Its frame, like Simone's, is also old-fashioned: this type of gabled rectangle did not appear with any regularity after about 1270 and is seldom seen in the early Trecento. Clearly, both pictures are inspired by the past and both borrow several central motifs from a much older

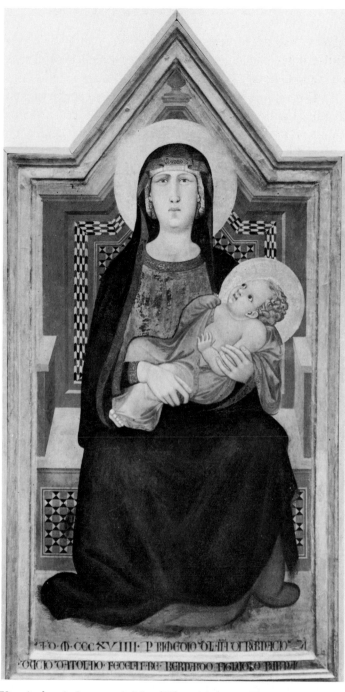

72. Ambrogio Lorenzetti. *Vico l'Abate Madonna.* Florence,
 Museo Arcivescovile.

idiom.[5] Simone, of course, took from the past to dynastically enrich his picture, to tie it to ancient, hallowed images which evoked awe in the mind of the contemporary viewer.

It seems clear that the Vico l'Abate panel also archaizes to evoke meanings and feelings tied to ancient iconic images. Both in style and motif its inspiration comes from at least three-quarters of a century before. One can only guess the reasons for this: maybe it was painted to replace a venerated or miraculous panel that had been destroyed, or perhaps the patron was extremely conservative and wanted an old-fashioned icon rather than a more modern Madonna.

Whatever the reason, the *Vico l'Abate Madonna* is an important visual and historical record because, like the *St. Louis of Toulouse* and the modernization of Sienese Duecento Madonnas during the early Trecento, it attests to a new attitude toward the past. These works by Ambrogio and Simone reveal conscious realization that there was an unbridgeable gap between new and old, between what might be termed modern art and the art of a hallowed but distant past. The cause of this historical attitude toward earlier art is found in the revolutionary developments of the early Trecento—specifically, in the almost miraculous pictures by Giotto and Duccio which redirected the development of style and made a return to even the most immediate past impossible. There may have been a longing for the old images, perhaps exemplified by Ambrogio's patron, but such return was impossible. The best the conservatively minded could hope for was an archaized version of a cherished but now distant past.

And, although the *Vico l'Abate Madonna* is old-fashioned in motif, it is the extremely modern qualities of Ambrogio's painting that make it so compelling. Apparent almost at once is the careful adjustment of painted frame to the panel's wooden frame. Cunningly, Ambrogio has continued the molding of the real frame into the fictive one and has made it difficult to tell where one begins and the other ends. He has, to put it another way, blurred the boundaries between the real and the painted, weakening the iconic barriers of earlier pictures. This is, of course, something never found in the Duecento paintings which inspired Ambrogio. These were exclusive images that set down a sharp division between worshipper and holy figures; the world of the sacred could never be confused with that of the onlooker. Ambrogio was not the only Sienese painter to blur the border between painting and reality; one has just to remember the *Denial of Peter and Christ Before Annas* from Duccio's *Maestà*, or Pietro's early Arezzo *Annunciation* or his late *Birth of the Virgin.* This spatial experimentation was one of the most important and remarkable characteristics of the Sienese Trecento.

Ambrogio's figure types demonstrate a knowledge of the monumental forms of Giotto. Like his brother, Ambrogio must have fallen under the spell of the famous Florentine at an early age. The broad, volumetric composition of the body, both in overall form and in individual parts, demonstrates Ambrogio's understanding of Giotto's figural style. The *Vico l'Abate Madonna* is stolid and rather static, but surely this is because Ambrogio has caught in her the spirit of his mid-Duecento prototype. On the other hand, the Child is wonderfully animated in a way that only Ambrogio could make him. His curving, diagonally placed body contrasts strongly with the immobile vertical of his mother's form, and his agitated motions are totally at odds with her grand pose. As he glances (mischievously?) up at his mother, he seems to be squirming out of her grip, and his right hand has become entangled in his cover. She, in turn, seems to hold him tight and close to herself with strong, wonderfully articulated hands. It is just this human and exuberant quality that stamps the picture with Ambrogio's personality. Of all the noteworthy painters of the Sienese Trecento, it is he who was the keenest observer of the small, intimate, often casual, but illuminating relations between people.

Another characteristic of Ambrogio's painting is his love of decorative detail. This he shares with most other Sienese artists, but in his hands it is always combined skillfully with a monumental feeling for form. On the backrest and the front of the throne's seat are lively rows of geometric decoration. These not only activate the area around the Madonna but act as a barrier to the recession of space. Here again Ambrogio seems to have been thinking about his prototype and the need to keep his images—like those of the mid-Duecento—within a limited spatial field. Other areas of decorative pattern appear on the Madonna's headdress and around her cuffs and collar. The overall rhythms of the drapery and the opposition of the shapes of the two figures and their haloes create further abstract interrelations.

Ambrogio pays a great deal of attention to the costumes of his figures, more so perhaps than any other painter of the Sienese Trecento. The Madonna, for instance, wears splendid heavy robes fringed at the bottom, her hair is covered by a patterned white and gold scarf, and elaborate earrings hang from her pierced ears. The Child's red robe is also decorated along the hems.

The *Vico l'Abate Madonna* is a complex work. Because it is obviously archaizing, it does not allow Ambrogio to express fully the range of his own style. Yet within the limits imposed by the commission, he has created a highly sophisticated masterpiece. It is a work, however, which does not quite afford the glimpse into the origins of Ambrogio's style furnished by three panels in the church of

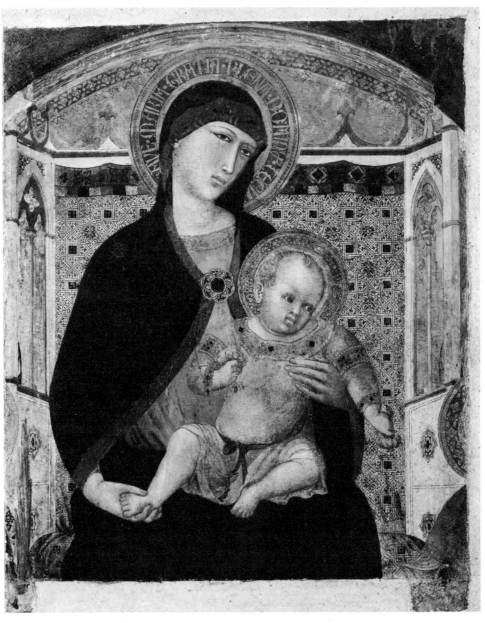

73. Ambrogio Lorenzetti. *Madonna and Child.* Roccalbegna, SS. Pietro e Paolo.

SS. Pietro e Paolo in the small town of Roccalbegna, south of Siena.

Part of a single altarpiece, these panels have now been separated. The *Madonna and Child* [73] has been drastically cut and reframed, but one can see that the figure of the Madonna must have been seated full-length and originally flanked by at least two saints whose fragmented haloes still remain to the lower left and right; perhaps this once was a sort of abbreviated *Maestà*.

In any case, Ambrogio has placed mother and Child within a space created by the back and sides of the throne. The lancet windows with pierced decoration in the foreshortened sides are reminiscent of those in Simone's 1315 *Maestà*, which seem to derive, in turn, from Giotto's *Ognissanti Madonna*. Interestingly enough, Ambrogio does something different from either Simone or Giotto: he extends the throne's side walls and finials over the tooled gold background, creating the illusion that they project beyond the frame and thus into the viewer's space. Like the space of the *Vico l'Abate Madonna*, there is here a blurring between the real and the painted.

In the intertwining of the Madonna and Child, Ambrogio has created a touching and intimate relation. The baby, whose body moves expansively in space, is gently held in the protective circle of the Madonna's arms. As he grasps bunches of cherries (symbols of heaven, rarely seen in Sienese painting) in each hand, he looks and leans eagerly toward our right.[6] His active, childlike movements contrast strongly with the melancholy quiet of his lovely, contemplative mother. There is in this picture a subtle interrelation and contrast of form and emotion which makes it remarkable.

The two saints [74–75] that once flanked the Madonna are seated on low stools almost totally covered by the figures' voluminous robes. The charged, tense feeling that emanates from the stern saints, and the flinty, prismatic foldings of their robes, seem to stem from Giovanni Pisano, particularly from his figures for the facade of Siena Cathedral.[7] From Giotto's work, Ambrogio seems to have learned how to apply the tempera in broad planes created by light instead of line. In the faces of the saints, strongly influenced by the *Maestà*, Duccio's sway is also evident. No doubt Ambrogio was impressed by this famous work and other late paintings from Duccio's shop; in all likelihood, he was trained by Duccio or someone close to him. Yet in spite of the generic influence of Giovanni Pisano, Giotto and Duccio, none of the figures from the Roccalbegna altarpiece look like the work of these men. Ambrogio was one of those artists of genius who transforms what he borrows and makes it his own.

To see how personal the Roccalbegna altarpiece is, one need only compare

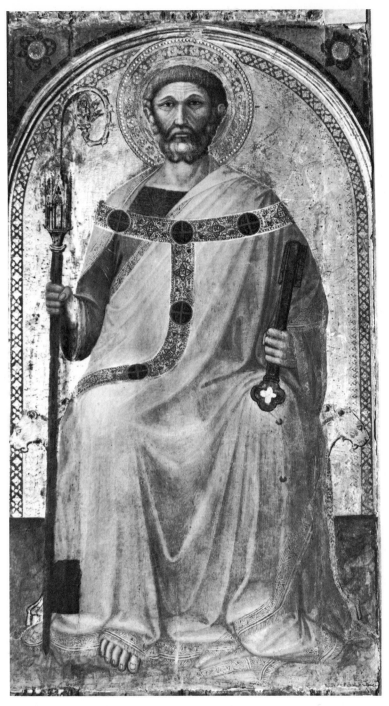

74. Ambrogio Lorenzetti. *St. Peter*. Roccalbegna, SS. Pietro e Paolo.

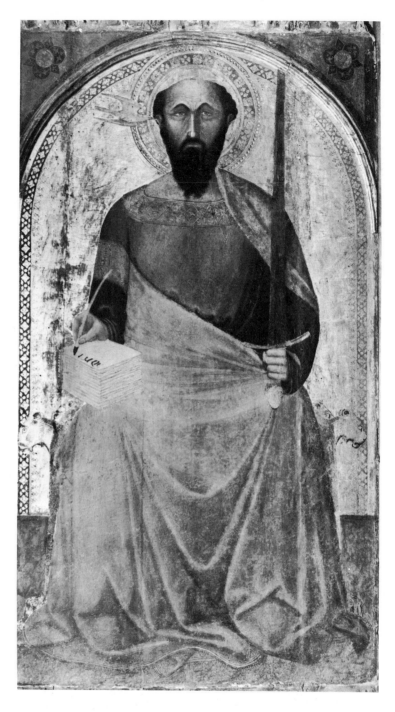

75. Ambrogio Lorenzetti. *St. Paul.* Roccalbegna, SS. Pietro e Paolo.

it with the *Vico l'Abate Madonna*. In both pictures there is an overall looseness of the surface where brushstrokes combine to form the boldly modeled features of face and drapery. No other Trecento artist—aside from Giotto—was able to attain the freedom of form and volume achieved by Ambrogio, even in these early works. The feeling for pattern evident in the Vico l'Abate panel is seen again at Roccalbegna, where it decorates the back of the throne, the costumes and the elaborately punched haloes. Strikingly similar are the strange, thick hands and feet articulated in a powerful but slightly clumsy fashion.

In both the Vico l'Abate and the Roccalbegna panels Ambrogio used a restrained, harmonious palette probably indebted both to Giotto and Duccio. The colors—yellow, blue, pink and red—are original and subtly combined. Although beautiful, they principally aid in the construction of form in a very Giottesque way.

A similar restrained palette appears in the famous nursing *Madonna* (often called the *Madonna del Latte*) which Ambrogio seems to have completed after the Roccalbegna work [76]. Pink, red, blue, white and touches of green are carefully distributed over the picture's surface. The same ordered sense of color pervades both pictures.

Ambrogio has once again manipulated space in a fascinating way, this time by making the figures seem in front of the frame and gold background. This overlapping pushes the figures out into the observer's space and away from the gold, which appears here to be a solid metallic backdrop for the volumetric bodies.

The illusion of the figures' existence in the viewer's space is also heightened by their positions. The Madonna has been placed far to the left and so turned that her body moves diagonally out of the picture's space. Her solid vertical, the opposing diagonal, undulating shape of the Child, and the beautiful patterns of void form a pictorial arrangement breathtaking in its integration.

Such dynamic composing reminds one of Giovanni Pisano. There is, in fact, a half-length sculpture of a *Madonna del Latte* by Nino Pisano which can be dated around the middle of the Trecento.[8] Nino was strongly influenced by Giovanni, and there is a strong possibility that his statue was a copy of some now lost group by that artist—a group that might also have influenced Ambrogio.

Throughout the entire Trecento Sienese artists fell under the spell of Giovanni Pisano, but no one seems to have understood his aims better than Ambrogio Lorenzetti. Yet in the marvelous physical and emotional interrelation of the Madonna and Child, Ambrogio comes into his own. The active, squirming baby, who pauses in his nursing to look out at the spectator with a mixture of surprise

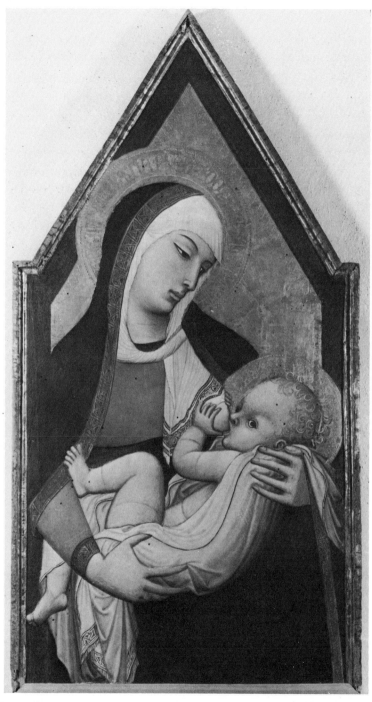

76. Ambrogio Lorenzetti. *Madonna del Latte*. Siena, Palazzo Arcivescovile.

and curiosity, is one of the most lifelike and human infants of the fourteenth century. His more restrained mother is in a much different mood: she is clearly apprehensive for the bright, plump, innocent child whom she holds so tenderly and protectively. Ambrogio's ability to unify the most basic formal and emotional elements of his pictures is, as the *Madonna del Latte* proves, extraordinary.

Four panels of the legend of St. Nicholas (Uffizi, Florence) seem to date from the early thirties, the same period when the *Madonna del Latte* appears to have been painted. The Uffizi pictures come from the Florentine church of San Procolo and were probably grouped around a larger, lost panel representing St. Nicholas.[9] That Ambrogio got another commission in Florence about a decade after the *Vico l'Abate Madonna* suggests that he was still active and popular in that city. One wonders how many other works he did in Florence which have since been lost.

The Uffizi pictures are Ambrogio's earliest extant pictorial essays on religious narrative, but their accomplished style indicates that they are not his first attempt at the portrayal of figures in dramatic action. The scene of *St. Nicholas Resurrecting a Child* makes this clear [77]. In the upper right corner is a banquet, where the guests sit at a long L-shaped table as servants bring in platters of food. Just outside the front door a boy talks with the Devil dressed as a pilgrim. Then at the foot of the stairs one again sees the Devil who, after luring the boy away from his home, chokes him to death. The real subject of this story, the miracle, takes place inside a room located directly under the banqueting scene. Here the boy appears twice: once lifeless in bed, and then resurrected by St. Nicholas, who hovers near the upper left corner of the panel.

Obviously this is a complicated scene, demanding the portrayal of several different time periods and a number of different locales. Ambrogio's solution to the problem was brilliantly simple. The architecture of the complex building both articulates and unifies the action. The building guides the onlooker through each episode and compels her him to consider them first in isolation and then in the overall narrative sequence. Of course Ambrogio did not invent this type of sophisticated construction. It was Duccio in the *Maestà* who first began to explore the possibilities of complex architectural space by which one sees under, over, and through buildings. But it was Ambrogio and, to a lesser extent, Simone who began to use this type of composing to articulate the narrative more fully.

Ambrogio's *St. Nicholas Resurrecting a Child,* his *St. Nicholas Saving the Three Maidens* and the *Consecration of St. Nicholas* from the same altarpiece must have caused a stir in Florence because they were so different from the less spatially innovative painting of that city. There is even reason to suspect that they

77. Ambrogio Lorenzetti. *St. Nicholas Resurrecting a Child* and *Famine at Myra.* Florence, Uffizi.

exerted some influence on Giotto, who in his Bardi and Peruzzi chapel frescoes turned to a new narrative style in which architectural subdivisions were increasingly used to create both deeper space and more complex narrative.[10]

But Ambrogio is also a painter of mood, and the creation of a specific feeling was his goal in the *Famine at Myra*, where St. Nicholas multiplies the grain being unloaded at the plague-stricken city [77]. The saint stands on the shore, while at the upper right corner angels miraculously dump grain into the ships' holds.

The artist has infused the picture with fantasy. From the near shore the land sweeps backward in a series of inlets formed by twisted, craggy grey mountains which make spectacular patterns against the sky. The right three-quarters of the panel is covered by a vast blue-green sea stretching to the horizon, where there appear the silhouettes of sails seen against the gold background. The eye is, however, quickly brought back to the picture's center by the splendid ships, which fly great banners emblazoned with numerous coats of arms. There is throughout this scene a fantastic, utterly captivating mood which both amplifies the miracles and marks the painting as Sienese. Yet even the most lyrical scenes of Duccio or Simone do not have the fairy-tale-like qualities of this panel. And it was probably just these qualities which made Ambrogio's *Famine at Myra* so popular with later artists of the same bent: panels by Gentile da Fabriano and Fra Angelico indicate that the inspiration of Ambrogio's picture lasted over a century.[11]

Ambrogio's own relation to the past is never more fascinatingly seen than in a major altarpiece done for the Cathedral of Massa Marittima, a dependency of Siena located to the southwest of the city [78]. Commissioned, probably in the late thirties, to paint a *Maestà*, Ambrogio must have thought at once of the renowned examples of that subject by Duccio and Simone in Siena. But he was not intimidated by these famous works, for he created a painting that, while dependent on them for some basic motifs, is a masterpiece of stunning innovation.

Like Duccio's *Maestà*, Ambrogio's is composed of ranks of saints and angels surrounding a massive central throne where the Madonna and Child sit. Ambrogio, however, has moved his Madonna both up and back by placing her on the top of three oval steps. She thus becomes the apex of a great triangle, extending from the top of her head down through the standing and kneeling angels who flank her. A strong recession is also created by the two inward-moving front rows. This movement is begun by the strongly foreshortened music-making angels, who lead the eye into the picture and then upward toward the Madonna. Of course, this is very different from the more planar orientation of Duccio's *Maestà*. It is, in type, similar to the wonderfully integrated groups of Simone's *Maestà*—a work

78. Ambrogio Lorenzetti. *Maestà.* Massa Marittima, Municipio.

which may have suggested, in embryonic form, the powerful, funnel-like rush of space in the Massa Marittima picture.

But Ambrogio was unwilling to abandon completely several features of Duccio's famous painting, and he introduced them into his own work, albeit in modified form. The rows of saints at the back of the picture, for example, are reminiscent of the ranks of standing figures in Duccio's altarpiece, but Ambrogio has crowded his actors closer together and has suggested many more by showing only the tops of their haloes. This is something that the more dignified and elegant Duccio would never have done. And by putting just the heads of prophets and saints in the arches at the top above the sea of haloes, Ambrogio is perhaps remembering the small saints placed right above the angels of Duccio's *Maestà.*

There are a number of elements in Ambrogio's panel not found in either of the earlier ones: the music-making angels, the figures of Fortitude, Charity and Hope on the throne's steps, and the back of the throne itself, cunningly formed by the outstretched wings of the angels holding the bolster on which the Madonna sits. This last invention, a particularly happy one, demonstrates how completely

Ambrogio was willing to depart from traditional types.

Yet the real differences between the *Maestàs* of Duccio, Simone and Ambrogio lie not in the formal elements of the pictures but in the way each artist has conceptualized the scene. The *Maestàs* by Duccio and Simone are gracious, melodious, radiant depictions of the Queen of Heaven in the midst of her court. The attention of the saints, angels and the spectator is allowed to wander; the mood of each picture is dignified but relaxed. But in Ambrogio's Massa Marittima *Maestà*, the focus of the assembled crowd is riveted on the Madonna who, as one can see from the somber, worshipful faces, exerts a compelling fascination on all around her. She, in turn, is engaged in a silent and solemn dialogue with her son, whom she presses close to her face as she stares melancholically into his worried eyes. Each of the other holy figures seems to be caught up in this drama, which holds the onlooker. The expressive, dramatic charge of this picture is fundamentally different from the earlier versions; it is invested with a tension not seen in them.

There are certain passages in Ambrogio's painting that are disturbing in their visionary quality. From the wraithlike swaying bodies of the music-making angels, the flickering movement of the cascading cloaks worn by the two angels behind the throne, and the strangely transfixed faces seen in the dense crowd, there arises a hallucinatory note which sets this *Maestà* apart from any other in the history of early Italian painting.

Here, as in all his paintings, Ambrogio is keenly interested in details. One notes with pleasure the varied and intricate costumes worn by the saints, the fantastic headdresses of the prophets and the delicately folded robes (perhaps taken from antique prototypes) of the Virtues. Flowers play an important part: they appear in the hair of the music-making angels and the angels behind the throne hold bouquets in each hand. Gesture, too, has been studied carefully, and many of the figures make highly expressive movements of surprise, longing or adoration. There is even a humorous note in the right-hand corner where St. Cerbone, the patron of Massa Marittima, stands with his attribute, a flock of busy geese.

The appearance of St. Cerbone reminds one that the Sienese *Maestà* often had civic overtones. In fact, painting in Siena was often closely tied to the service of the commune, as Duccio's *Maestà* and Simone's *Maestà* and *Guidoriccio* demonstrate. The most famous examples of this type of painting are by Ambrogio Lorenzetti and date around the time of his Massa Marittima *Maestà*. During the late thirties his name appears on a series of documents which can be connected

79. Sala della Pace. Siena, Palazzo Pubblico.

to the frescoes of *Good and Bad Government* painted in the Sala della Pace of the Sienese Palazzo Pubblico [79].

Three walls of the Sala della Pace are covered with frescoes devoted to essentially civic themes.[12] The iconography of the scenes is sometimes complicated, and it is very unlikely that Ambrogio had much to do with the formulation of the program. The subjects of the paintings can be broadly described by surveying each wall. On the end wall is the *Allegory of Good Government*, in which appear the seated figures of the commune, the Virtues, Concord, and the twenty-four members of the Sienese Council. This is a painting heavily dependent on the heritage of medieval political thought and it is the one that seems to have given Ambrogio the most trouble. The need to include so many diverse, sometimes allegorical, figures, and the lack of any narrative focus, forced him to create a composition that is somewhat disorganized both in scale and rhythm. The eye often wanders aimlessly across the surface of this large work. Yet many of the individual figures are among Ambrogio's most successful. Especially noteworthy are the reclining figure of Peace—probably taken from an antique prototype—and

the handsome Concord seated in the lower left foreground.

Originally the left wall was given over to the *Allegory of Bad Government* and the *Effects of Bad Government in the Town and Country,* but this has been horribly damaged and remains only in fragmented condition. A large part of the injured wall was covered by what must have been a very interesting landscape, now mostly obliterated, showing the effects of bad government on the country-side.

Across from *Bad Government* is, on the right wall, the most renowned work in the Sala della Pace: the *Effects of Good Government in the Town and Country* [80–81]. This is, of course, directly opposed in a physical, political and moral sense to the *Bad Government* frescoes. The citizen standing in the Sala della Pace would have been able to make a graphic comparison between two types of government simply by looking at the room's two long walls.

Ambrogio's *Good Government* is divided into two. At the left is the well-governed city, prosperous and at peace. Surely the fourteenth-century visitor to the room would have believed it was Siena, for in the upper left corner rise a dome and bell tower like those of the Sienese Duomo. The tranquility of the painted city then demonstrated that the councilors of Siena, some of whom met in this very room, were virtuous and just men capable of governing well.

In this part of the fresco are the city's stately buildings. Among these one recognizes shops, palaces, towers and other structures common to the early Italian commune. There is an order and unity about them absent from the arrangement of structures in the opposing *Effects of Bad Government,* where the damaged and dilapidated buildings are either strongly foreshortened or ominously empty. There is, in the *Bad Government,* a disconcerting jumble of forms which contrasts with the more stable composition of the *Good Government:* a dissonance instead of harmony.

Strongly illuminated, the well-governed city is alive with activity: a teacher with his students, a shoemaker, masons working on a building, and various other craftsmen and tradesmen are seen. Fully laden mules have just arrived from the country; a herd of sheep are about to leave through the gate at the right. Everywhere there is a busy coming and going which gives the city an alive, bustling feeling. And, in the midst of all this, ten beautiful women dance and make music in one of the city's largest piazzas. Ambrogio has caught, preserved and at the same time idealized mid-Trecento Siena, and in so doing, has created something that is infinitely more revealing and understandable than any set of fourteenth-century archival records.

80. Ambrogio Lorenzetti. *Effects of Good Government in the Town and Country* (left half). Siena, Palazzo Pubblico.

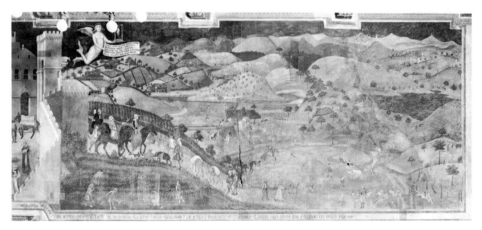

81. Ambrogio Lorenzetti. *Effects of Good Government in the Town and Country* (right half). Siena, Palazzo Pubblico.

Beyond the wall dividing the fresco roughly in half, the countryside begins. Here exists one of the most amazing landscapes ever painted in Italy: a panoramic view, much like the one visible from the windows of the Sala della Pace, stretches from the fields near the picture plane back to the distant hills miles away. This is the Tuscan landscape surrounding Siena, a landscape of surpassing beauty that is itself a work of art.[13] It is this gentle, hospitable countryside where every hill and field bears the trace of a human hand that one recognizes in the cultivated

lands and vineyards of Ambrogio's fresco. The accuracy of the portrait—and it is one of the very first topographical portraits in European painting—even extends to the depiction of the bare chalk hills and walled cities so characteristic of the area around Siena.

In this smiling land Ambrogio experimented with the language of his brush [82]. The vineyards, trees, grass and haystacks are all created with bold and varied brushstrokes. Although discussed in the context of later artists, the application of paint is seldom an important consideration in fourteenth-century painting, where for the most part there is a rather slick and uniform finish. But the tight control of almost all his contemporaries is abandoned as Ambrogio dabs, flicks and swirls his brush across the painting's surface. He has an almost uncanny ability to make its touch form and energize a lake, a leaf, or a patch of grass. This daring and totally successful technique is also found on some of the figures in the Sala della Pace. The robes of Peace, the face of the seated Concord, and several other passages also contain series of loose brushstrokes which define planes and create volume. Throughout his career Ambrogio's painting is distinguished by decisive and free brushstrokes, yet from the Sala della Pace onward these become more important and bolder. It is Ambrogio's brushwork which, to a considerable extent, allows his pictorial thoughts to be so well realized.

Unlike the landscape in the *Bad Government,* the *Good Government*'s countryside is fertile and peaceful. A hunting party complete with hawks rides out of the gate to enjoy the splendid day and is met by a less elegant parade of mules, farmers and a large pig. Workers bring in the bountiful harvest, figures saunter along the roads which snake into the distant hills, while shepherds tend their flocks. Everywhere there are well-kept farmhouses, the sure sign of a safe country-side. It is a gentle, calm, inviting world, the perfect product of a well-governed state; its wonderful expression of the room's central message is testimony to Ambrogio's narrative skill.

Aside from the paintings of the Sala della Pace, the only sizeable extant fresco works by Ambrogio in Siena are two fragments—probably dating from the late thirties—in the church of San Francesco, Siena. These fragments belonged to a cycle which seems to have been in the church's chapter house, but in the last century they were discovered under a coat of whitewash, then detached from their wall and moved into the church.[14] They have been cut down around the edges and have suffered considerable paint loss.

In the *St. Louis Kneeling Before Boniface VIII,* Ambrogio has put the action in a complicated setting [83]. Various clearly defined spatial units—the area

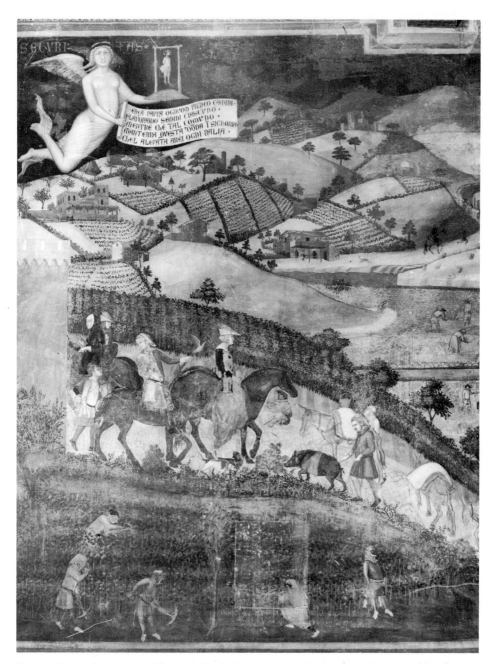

82. Ambrogio Lorenzetti. *Effects of Good Government in the Town and Country* (detail). Siena, Palazzo Pubblico.

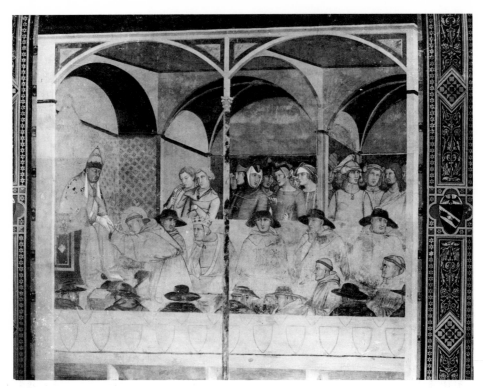

83. Ambrogio Lorenzetti. *St. Louis Kneeling Before Boniface VIII.* Siena, San Francesco.

occupied by the foreground row of cardinals, the space surrounding the Pope and St. Louis, the bays under the vaults filled by the standing men—move the viewer's eye rhythmically back into space. The immediate foreground is established by the arches, the central column and the two pilasters at the sides. Like the architectural elements in Pietro's Arezzo *Annunciation* and his *Birth of the Virgin* in Siena, these painted supports raise no barriers between the picture's space and the world of the observer; instead, the architecture seems to blur the boundary between painted and real.

Ambrogio's use of compartmentalized space is paralleled in Giotto's late fresco cycles in the Bardi and Peruzzi chapels in Santa Croce, Florence (c.1325). Especially close to Ambrogio's fresco is the Bardi *Apparition of St. Francis at Arles* in which there appears a somewhat similar arrangement of seated figures seen from the back. Giotto's and Ambrogio's frescoes resemble each other not so much in the motifs, but rather in the use of architecture, which articulates the space and enhances the drama in an economical yet complex fashion. It is usually suggested that here Ambrogio is indebted to Giotto.[15] This, however, cannot be proven, and

it is just as likely that the influence went the other way. In fact, Giotto's compositions in the Santa Croce cycles are different from anything else that we know by him.

It was not Giotto but Simone who exerted an influence on the figure types of the back rows of the *St. Louis Kneeling Before Boniface VIII*. Ambrogio, faced with the depiction of these well-dressed and elegant figures (they include King Robert, brother of Louis, and his court), turned to the art of Simone Martini for help, just as his brother Pietro did in the large *Crucifixion* at Assisi. In the elongated faces with their sinuous features and the fashionable robes and head-dresses one sees a direct echo of figures scattered throughout Simone's Assisi *St. Martin* frescoes. Undoubtedly for the Lorenzetti brothers, as for so many other Sienese artists, Simone's contemporary idiom was the model of gracefulness and style.

Yet in Ambrogio's triptych [84] in the Siena Pinacoteca with the Madonna, Child and Sts. Dorothy and Mary Magdalen, probably executed about the time of the *St. Louis* fresco (late 1330s?), there appears a daring new concept which seems to owe nothing to any of the artist's contemporaries.[16] The figures are arranged in their traditional positions (the Madonna and Child in the central panel and the two saints in the side wings), but the ancient convention of sequestering each saint neatly within his or her own compartment has been abandoned by Ambrogio. Instead, he has sharply turned Mary Magdalen and Dorothy to nearly profile positions. They look and gesture, not at the spectator as they do in so many earlier Sienese altarpieces, but toward the Madonna and Child. Sharing the same time and the same space, the figures weld the triptych into a seamless whole. The usual separate articulation has been abandoned and the altarpiece type has been utilized to draw the holy figures together. This ability to almost completely change well-established convention is shared in Siena only by Pietro Lorenzetti, who gave an amazing demonstration of the new possibilities inherent in the triptych form in his *Birth of the Virgin*. Both Pietro and Ambrogio were, time after time, to breathe a new spirit into already standardized types.

Behind Ambrogio's modification of the side figures of his painting lies the central meaning of the altarpiece: the transfixed worship of the Christ Child by the two saints. Not only their bodies but their minds and hearts are riveted on the divine presence literally within their midst. The turning shapes of the substantial women, their longing looks and the gestures of their hands reveal their emotional fervor. By the placement and attitudes of the saints, Ambrogio has made this triptych a scene of adoration and desire.

84. Ambrogio Lorenzetti. Triptych.
Siena, Pinacoteca Nazionale.

Although comely, the saints are the corporeal stolid women characteristic of
Ambrogio and Pietro, rather than Simone's lithe, slightly withdrawn, lyrical crea-
tures. The brilliantly foreshortened faces of Mary Magdalen and Dorothy are close
to those seen throughout the *Effects of Good Government*. Models of broad,
economic construction, the bodies of the saints are covered with robes falling in
large soft folds. Here material has a weight and substance that the onlooker can
sense; all superfluous detail has been held to a minimum.

In the triptych, Ambrogio has paid the usual attention to costume. Mary
Magdalen's blue and yellow scarf makes vibrant contrast to her bright red gown
(now badly damaged), while the yellow, red and black headdress of St. Dorothy
complements the light violet of her softly falling robe. The flowers Dorothy holds
are remarkably rendered, and their appearance here and in the Massa Marittima
Maestà make one realize how well Ambrogio painted them and how much he
loved them. The abundant green, white and red blossoms spilling out of Dorothy's
robe, and the delicacy of the small bouquet which she shyly offers, make this figure
one of the most attractive in the history of Sienese painting.

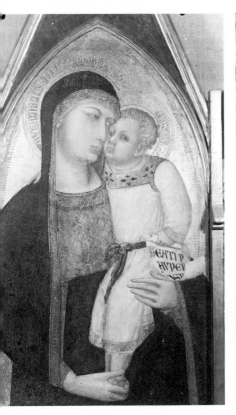

The central figures of Christ and the Virgin are splendidly integrated. The Virgin, who fills the entire width of the panel, holds her half-sitting, half-standing son. Her bent right arm and Christ's right arm slung around her shoulder form a rough circle, which is continued along the Virgin's back and up through Christ's left leg and arm. This circle is exclusive, for it isolates the mother and infant. Wrapped in their own thoughts, which seem to be disturbing and frightening, they neither acknowledge the adoration of the saints nor seem interested in the worshipper. The brooding mood is similar to that which envelopes the principal figures of the Massa Marittima *Maestà*.

By breaking the traditional formal restrictions of the triptych type, Ambrogio was able to create a vivid interaction between the holy figures. A new and heightened emotional drama endows the actors with a psychological complexity and religious fervor particularly characteristic of Ambrogio's late works. To understand how truly expressive these figures are, one need only compare them with saints from altarpieces by Duccio or Simone, two painters whose elegant but much more controlled images seem to belong to a different world, a world where feelings

are under tight rein and religious ecstasy is a much more private experience.

Ambrogio's rapidly developing ability to brilliantly unify the formal and emotional elements of his pictures is nowhere better demonstrated than in a Madonna panel in the Siena Pinacoteca [Plate 5]. This work, known as the *Rapolano Madonna* from its former location at Serre di Rapolano near Siena, is integrated by a series of large interlocking arches: the arch of the panel itself and the smaller echoing arches of the Madonna's head and back, her right arm, the sweep of her cloak, the curve of the Child's body and the shape of his left arm. Smaller arches—the hems and headdress—furnish further variations of the large curves. All work together to help create an astonishing tenderness between mother and Child. The encircling arms of the figures and the nearness of their faces play their part in this symphony of physical and emotional intimacy.

As in the Massa Marittima *Maestà* and the *Madonna and Child with Sts. Dorothy and Mary Magdalen,* there exists here a troubled and uncertain feeling, which is expressed by the serious, worried Madonna and the innocent Child, who looks out at the spectator with what appears to be alarm. So preoccupied is Christ by the worshipper that he unintentionally hurts the bird, grasping its wing too tightly in his plump, baby hand. This detail is characteristic of Ambrogio's humanity: the divine Child is allowed to act in a very childlike way. The uneasy feeling that arises from the two figures makes their interlocked closeness more significant; they seem to draw strength and protection from each other. How very different, and how much more complex, is this picture with its layers of meaning from the earlier Sienese *Madonna* panels, even those supremely beautiful ones by Duccio. There is in Ambrogio's picture a consummate mastery of both subject and form which makes this wondrous panel a milestone of early Italian art.

Although the surface of the *Rapolano Madonna* has been badly abraded, enough of the color is left to demonstrate that Ambrogio has once again used a limited palette. Large areas of unmodulated color dominate the picture: the Madonna's blue robe and reddish orange tunic, and the Child's pink garment. Punctuated only by the enlivening yellow, red and black of the Madonna's headscarf and the blue-green of the Child's belt, the simple, restrained palette informs the picture with a simplicity and dignity worthy of the Madonna and Child.

There is a grandeur of composition and execution about the *Rapolano Madonna* that is anticipated by many of Ambrogio's earlier works. The way the figures fill the painting's space and turn in it is majestic; but even at this late date (it is possible that this comes from the early 1340s) one is reminded of sculpture in general and the art of Giovanni Pisano in particular. Throughout the fourteenth

century the work of this famous sculptor must have been held in the highest esteem by Sienese painters, yet it was Ambrogio and Pietro Lorenzetti who seem to have understood best his style and emotional expression.

From the Vico l'Abate panel onward, Ambrogio created a series of Madonnas unequaled in their variety and inventiveness. While working within the iconographic constraints of a conservative tradition, he was able to conceive and paint an amazing number of variants on a single theme. If one thinks back to the *Madonnas* of Vico l'Abate, Roccalbegna, the *Madonna del Latte,* and the *Madonna and Child with Sts. Dorothy and Mary Magdalen,* one realizes how strikingly different these all are. It is as though Ambrogio rethought the entire problem of the image of mother and Child each time he was commissioned to do a new painting, and indeed, he probably did. Seldom does one have this feeling about other artists of the Trecento.

This process of rethinking is also apparent in a series of *Maestàs* executed by Ambrogio. During the last part of his career he did three, each containing a number of highly noteworthy inventions. Perhaps the earliest of these late works is the small *Maestà* in the Siena Pinacoteca [85]. Only 50 centimeters high, this panel may have served originally as the center of a little triptych, but its size has not solicited from Ambrogio a miniaturized composition. Instead, the sharply foreshortened figures circling the Madonna create a powerful sense of bulk and recession. Very much like the figures of Dorothy and Mary Magdalen from the Pinacoteca triptych, these serious creatures are transfixed before the gentle Madonna and the Child who holds the scroll for the two bishop saints in the right corner. Particularly noteworthy are the wonderfully wrought kneeling figures in the foreground, whose cloaks of saturated red, brown-gold and green conduct the onlooker into the picture's space. The bright blue robe of the graceful Dorothy (again holding a bouquet of lovely flowers) makes vivid contrast to the dark brown gown of Catherine, who turns toward the mother and son. At the center, the circle of adoring figures parts to allow the eye of the worshipper to move along the patterned floor and ascend up the carpeted steps of the throne to the majestic Virgin and her lively son.

The most surprising passage in this painting is found to either side of the Madonna's head and shoulders, where six angels, their blond heads wreathed with flowers, hover in an indeterminate space [86]. They have been partially dematerialized by the pure, supernatural light radiating from the Madonna. The idea that brilliant light can optically dissolve form is not encountered in any previous Sienese or Florentine painting; Ambrogio's incredibly sophisticated mind appears

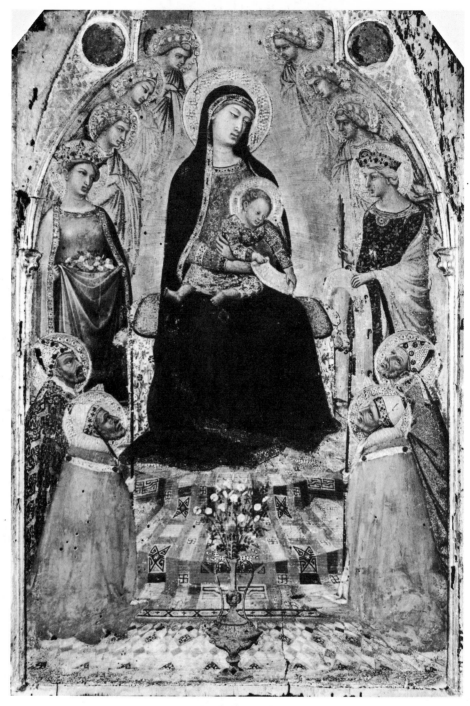

85. Ambrogio Lorenzetti. *Maestà*. Siena, Pinacoteca Nazionale.

86. Ambrogio Lorenzetti. *Maestà* (detail). Siena, Pinacoteca Nazionale.

to have been the first to demonstrate this in paint. But, even more surprisingly, he has used the traditional gold ground to create this effect. The torsos of the angels are not fully finished; instead, the gold over which they are painted is allowed to come through, blurring their outlines and making them disappear in the heavenly radiance. Ambrogio no longer thinks of gold as background, but as a source of luminous energy. In the first half of the Trecento in Siena, this was an unprecedented and prophetic realization, which only an artist of Ambrogio's intellectual and compositional gifts could make.

Prophetic also is the great wealth of decorative detail in this small *Maestà*. The patterned tile floor, the gold vase, the striped oriental rug, and the gold embroidery on many robes and hems enliven the picture and create various centers of interest. Ambrogio's fascination with pattern and costume finds its high-water-mark in the remarkable flower patterns on the seat of the throne and the stunning brocade of the Child's gold-encrusted robe. Yet, as always, he maintains a careful balance between detail and the overall compositional function of the large forms —a balance that was not sustained by many later painters, who were purposely to allow marvelously decorative detail like the gold embroidery to dominate their pictures. In this tiny picture Ambrogio achieves a remarkable harmony between broad and voluminous shape, vivid and varied color, and decorative detail of the highest quality.

A much different conception of the *Maestà* is seen in his fresco [87] in Sant'Agostino, Siena.[17] In this painting, probably once part of a cycle now destroyed, he has once again surrounded the Virgin with a circle of figures; but here he has constructed his composition to fit and respond to the lunette in which it is painted. The curving shape of the lunette is echoed by both the disposition of the figures and the Virgin's throne, mysteriously made by the outstretched wings of two fiery red seraphs. Ambrogio has turned the somewhat awkward shape of the lunette into a decided advantage, much as Pietro did in his Assisi *Deposition*.

In this fresco, which seems to date from the mid-forties, Ambrogio demonstrates the ease and confidence of a great artist at the peak of his maturity. Problems of foreshortening, placement of figures, and creation of space are solved with graceful brilliance. Never before had Siena seen such convincingly drawn, volumetric beings, nor such unity of composition.

But the compositional brilliance of the work is equaled by its emotional complexity. Transfixed by the Madonna and Child on the seraph throne, each of the saints is frozen in the act of proffering their particular attribute. This offering

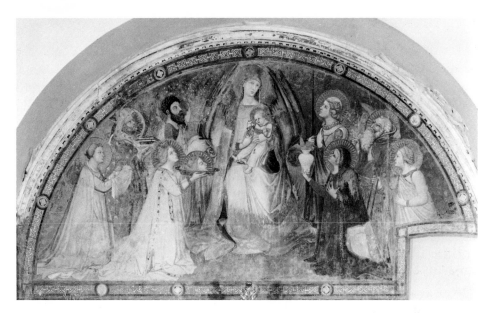

87. Ambrogio Lorenzetti. *Maestà*. Siena, Sant'Agostino.

of objects, different from any of Ambrogio's earlier *Maestàs,* creates an active relation between the saints, mother and Child. But the relation is a charged one, for five of the eight saints offer disturbing attributes: Agatha holds her severed breasts; on Catherine's plate is her head; Bartholomew grips the knife used to flay his skin; tongs used to pull out her teeth are offered by Apollonia; and Lucy (?) grasps a jar from which issues a seraph. Such an unusual array of disconcerting attributes suggests that the fresco may have some connection with a medical confraternity. Certainly these are saints who have all suffered bodily afflictions and who, seen grouped around the Madonna and Christ, may have offered hope to the ill or to those who tended them.

Whatever the reason for the commission, it is clear that the fervent figures with their grisly attributes establish a worrisome feeling absent from any other Sienese *Maestà.* The Child himself participates in this strange drama by reacting suddenly and vigorously. He raises his hands and there is fright mirrored in his bulging eyes. Exactly what he is reacting to is not quite clear: perhaps it is the horrible head on Catherine's plate. Like the Child in the *Rapolano Madonna,* Christ here demonstrates a totally human and childlike reaction. He does not see the head as a symbol of glorious martyrdom, but is frightened and repulsed by it.

Much of the fresco's surface, especially the robes of the Madonna and Catherine, have suffered paint loss and abrasion. Enough remains, however, to

demonstrate that it is very like that of the Palazzo Pubblico *Good and Bad Government* picture. A large, fully loaded brush has swept across the *Maestà*, forming the broadly conceived forms with a breadth and confidence characteristic of Ambrogio during the last part of his career. As in the Sala della Pace, the individual brushstrokes often follow the contour of the shapes (this is best seen in the Madonna's face), creating a strong sense of plasticity. There is here an unprecedented freedom of both form and handling of paint that is another of the prophetic characteristics of Ambrogio's late style.

It is difficult to discuss the color of this fresco because a great deal of it is lost. Yet what remains indicates clearly that it was, on the whole, restrained and measured. Centered on the bright blue of the Madonna's multicolored robe and the red of her throne, a limited range of hue—yellow, grey, white and red—spreads out across the fresco's surface. Several notes of brighter color energize the painting, but overall, the decorous palette is a perfect compliment to its sober content.

Sometime around the completion of the *Maestà* in Sant'Agostino, probably in the mid-forties, Ambrogio painted another fresco of the same subject [88] in

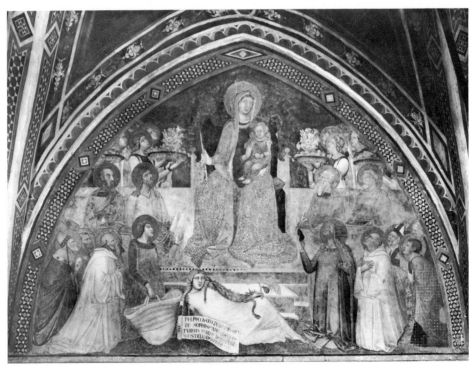

88. Ambrogio Lorenzetti. *Maestà*. Montesiepi, San Galgano.

89. Ambrogio Lorenzetti. *Saints and Angels.* Montesiepi, San Galgano.

the hillside chapel of San Galgano at Montesiepi south of Siena.[18] This small
structure, built on the site of St. Galgano's miraculous vision of the Virgin, was
a dependency of what was then one of the major religious structures of the Sienese
territory, the large Cistercian church of San Galgano, now a splendid ruin sur-
rounded by miles of gently rolling fields.

Situated in a lunette below the chapel's vaults, the San Galgano *Maestà* is
flanked by two other frescoes each containing saints and angels. All three paint-
ings, and the *Annunciation* placed below the *Maestà,* have suffered considerable
losses. Originally the lower parts of the side walls were painted but the right wall
is now blank. On the left wall only about half of the subject, the Vision of St.
Galgano at Rome, remains.

Once again Ambrogio amazes us with the inventiveness of his mind. In the
San Galgano *Maestà* he modifies the image's traditional concept in a daring and
unique way: instead of limiting the *Maestà* to a single field, he has extended it
to the other walls of the small chapel as well. The enthroned Madonna, the center
of her lunette, is surrounded by angels bearing bowls of flowers and by about a
dozen saints who stand and kneel before her. But this is not a self-sufficient
composition: it is closely related to the flanking paintings, whose saints and angels
move toward and stare fixedly at the Madonna and Child. In the left-hand
painting [89], St. Michael turns toward St. Galgano (who holds his attribute, a

90. Ambrogio Lorenzetti. *Saints and Angels.* Montesiepi, San Galgano.

rock with a sword) and gestures toward the Madonna. Both gesture and look connect St. Galgano to the enthroned Madonna, who is at one and the same time the center of a *Maestà* and the saint's vision. On the wall [90] to the right of the Madonna, angels with large splendid wings kneel before rows of saints, who are in turn backed by standing angels. This arrangement of saints and angels is, of course, traceable to Duccio's seminal *Maestà.*

In the small chapel of San Galgano it is as though the spectator himself stands in the *Maestà.* Surrounded by images of devout, yearning saints, he, like them, looks upward at the glorious, enthroned Madonna adored by her court. The close interrelation between the various paintings of a chapel is not unique in the Trecento, but seldom has the arrangement of frescoes involved the onlooker in such a bold and compelling manner. The traditional *Maestà* has been expanded to include not only the spectator's space but the spectator as well.

Also of considerable interest are the many novel features of the central fresco. Constructed around the stepped platform on which the throne is placed, the composition is one of Ambrogio's most spatially sophisticated achievements. Extremely deep space is suggested by the measured backward movement, which

begins in the sharply foreshortened kneeling foreground figures, extends through the standing saints, and ends in the angels standing behind a wall, an extremely unusual motif. This is a layered, compartmentalized space which finds its origins in something like Ambrogio's *St. Louis Kneeling Before Boniface VIII* and its contemporary analogue in several of Giotto's Bardi frescoes. It also anticipates, to some degree, the planar spatial construction found in the work of a number of Florentine painters—the Cione among them—active in Florence around mid-century.

At the Madonna's feet Eve reclines, holding a fig branch. The Virgin was often seen as the new Eve and the Annunciation (painted just below this fresco) was sometimes linked to the Temptation, for in the Annunciation the new Eve redeemed mankind which had fallen at the Temptation. It is Eve as temptress that Ambrogio emphasizes in this beautiful figure. Dressed in a long robe, which pulls seductively across her legs and chest, Eve looks languorously out of the picture. Framed by two large braids, her comely face with its regular features and bright eyes is every bit as splendid as the Peace from the Sala della Pace. Here is a stunning but dangerous creature. Her great siren-like beauty is ignored by the saints around her, who have their eyes fixed only on the Madonna, the fresco's symbol of redemptive goodness.

Many of the saints in the San Galgano frescoes are memorable images. One has only to look at the two female figures—one (Hope?) holding a giant straw basket [91] and the other (Charity?) offering a heart—that turn toward the Madonna with faces full of religious excitement, to realize how great was Ambrogio's ability to articulate and energize the figure. The frescoes abound with vivid, unforgettable types, from handsome to ugly, from youthful to ancient, all encompassing a truly amazing range of emotional expression.

This ability and willingness to let the figures give vent to the emotions associated with religious drama is a marked characteristic of Ambrogio's later work, and nowhere is it seen in a more interesting example than in the *Annunciation* [92] painted around the window of the chapel at San Galgano.[19]

Luckily the sinopia underdrawing of this badly damaged fresco has been preserved [93]. Unlike the repainted fresco which covered it, this reveals Ambrogio's original intentions. In the area to the left of the window kneels the angel, whose large wings are still extended as though it has just alighted. This wondrous being is a miracle of drawing: body, head, drapery and wings are sketched in with a breathtaking economy, confidence and ease. Behind the figure is the painted outline of someone standing in the doorway. What one sees here is the culmina-

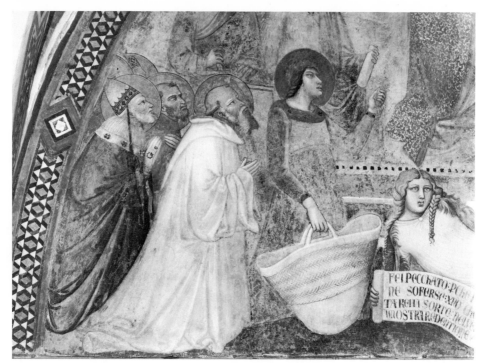

91. Ambrogio Lorenzetti. *Maestà* (detail). Montesiepi, San Galgano.

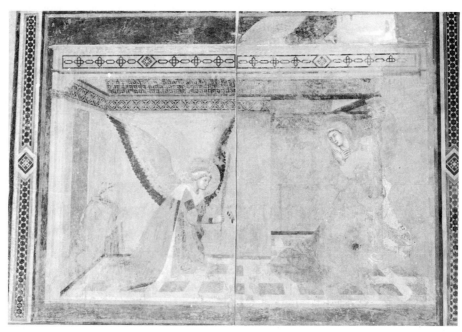

92. Ambrogio Lorenzetti. *Annunciation.* Montesiepi, San Galgano.

93. Ambrogio Lorenzetti. *Annunciation* (sinopia). Montesiepi, San Galgano.

tion of a lifetime of practice and observation reduced to a dozen or so magical strokes of the brush. The work of an inspired instant, this timeless sinopia is one of the most appealing drawings of the Trecento. It is also a reminder of the stylistic dichotomy that existed between the loose underdrawing and the final, more formal fresco.

Across from the angel is the Virgin, who has slumped to the floor and now clings to the column for support. Frightened almost into unconsciousness, she turns back to look at the huge angelic figure who offers her the palm. Ambrogio's rendition of the Annunciation is astounding. To depict the Virgin in this way is contrary to the spirit of almost every other contemporary version of the scene in which she willingly accepts the angel's message.[20] Ambrogio has chosen to emphasize her frailty and humanity, just as he stressed the human qualities of the Rapolano Madonna and Child and the human longing of Sts. Dorothy and Mary Magdalen in the Pinacoteca triptych. The brilliant drawing reflects the originality of Ambrogio's ideas: the Virgin is much more worked than the angel, and Ambrogio's brush had to do considerable experimenting before the right form was found. Certainly this must be because the posture and gesture of the bewildered Virgin were not in Ambrogio's vocabulary of form, and it was therefore necessary for him to invent them on the wall.

Unfortunately Ambrogio's marvelous inventions no longer exist in their original state. Shortly after the fresco was painted, it was horribly mutilated by someone obviously disturbed by the daring and humanity of its ideas. The Virgin was repainted, perhaps by a mediocre follower of Ambrogio, into the conventional type who stands with hands crossed over her breast, passively accepting the angel's greeting and message. Fortunately the angel was left undisturbed, although it is now in a very damaged state. The woman standing in the doorway, however, was suppressed and a donor, perhaps the instigator of the changes, was added. This figure, put on in *fresco secco* (tempera), has now almost completely fallen from the wall.

Both fresco and sinopia demonstrate Ambrogio's continued interest in the creation of complex space. The columns and rafters of the Virgin's room, the walls which divide it, and the receding orthogonals of its pavement are enclosed by a lintel which marks the foremost extension of the building. Several of these same elements also exist in what must be one of Ambrogio's last versions of the theme: the *Annunciation* of 1344, now in the Siena Pinacoteca, but probably commissioned for the Palazzo Pubblico [94].

Simplicity, dignity and monumentality are the hallmarks of this remarkable interpretation of one of the central themes of Christian art. Each of the huge, volumetric figures has a palpable and certain existence in the picture's space. The complicated articulation of the angel's body, its extension across and into the panel, and the abstract planes of its light red drapery formed by the carefully modulated play of light and dark, make it startlingly realistic. Across from the angel, the Virgin's bulky blue shape seems rooted to the earth. The two powerful protagonists face each other with the full knowledge of the part they play in the divine drama, a drama very different from that at Montesiepi.

Seldom in the history of painting has a scene invested with such supernatural meaning been so tactile and corporeal. In Ambrogio's late paintings one finds a rare tendency to bring the miraculous and supernatural within the grasp of the worshipper. The Giotto of the Arena Chapel was the only other Trecento artist to accomplish such a difficult feat. Both he and Ambrogio were involved in a constant search to humanize the divine and, by so doing, to elevate the world of the spectator into a holy realm.

It is the desire to include the spectator that has, to a large extent, determined the design of this *Annunciation*. Each of the orthogonals of the white and grey floor moves toward a central vanishing point: the floor is constructed with a single fixed viewpoint; space recedes in a fashion that duplicates our own experience in the physical world around us. The location of the plastic figures, our relation to

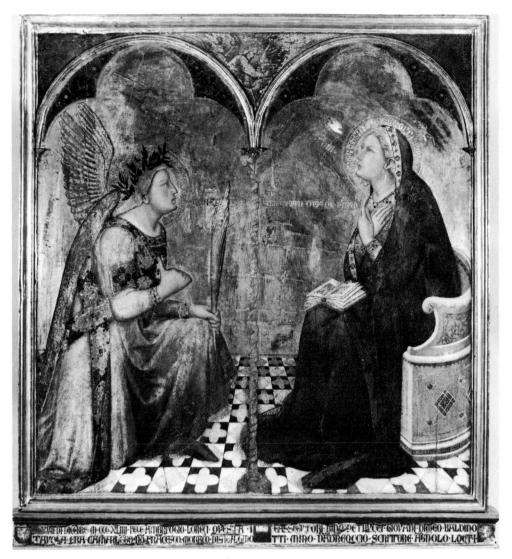

94. Ambrogio Lorenzetti. *Annunciation.* Siena, Pinacoteca Nazionale.

them and their relation to each other are immediately comprehensible. The gold background appears as a distant wall. It does not matter that all this is done with a nonmathematical, intuitive perspective; it is the effect that counts, and that effect is one of startling realism. It appears that just beyond the frame, yet still within the spectator's world, there is a drama of cosmic significance unfolding. Even the floor, which shifts from light to dark as the squares recede, seems lit by the light surrounding the onlooker.

This is one of the most somber *Annunciation*s in the history of Italian

painting. So ponderous, immediate and serious do the figures seem in their coherent space that one suspects the subject is not the annunciation of Christ's birth, but rather the annunciation of the death of the Virgin, a scene found in Duccio's *Maestà*. For various reasons, scholars have argued at some length over this problem, which seems incapable of a neat solution.[21] If it is indeed the annunciation of the birth of Christ, how radically different it is from the San Galgano *Annunciation,* in which the Virgin is certainly not the willing participant in a divine scheme that she is here. But an artist as intelligent as Ambrogio would not want to establish a consistent treatment of subject; the development of his *Madonna* panels proves this point. In the Pinacoteca *Annunciation* his interest was caught by the nobility of the Virgin's acceptance of God's will. Whatever the answer, the fact remains that in its majestic solemnity and grandeur the Pinacoteca *Annunciation* is unique.

The painting seems to have had almost no effect on Sienese art during the second half of the Trecento. Neither its solemn spirit nor its daring spatial innovations was duplicated. It may be that its visual and emotional ideas were not understood or, more likely, that they were understood and rejected. There is every possibility that Ambrogio's contemporaries felt that the picture was too real, that it brought the holy figures and their story too close for comfort. For eyes and minds accustomed to a psychological and pictorial distance from the sacred drama, the Pinacoteca *Annunciation* may have seemed too immediate and, possibly, too profane. Major innovations are accepted only when there is a favorable intellectual climate; this was not the case with Ambrogio's daring picture. It was only in the early fifteenth century, when artists began once again to explore a number of the same concepts, that there arose an art with some of the same goals. The ordered placement of vivid monumental figures in a rational space which is an extension of the viewer's own world is found in works by Donatello, Masaccio, Filippo Lippi, and several other noteworthy artists of the first half of the Quattrocento. Ambrogio's prophetic painting would not be fully understood until long after his death.

The Uffizi *Presentation in the Temple* [95], along with the Pinacoteca *Annunciation,* documents the style of Ambrogio during the end of his fruitful career. Signed and dated 1342, its provenance has not been fully established, but there is a strong possibility that it was originally on the altar of San Crescenzio in the Sienese Duomo.[22] It is probable that—like Pietro's nearly contemporary *Birth of the Virgin,* also painted for the Duomo—it had side wings containing standing saints.

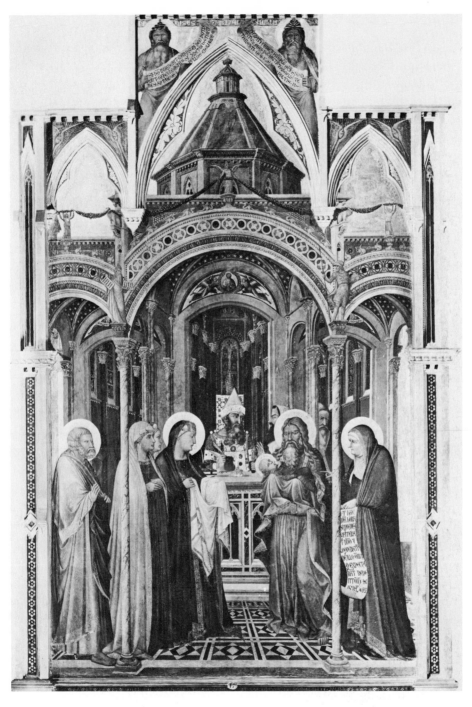

95. Ambrogio Lorenzetti. *Presentation in the Temple*. Florence, Uffizi.

As in the Pinacoteca *Annunciation,* the exploration of space is here of paramount interest. The action occurs within a church whose colonnaded nave and side aisles move swiftly into the deep background. The recession of these convincingly rendered architectural units is echoed by the rushing orthogonals of the floor and by the figures, who move rearward in a "V." Everywhere there is the measured alternation of solids with carefully planned intervals of void. In its harmonious arrangement of figures and realistically scaled architecture, set within a coherent, believable perspective system, the *Presentation* heralds many Quattrocento paintings.

Each of the figures is an elegant, regal being. The handsome, columnar women wear splendid brown, red, blue and orange robes, white scarves and golden earrings—Ambrogio never lost his love for decorative accessories. The High Priest is attired in a magnificent gold-encrusted blue and red gown. Various areas of red, green, pink and grey enliven the architecture. The foreground figures present a friezelike progression of pink, orange, blue, red, green and brown.

The importance of detail is not overlooked in this broadly conceived picture. The marble inlay of the altar, the gold-fringed hems, the lovely embroidered cloths, the architectural decoration, and the statues on columns and roof energize the painting and testify to Ambrogio's all-encompassing eye.

But decoration and color are never allowed to hide the story's spiritual significance. The attention of each foreground figure is fixed on Simeon, holding the Child who is wrapped in a bright red cloth. Intoxicated with joy and wonder, he tenderly cradles the thumb-sucking infant whose upward gaze reflects his total childlike indifference to the people around him. It is the tender and touching contrast between the old man and the baby that forms the psychological heart of the story. And it is the hushed, awed silence and tenderness of the other holy figures that makes the onlooker understand he is in the presence of one of the most humanly conceived *Presentation*s. All the grandeur and beauty of figures and setting pales before the elemental human happiness that forms the painting's emotional core.

In the Uffizi *Presentation* and the Pinacoteca *Annunciation* one sees the final flowering of Ambrogio's art. Formally breathtaking, filled with expression, compassion and nuance, it is ineffably moving. In the entire Trecento only Pietro Lorenzetti and Giotto were as brilliantly coherent. Yet it was Ambrogio alone who was able to, paint such piercing and immediate drama within settings of great realism. His pictures, from the earliest preserved examples, demonstrate an unceasing progression of striking invention and an ever-increasing understanding of

the human strengths and fears of those divine actors predestined to play their parts in the sacred drama. His is an art notable for the richness and profundity of its insight.

Like Giotto, Donatello and Rembrandt, much of Ambrogio's art soared above the artistic conventions of his time. There was a great deal about it that was neither understood nor accepted by his contemporaries and followers. Consequently, his influence was limited. The reception and subsequent modification of his style and the idioms of the two other supreme Sienese artists of his generation, Pietro Lorenzetti and Simone Martini, are among the most interesting and neglected developments of Sienese Trecento painting. It is to these events that we now turn.

VI

PAINTING AFTER MID-CENTURY

By 1350, the artists who had dominated Sienese painting in the generation after Duccio were dead. Simone Martini died in 1344, and the Lorenzetti brothers appear to have been carried off by the Black Plague of 1348 which devastated Tuscany. As in Florence, the beginning of the second half of the Trecento saw the rise of a generation of painters destined to move toward the new styles of the Quattrocento.

Sienese painting of the last fifty years of the fourteenth century has been undervalued. With the exception of Barna da Siena, the painters of the period have been considered highly imitative, untalented, and not worthy of much attention. The adjectives retardataire, derivative, traditional and uninventive sometimes have been used to characterize the art of these decades.

It is, of course, true that the first fifty or so years of the Trecento in Siena saw the birth and development of an art of remarkable invention and power. No other place in the Italian peninsula could boast of such a progression of artists, not even Florence. Inevitably, the dazzling success of Duccio, Simone Martini and the Lorenzetti brothers has blinded critics to the less obvious but nevertheless considerable talents of those painters working into the late fourteenth century. None of these artists—again excluding Barna da Siena—had the profundity of vision or the sustained originality of the great figures of the earlier years; but, on a more restricted scale, they were able to create works filled with new ideas and often possessed of striking form and color. Not the least interesting aspect of these painters is their relationship to the art of the first half of the Trecento, to which they fell heir.

Barna da Siena is one of the most mysterious figures of mid-Trecento Siena.[1] Next to nothing is known of his life or career, and his artistic personality can be reconstructed only through several works. The most important of these is a fresco cycle on the right-hand wall of the Collegiata of San Gimignano. These paintings of the life of Christ are undocumented, but it seems safe to date them somewhere in the late 1350s.[2]

The San Gimignano *Pact of Judas* [96] is obviously based on the famous version in Duccio's *Maestà* [25], painted some fifty years earlier. However, Barna has made a number of substantial modifications indicative of his different approach to the story. He has enclosed the action, so that the protagonists are now confined by the walls which surround them. No longer is the bargain struck in a luminous piazza, but in a shadowy room nearly bursting with elongated figures hunched in a tight semicircle. The peaked roof marks the center of the fresco, but the psychological core of the drama has been moved off-center to where Judas and the High Priest huddle slightly to the right; this subtle but important shift creates a disturbing tension. How different from Duccio's panel, where the exchange of money occupies the center of a more stable composition!

Each of Barna's figures is an expressive entity. Not only do their tall and angular bodies appear engaged in some foul deed, but their cunning, dark and angry faces seem wrapped in sinister thoughts. Theirs is clearly a silent conspiracy bent on the destruction of Christ. Evil permeates the room, infecting each of its inhabitants. This arresting image is radically different from Duccio's picture, where the spectator's eye sojourns amid the balletic movements of the figures, the swinging arches of the vaults, and the lovely color harmonies of the clothes. Nowhere does the frightening malevolence of Barna's frescoes present itself better.

Color is also an expressive tool in Barna's hands. In place of the subtle and pleasing chords employed by Duccio, he has chosen a number of strange and disturbing hues, and has combined them in striking ways. Acidic greens, pinks, yellows and blues appear, often uneasily juxtaposed to oranges, reds and violets. The combination of pink with orange and with green occurs in the robes of several figures in the *Pact of Judas*. Sumptuous fabrics are seen everywhere in Barna's paintings, but nowhere are they more striking than in the pink robe shot with green worn by the priest who hands Judas the pieces of silver. There is a sharpness about Barna's palette that differs from anything found in the first half of the fourteenth century. His color combinations are calculated to jolt the eye from one passage to the next and to make the spectator feel restless and uneasy. This is why they so wonderfully capture the tension inherent in the *Pact of Judas*. Little of

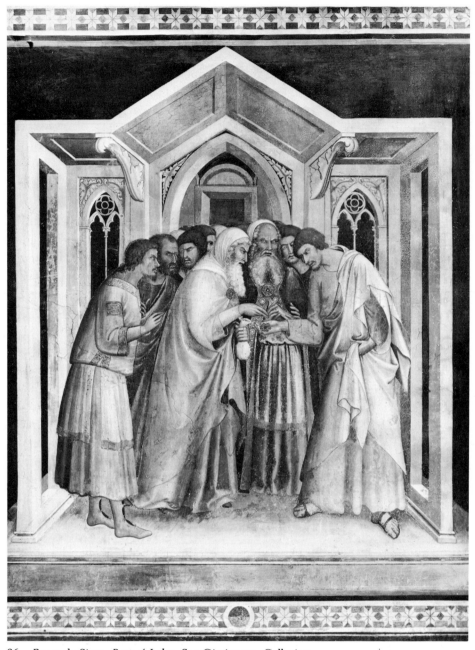

96. Barna da Siena. *Pact of Judas*. San Gimignano, Collegiata.

Duccio's or Simone's sensuous and graceful feeling for color has survived in this highly charged art.

Of course, Barna's art is grounded in the styles of the major figures of the early Trecento. The basic scheme for the *Pact* comes from Duccio, and the style of Barna's figures is certainly indebted to both Duccio and Simone Martini. But he has used these elegant beings for different, more expressive purposes. Fear and discontent have replaced the grace and beauty of former times. It was to the Lorenzetti brothers that Barna turned for the power of their drama and its penetrating portrayal of strong feeling. With the help of their innovations, he was able to create a world supercharged with emotion.

Throughout Barna's frescoes there runs a thread of brutality absent in the work of other Sienese artists, with the exception of Pietro's Passion paintings in the lower church at Assisi. It is possible that Barna knew these scenes and was inspired by them. Certainly, in his *Way to Calvary* [97] he gives full rein to this side of his artistic personality. The center of the composition is occupied by the pathetic figure of Christ, who is pulled forward by a rope tied around his neck. Driven onward, he looks longingly back toward the small band of his friends. But Christ is not sentimentalized. He is strangely spectral and silent as he seems almost to glide across the picture's surface.

There is an exaggerated emphasis on the instruments of Christ's torture: the large cross placed diagonally across the fresco, the ladder paralleling it, the hammer held near Christ's face, and the huge nails pointing at his body, are all reminders of the suffering he is soon to undergo. Behind the steel helmets around him rise the dizzying diagonals of sharp spears. Equally horrible is the long dark sword pointed menacingly at the Virgin, who draws back in fright with a gesture not unlike that which she makes in the Annunciation. Mary's isolation is equaled by that of Christ, whose enemies overwhelm him. Pushed and pulled, threatened and despised, he is lost in the swirling events.

All this takes place in a dizzying setting, making it nearly impossible for the spectator to get his bearings. The quick, diagonal movements of the crosses, ladder and spears are countered by the city wall, which rapidly recedes into the far distance. Equally disorienting are the many angular, conflicting shapes of the tormentors' legs, arms and helmets. The entire scene seems physically and emotionally chaotic. This is, of course, a perfect complement to the story's awful content: the humiliation of the isolated and doomed Christ.

But Barna's fascination with violent, brutal drama is best seen in the huge Collegiata *Crucifixion* [98], in which the reeling emotions of the *Pact of Judas*

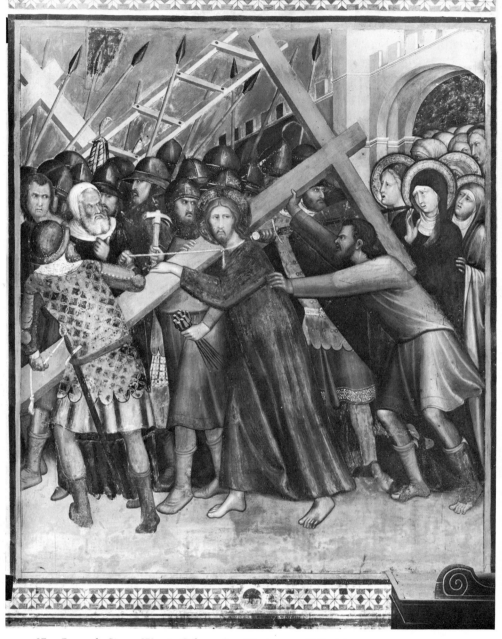

97. Barna da Siena. *Way to Calvary.* San Gimignano, Collegiata.

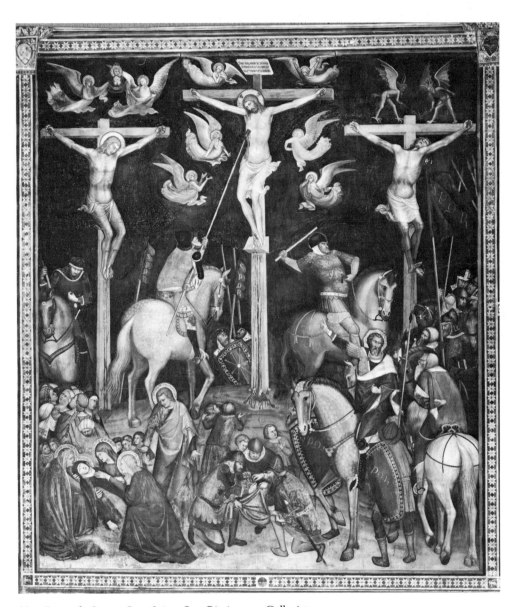

98. Barna da Siena. *Crucifixion.* San Gimignano, Collegiata.

and the *Way to Calvary* find their apex. Pietro Lorenzetti's Assisi fresco of the same subject probably inspired Barna, who seems to have borrowed its tumultuous confusion and figure types but not its reflective and sometimes contradictory displays of feeling. Instead, he has concentrated only on the horror surrounding the event. Again confusion and violence reign. Rising from the hill of Golgotha, the magnificent wind-blown Christ towers over the scene, surrounded by contorted angels who writhe in mourning. His side is cruelly pierced by the lance of an old, bearded soldier on horseback. Just to the right another mounted warrior breaks the legs of the bad thief, whose twisted body is seized by a spasm of pain. At the far left angels transport the soul of the good thief to heaven. The agitated angels, the twisting bodies of the crucified, and the soldiers' gestures make the middle ground of the picture erupt with action. Confusing and eerie, it is one of the most striking and memorable *Crucifixion*s of the entire century.

There is a strange dichotomy between foreground and background. Although narratively they are reacting to it, the knot of women around the unconscious Mary, the standing St. John, and the group of men gambling for Christ's robe all appear almost unaware of the momentous event being enacted behind them. Everyone seems caught up in one of the small subdramas unfolding in the foreground. The picture is consciously disjointed: no central focus is allowed to predominate, and the onlooker's attention is pulled from one location to the other. Discordant and seemingly random patches of red, blue, green and pink appear frequently, blocking any potential color harmony. The careful color chording of Duccio's *Maestà Crucifixion,* the prototype for almost all subsequent Sienese *Crucifixion*s, has been abandoned in favor of something much more erratic. This, as we shall see, is to happen often in the second half of the Trecento.

Barna has chosen to emphasize the cosmic significance found in the biblical text of the Crucifixion. One can feel the divine winds whipping the loin cloths and hear the dreadful screams and moans of the bad thief and the writhing angels. It is a scene of such universal power that it seems to catch both heaven and earth in its wild drama.

Barna is seen at work again in the compelling panel [99] in the Museo Parrocchiale di Arte Sacra in Asciano, a small town near Siena. This unusual full-length *Madonna and Child* (the panel has been cut down at the top and bottom) is a marvel of elegant composing worthy of an artist who understood fully the art of Simone Martini. But the long, sinuous silhouette and the Madonna's cascading robe are on the brink of becoming caricatures of Simone's style.

As in Barna's San Gimignano frescoes, the basic manipulation of form creates

an uncomfortable feeling. There is something unsettling about this tall, thin, angular Madonna. Confined in a large throne, whose patterned armrests move aggressively toward the spectator, she clasps the Child to her body. Clearly derived from Simone, but without the wistfulness so characteristic of that artist's women, her face is filled with foreboding, and her unnecessarily tight grip on the baby seems desperate. The infant, whose body is tensed, appears worried and restless. There arises from this picture a claustrophobic, brooding atmosphere that is, in spirit, found also in the perturbing San Gimignano frescoes.

Barna, like many of the painters who worked during the last fifty years of the fourteenth century, owed much to the past. The basic inspiration for his style came from both Simone Martini and Pietro Lorenzetti; the prototypes for many of his figures appear to stem from the latter's Assisi frescoes. Certainly, the highly expressive quality of his art would have been impossible without his immediate predecessors. Yet he and a number of his contemporaries were able to forge styles that are different from their influential forerunners. The violence, agitation and

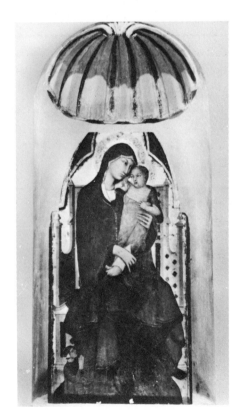

99. Barna da Siena. *Madonna and Child.* Asciano, Museo Parrocchiale di Arte Sacra.

disorientation of Barna's art are, for example, not seen to the same degree in the century's first half. It has been suggested that these aspects of Barna's style may be the result of the Black Death, the great plague which raged through Tuscany in 1348; but the evidence for this is scant, not only in Barna's paintings but in those of his contemporaries as well.[3] Rather, it seems that the motivation for Barna's unique style and narrative interpretation came from his own fertile and independent mind.

Niccolò di Ser Sozzo, Barna's contemporary and another artist of considerable talent and invention, seems to have begun painting around the middle of the century.[4] Documented in the fifties and sixties, he probably died in 1363 at a young age. The only dated work by Niccolò, who was a miniaturist as well as a panel painter, is a large polyptych now in the Siena Pinacoteca [100].

Dated 1362, the altarpiece bears the signatures of both Niccolò di Ser Sozzo and Luca di Tommè, an artist who worked in Siena from the fifties to the late eighties. Because there is no documentary evidence connected with this panel, it is difficult to determine the exact circumstances surrounding its commission.

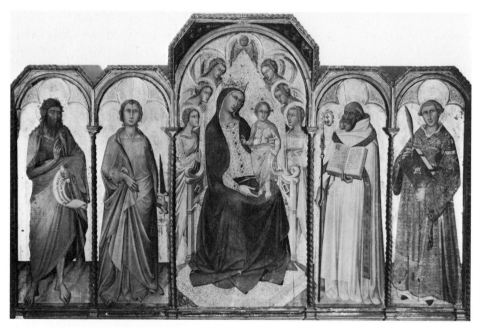

100. Niccolò di Ser Sozzo. *Madonna and Child with Angels and Saints.*
Siena, Pinacoteca Nazionale.

Perhaps the artists were partners, or maybe Niccolò was unable to finish the work and the job was then give to Luca. Whatever happened, it is certain that, on the basis of his other works, the central panel with the Madonna, Child and angels is by Niccolò's hand.[5]

Seated on a grey throne, the beautiful Virgin looks out at the spectator. There is an immediately appealing quality about this elegant figure, whose bright blue robe flows rhythmically down her body to fall in broad, cascading folds at her feet. Both she and her son are imbued with Simone's elegant spirit. It is clear that Niccolò is indebted to Simone in many ways; but like Barna, he also fell under the spell of the Lorenzettis: the breadth of the Madonna, the volume of her body, and the faces of all the figures demonstrate this. Yet the various styles borrowed by Niccolò do not dominate. They are only the foundations upon which he has built a highly personal, extremely accomplished idiom; each of Niccolò's pictures is stamped with the hallmarks of an original, attractive artistic conception.

Niccolò's conception of religious drama is, unlike Barna's, a glorious one filled with idealized, accessible figures. Especially noteworthy is the use of much patterned gold: this appears on the cloth of honor, the robes of the Madonna, Child and angels, the pillow, and on the carpet at the base of the throne. Niccolò's splendid vision is anticipated in works such as Ambrogio's Pinacoteca *Maestà* [85] and the nearly contemporary *Assumption of the Virgin* [71] by the Ovile Master in the same gallery, where the central figure is surrounded by a blaze of gold. But in Niccolò's hands the gold is more decorative than supernatural; it seems more substantial, less radiant, and less vaporous. The decorative tendencies implicit in the works of the older artists have here become explicit.

Niccolò's Pinacoteca *Madonna* is a good example of the burgeoning tendency toward highly decorative painting found in Sienese art after the middle of the Trecento. In its extensive use of gold, in the isolated fields of the Madonna's bright blue robe and the Child's pinkish-red wrap, and in its attention to splendidly patterned fabrics, Niccolò's painting shows a new sensibility. As the century advanced, Sienese artists became more and more interested in the decorative possibilities inherent in the combination of large areas of gold and bright, patterned color. An approach to images and religious narrative quite different from anything seen in the early years of the century was forming, and Niccolò di Ser Sozzo was instrumental in its development.

But this newfound sensitivity to decoration did not mean a sacrifice of the volume and clarity characteristic of much Sienese painting before Niccolò. In his Pinacoteca polyptych there still remains that feeling for weight and solidity,

101. Luca di Tommè. *Assumption of the Virgin*. New Haven,
Yale University Art Gallery.

especially notable in the Madonna's form and the faces of the angels, which demonstrates that he understood fully the principles of the art of Ambrogio and Pietro Lorenzetti, even down to the details of facial construction and expression.

The other artist who, along with Niccolò di Ser Sozzo, signed the 1362 Siena polyptych was Luca di Tommè. Luca, responsible at least for the *St. John the Baptist* panel of the polyptych, was active between 1356 and 1389.[6] Although less talented and imaginative than Niccolò di Ser Sozzo, his work parallels that artist's painting in many ways. This is especially obvious in perhaps his finest extant painting, the *Assumption of the Virgin* [101], now in the Yale University Art Gallery. Extremely close to a fragmentary *Assumption* by Niccolò in the Museo Civico of San Gimignano, the Yale panel demonstrates just how much influence that artist had on Luca.

Floating in an elongated, multicolored mandorla, the delicate Virgin is carried up to heaven by ten angels. Each of the figures wears an embroidered gold robe similar to those in Niccolò's Pinacoteca *Madonna;* the overall effect is also similar, for again the spectator is confronted by a blaze of patterned gold. But instead of the single seraph in Niccolò's painting, there now appear seven of these creatures at the top of Luca's panel, their strange, disembodied presence adding a fantastic note to the picture. Also similar to Niccolò's work are the facial types, the hair, and the gently curving articulation of the bodies.

Luca's *Assumption* contains some interesting spatial complexities that often occurred in Sienese painting after mid-century. Each of the bodies is a volumetric unit, and there is a convincing placement of figures and objects in space seen, for example, in the overlapping of angels' bodies, in their crossed arms, or in their hands which extend over the mandorla, indicating that it is a solid, weighty object which needs to be supported. Yet volume and plasticity are contradicted by the overlapping frame, the patterned gold which flattens the figures, drawing them close to the picture plane, and by the development of the composition up the picture surface rather than back into space.

It is precisely this ambivalence which makes Luca's *Assumption* so attractive. A fine tension between movement into space and movement across the picture plane energizes the *Assumption,* as it does Niccolò's *Madonna* from the 1362 Pinacoteca polyptych and many other works from the second half of the Trecento. Of course, such tension complements the supernatural event depicted on Luca's panel where, in golden glory, the Virgin is lifted to heaven by a group of svelte angels as seraphs look on. It is, in short, no ordinary event: the dynamism of Luca's skillful composition and the splendor of the use of gold remove

it from the realm of the mundane.

In the work of both Niccolò di Ser Sozzo and Luca di Tommè one finds a high level of compositional skill. It is true that they paint quite differently from their immediate artistic ancestors, but their work does not show, as has been sometimes suggested, a qualitative decline; on the contrary, it is inventive and rich in visual and spiritual meaning.

A good example of the differences between the first and second halves of the Trecento is found in the *Birth of the Virgin* [102] by Paolo di Giovanni Fei in the Siena Pinacoteca. Fei, who seems to have been born in the 1340s, was an extremely prolific painter who worked through the first decade of the Quattrocento. He appears to have been the head of a large shop, and there are numerous paintings reflecting his influence.[7]

Fei's *Birth of the Virgin,* perhaps painted in the eighties, may have originally been in the Sienese church of San Maurizio. Whatever its provenance, it is clearly modeled after Pietro Lorenzetti's panel of the same subject [69]. But Fei's debt to Pietro is a limited one, and the nature of his borrowing from the older master is of considerable interest.

Fei changed the role of the central panel by conflating the three wings into a single, spatially unified environment. He has thus carried Pietro's quest for the unification of the triptych type to its logical conclusion. Yet Fei, either through timidity or out of respect for his model, has not done away with the columns, which continue to suggest the old tripartite division of the triptych. These columns still appear to support the frame, but Fei has ignored to a great extent the highly sophisticated play between the real and the fictive found in Pietro's work: the fact that he has consciously not attempted to make the frame a continuation of the painted vault clearly indicates this. His suppression of the revolutionary features of Pietro's paintings demonstrates that Fei—who in this respect was paralleled by many of his contemporaries, Niccolò di Ser Sozzo and Luca di Tommè included—regarded the altarpiece as the detached representation of a sacred story, not part of the spectator's environment.

Fei has held roughly to the internal divisions of Pietro's work: Joseph appears in one section, the Virgin and her maids in the center, and the visiting women in yet another unit. But the composition has been reversed. It is, so to speak, a mirror image of its prototype.

Yet the major change between the two pictures does not lie in the relation to the worshipper or the arrangement of the figures, but in the overall concept of the scene. Instead of Pietro's balanced and restrained narrative, Fei has painted

102. Paolo di Giovanni Fei. *Birth of the Virgin*. Siena, Pinacoteca Nazionale.

a scene filled with intimate charm and domesticity. There are more objects and more details. Fei glories in the minutiae of the interior, which he paints lovingly. The grave and measured atmosphere of Pietro's scene has been replaced by the warmth and bustle of the household after the Virgin's birth. It is, in fact, the feeling of domesticity radiating from this altarpiece that makes it so remarkable and so different from Pietro's more monumental painting.

In many ways the overall compositional principles of Fei's *Birth of the Virgin* are similar to those found in the works of Niccolò di Ser Sozzo and Luca di Tommè: their prominent use of pattern, for example, also appears in Fei's work. The painting's surface has been broken into a number of discordant areas of pattern: the marble floor, the plaid bedspread, the striped scarves, the decoration on architecture and furniture, the beautiful twisting shapes of the flowering bushes outside the windows. The figures, each engaged in some busy action, also form separate and distinct units. The eye moves at random over the rich and heavily worked images.

Color, too, enhances the fragmented, decorative effect. Patches of red, pink, orange, greenish-blue, white and gold appear scattered throughout the work. In Fei's style and in the paintings of many of his contemporaries, color was used not to unify the composition, but rather to decorate and activate the surface. This is very different from the first half of the century during which, on the whole, color was more controlled and integrated with the overall composition. It is, of course, their sparkling, bold use of hue that makes Fei and his contemporaries such interesting colorists.

One of Fei's most genial altarpieces is the small *Assumption of the Virgin* [103] now in the National Gallery of Art, Washington. Divided into an upper and a lower section, bridged by the twisted body and outstretched arms of St. Thomas, it is alive with color and rhythm. The sinuously intertwined group of apostles who peer into the sarcophagus miraculously filled with flowers is a happy invention. Vividly agitated, these delicate figures, who would be at home in a miniature, are strongly influenced by Simone's graceful style. This influence is much stronger than in the *Birth of the Virgin,* derived from a prototype by Pietro Lorenzetti. In the *Assumption* there appears some contemporary influence from Florence. The foreshortened head of the bending man below St. Thomas, and the kneeling figure in front of the sarcophagus, seem to derive, respectively, from Agnolo Gaddi and Spinello Aretino, two of the most influential artists of late Trecento Florence. As in the first half of the century, the last fifty years of the Trecento witnessed considerable artistic interchange between the two cities. This reciprocal influence,

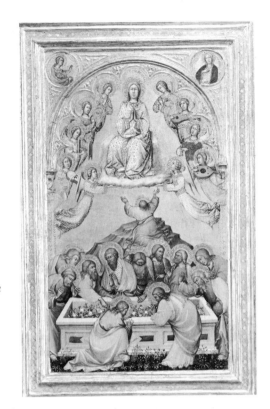

103.
Paolo di Giovanni Fei. *Assumption
of the Virgin.* Washington, D.C.,
National Gallery of Art. Samuel
H. Kress Collection.

while it does not appear to have been a crucial element in the development of any of the most prominent artists of the late Trecento, is apparent in the sharing of some motifs.

In the upper section of Fei's *Assumption,* the Madonna sits on a cloud supported by two angels and surrounded by eight others. There is, in this part of the picture, a wonderful softness and fluidity that often characterizes Fei's work. The pretty angels and the calm Madonna are homey and approachable. Although quite splendid in their radiant, patterned robes, they are different from the more svelte, more regal, gold-encrusted figures in the *Assumption* by Luca at Yale.

Perhaps the most interesting aspect of Fei's painting is its mood. The rippling mountains that echo the twisting figures provide a fantastic background; the animated, birdlike figures in the foreground seem equally unreal, as do the multicolored flowers and grasses which so beautifully enrich the picture. Dancing with color, filled with elongated form, and infused with a delicate, somewhat nervous display of emotion, Fei's *Assumption,* probably painted around 1400, heralds the visionary, often phantasmagoric painting of the dawning Quattrocento.

A similar development is found in Fei's Sienese contemporary Bartolo di

Fredi, who is first noted in 1353 working with the Sienese painter Andrea Vanni. The earliest dated painting by Fredi is the 1364 *Madonna of Mercy* in Pienza, which reveals the strong influence of both Simone Martini and Barna da Siena. Fredi, who died in 1410, left a large number of works stretching from the 1360s to the early years of the Quattrocento.[8] His art seems to have been quite popular in many of the smaller towns dependent on Siena, as well as in the city itself.

The *Adoration of the Magi* (Siena Pinacoteca), which appears to date from the last years of the Trecento, is among Fredi's most accomplished works [104]. A riot of warm color and form, even at a distance it catches and holds the spectator's eye. Pink, brown, blue, red, grey, white and black make up the extraordinary palette. Color is not distributed harmoniously, but is rather scrambled across the picture's surface. Not only is the range of color broad but each hue is vibrant as well. Highly saturated and enamel-like, the color is itself a telling compositional element. Beautiful combinations appear everywhere: pink and blue, red and blue, white and black, and pink and grey. Gold punctuates the picture, adding its brilliance to the strong colors. It is seen on the tack of the brown, grey, black and reddish horses, on the blue and red hats, on the embroidered robes of the kings, and in the haloes. The *Adoration of the Magi* is very much in the mainstream of late Trecento Sienese painting. Bright, varied and striking in its combinations, color is not allowed to form large unbroken areas. Instead, it charges the composition, making it warm and spirited. This use of color, which will be carried on into the fifteenth century, is perfectly matched to the forms in the paintings which are themselves broken and variegated.

Filled with sweeping rhythms, the *Adoration* is extremely active. The spring of the arches of the Virgin's little house, the tight curves of the horses' necks, the swooping hills, and the bending, twisting figures, invest the picture with considerable excitement. There is a crowded confusion about it, seen in the foreground group and in the cavalcade in the background, which adds to its visual agitation.

The graceful figures are certainly indebted to Simone and Barna, and nowhere is this debt more obvious than in the serious Madonna, who still bears some of the stern strangeness of Barna's Asciano Virgin. In the costumes and facial features, further influence from the two artists can be seen, and the horses may owe something to a work like Pietro Lorenzetti's Assisi *Crucifixion*. It would, however, be a mistake to consider Fredi a slavish follower of these men, for like most of his artistic contemporaries, he was very much an independent painter with a fully formed individual style.

The color, the sweeping, swinging forms which make the objects seem

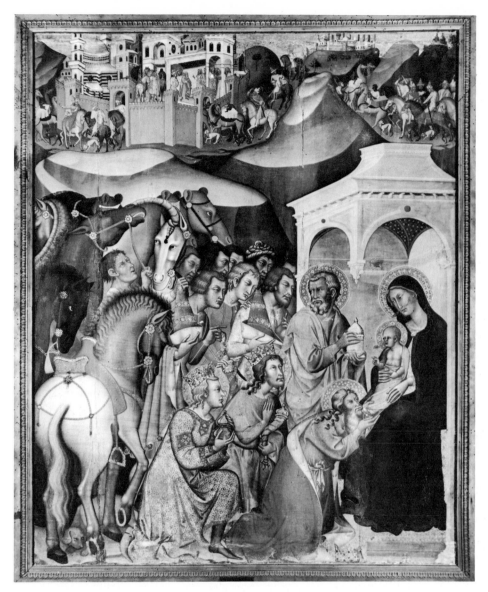

104. Bartolo di Fredi. *Adoration of the Magi.* Siena, Pinacoteca Nazionale.

unreal, and the rapid shift in scale impart a pervasive sense of fantasy. Everything seems divorced from reality. The spectator witnesses a highly stylized, glittering and quasi-mythical scene set within a landscape outside the realm of his experience. Like his fellow artists Barna, Niccolò di Ser Sozzo and Luca di Tommè, Fredi is here moving away from the much more concrete, fathomable idioms of

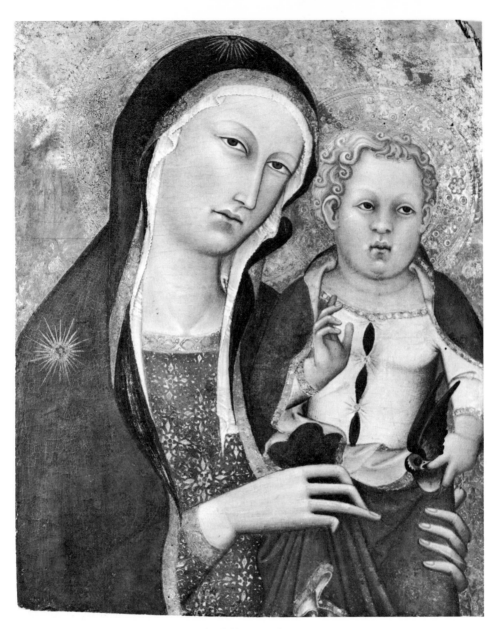

105. Bartolo di Fredi. *Madonna and Child.* Montalcino, Museo Civico.

the early Trecento toward a gorgeous unreality that will eventually come to dominate Sienese painting.

A fragmentary *Madonna and Child* panel [105] by Fredi in the Museo Civico at Montalcino is, both in style and spirit, close to the Pinacoteca *Adoration.*

Although drastically cut on all sides, the Montalcino picture remains, with the *Adoration,* one of the high points of Fredi's career. Probably painted during the eighties, it is at one and the same time a charming, intimate portrait of a beautiful Virgin and her chubby sloe-eyed son, and a highly abstracted, strangely disconcerting image.

Fredi's love of curvilinear form and pattern can be seen in each sinuous hem as it runs its slow course across the bodies, in the attenuated hands, in the Child's hair curling in serpentine arabesques, and in the fluid, almost molten, facial features. Before the picture was cut down, it must have been even more alive with other similar rhythms, lines and forms. Clearly Fredi is indebted to Simone, but he has here stepped beyond that earlier master's restrained sobriety.

In the Montalcino panel, as in the Pinacoteca *Adoration,* Fredi proves to be a colorist of distinction. The Madonna's blue robe (now damaged) was contrasted with two shades of red, one on her tunic and the other on the Child's robe. Although alike, these two reds are just different enough to create a slightly disturbing vibration when placed together. The other colors are the gold of the Madonna's hem, the yellow of the Child's hair, and the whites of the embroidered patterns on the Madonna's dress and the Child's tunic. Small notes of black on the bird's head and blue around the Child's shoulders are added accents. The range of hue seen in the *Adoration* is absent from this picture, but the original, subtle color sense appears in equal measure.

From the Montalcino panel there arises the same sense of unreality found in the *Adoration.* Lost in unknown thoughts, the strange figures seem outside the viewer's world. Entranced by their beauty, he observes and adores them, but always from a distance.

Taddeo di Bartolo, one of Bartolo di Fredi's pupils, spanned the Trecento and Quattrocento. Beginning in the eighties, he painted scores of altarpieces and frescoes for numerous patrons.[9] Certainly one of the most productive Sienese painters, he seems to have been the head of a large shop which often produced work of middling quality. Taddeo lived well into the Quattrocento (he died in 1422), but his work remained a compendium of the stylistic tendencies of the second half of the fourteenth century.

His dated (1409) *Annunciation* [106] in the Siena Pinacoteca is clearly based on Simone's Uffizi picture [42] of the same subject, then in the Duomo of Siena. Although Taddeo has borrowed the type and positions of Simone's angel and Virgin (a sure sign of the respect in which the picture was held almost a century after its completion), he has heavily modified his prototypes. His less elegant and

more volumetric figures betray the strong, tempering influence of the Lorenzetti brothers. His sense of interval is also quite different from Simone's: instead of separating the actors by a measured and significant space, he has moved them much closer together. This immediate confrontation has replaced the more elegant and attenuated relation between Simone's two figures.

106. Taddeo di Bartolo. *Annunciation.* Siena, Pinacoteca Nazionale.

In Simone's *Annunciation,* pattern appears only on the angel's robes; in the altarpiece by Taddeo, it is found not only there but also on the Madonna's dress and, most noticeably, in the gold and red cloth draped over the throne. These prominently patterned areas move the forms up to the picture plane and make the picture's surface extremely lively and decorative. The use of pattern is, of course, Taddeo's heritage from the many painters active in Siena during the last

half of the Trecento. The highly decorative sensibility formed during those years is, in fact, one of the touchstones of his idiom.

Taddeo's palette is typical of the waning years of the fourteenth century. Bright, highly saturated colors appear in patches. The angel's white and gold robes, the red of the throne cover and seraphs, the mottled black and red floor, and the blue of Christ's robe move the spectator's eye across the panel. Smaller touches of color—for example, the white, orange, yellow and red angel's wing, or the red of its slipper—add further strong accents. In concept and intensity, the palette of the *Annunciation* reminds one of Paolo di Giovanni Fei's *Birth of the Virgin* and Bartolo di Fredi's *Adoration of the Magi.* The basic role of color is decorative: it isolates formal units, rather than welding them together.

Taddeo's *Annunciation* demonstrates the considerable differences in style between the early Trecento and the opening years of the Quattrocento. Although based on a prototype by one of the most famous masters of the first decades of the fourteenth century, Taddeo's work manifests a decided stylistic independence, both in a formal and a dramatic sense. His work, like that of the great majority of his fellow painters, is indebted to the past, but different from it.

The second half of the Trecento in Siena did not witness the nearly uninter-rupted progression of painters of genius seen during the early years of the century, yet it was a period of considerable change and variety, in which a new, highly decorative and fantastic art began to emerge. More visionary, highly agitated, and further removed from the world of the worshipper, it was by no means a slavish imitation of the style of the great masters of the early 1300s. This is a good example of how, while remaining within a traditional pictorial framework, Sienese artists were able to create images of considerable originality and richness, imbued with new meanings.

This can be seen in the early Quattrocento. Even though they were heavily indebted to the city's past, innovative painters shaped images and narratives of stunning beauty and color, which brought Siena into a new golden age of paint-ing.[10] Obviously a book devoted to the Trecento cannot survey the art of the Quattrocento, but our discussion would be incomplete without at least mention-ing several fifteenth-century painters who carried on traditions born many years before.

Giovanni di Paolo, perhaps a pupil of Paolo di Giovanni Fei, is recorded between 1399 and 1482. A prolific and talented painter, he is among the most original and fascinating of all Quattrocento artists.[11] One of his major works, a

Presentation in the Temple in the Siena Pinacoteca [107], seems to date from around the middle of the Quattrocento. There is about this picture a particularization and love of isolated, hard detail and pattern that is Giovanni's inheritance from the late Trecento and calls to mind a work like Paolo di Giovanni Fei's *Birth of the Virgin.*

The major compositional elements of Giovanni's picture derive from Ambrogio's *Presentation in the Temple* [95], now in the Uffizi, but probably in Giovanni's time on one of the Duomo's altars. Yet they are used to create a very different pictorial context. Giovanni has compressed the temple and made its side walls more foreshortened. The overall effect of the architecture is no longer grand and majestic, but tunnel-like and slightly claustrophobic. The space of the room, with its tipped-up walls and dizzying floor pattern, is irrational. At first glance, one can see that Giovanni's picture is not a slavish copy of Ambrogio's but an interpretation of it. He has perceived and understood it through the filter of his immediate artistic background, but he has refused to be stifled by the considerable debt he owes to the past.

In fact, Giovanni has created a highly personal and novel picture, for within the narrowed precincts of the temple a strangely tense drama unfolds. The figures, arranged in a rough triangle which moves up the picture plane as well as back into space, are tall, nervous beings whose pronounced facial features border on the grotesque. Clothed in yards of heavy, voluminous material, they make stilted, mannered, sometimes hermetic gestures. Each figure is withdrawn, self-obsessed, suffering from some inner torment. Like elegant specters these melancholy beings participate ritually in the drama. Instead of the more open and accessible world of Ambrogio, or the charming domestic interior of Paolo di Giovanni Fei, Giovanni di Paolo has here created a narrative which is psychologically closed and aloof. In place of the realistic atmosphere of Ambrogio's work, the spectator is now presented with a scene that seems full of magic and mystery, a scene where introspection and isolation rule.

The fleeing walls, vibrating pavement, and obsessive detail all add to this feeling, but it is the color which most effectively conveys the picture's message by fragmenting the surface and emphasizing the isolation of each of the scene's elements. Against the temple's grey walls and columns play the pinks, blues, oranges, yellows, roses, whites and browns of the figures' robes. Further separate areas of color are found in the floor pattern and in the windows and architectural decorations. Intense, vibrant, sometimes startling, the individual colors and their combinations add to the uneasy mood arising from the *Presentation.* In the range

107. Giovanni di Paolo. *Presentation in the Temple*. Siena, Pinacoteca Nazionale.

and nature of color and its chording, Giovanni demonstrates that he was a worthy heir of the great Sienese colorists. The same is true for most of Giovanni's contemporaries, who carried on the distinguished tradition of color that so characterizes Sienese painting of the fourteenth and fifteenth centuries.

Still firmly linked to the past and still within the formal tradition of his teachers, Giovanni's *Presentation* is nevertheless of a more intense and stranger spirit. The roots of its visionary, removed conception are to be found in the works of Barna, Niccolò di Ser Sozzo, Luca di Tommè, Bartolo di Fredi and Paolo di Giovanni Fei, where Sienese painting first veered toward a more fantastic and introverted presentation of religious drama. But the paintings by these artists never contained the degree of introspection and the pain of religious ecstasy found in Giovanni's *Presentation*. Here is a new and complex world, where spirituality is more formal and personal.

These tendencies, shared by many of Giovanni's fellow artists, appear in the sublime *Madonna of Humility* [108] in the Siena Pinacoteca. Probably dating from around the mid-1440s, this masterpiece by Giovanni contains one of the loveliest landscapes ever painted in Siena. Here is not the realistic, familiar countryside of Ambrogio's Palazzo Pubblico frescoes, but a fantastic pale blue, green and brown vista populated by twisted mountains, checkerboard fields and tiny walled cities. Like a dreamscape, this land dotted by trees and crops dissolves in the mist of the far distance. Inviting yet disturbing, comprehensible yet outside the range of one's experience, it stands as one of Giovanni's most brilliant inventions.

The charm of the landscape is matched by the Virgin and Child who occupy the picture's foreground. Both are related to the figures found in Giovanni's *Presentation,* but they are developed in a softer, more lyrical mood. Closely related to the style of Sassetta,[12] Giovanni's remarkable Sienese contemporary, their hands, arms, knees and backs form a rough oval which ties them together physically, not psychologically. The swinging hems of the Madonna's robes are ultimately derived from Simone—who seems to have invented the type—but they are now articulated with a vigor which would have amazed that older artist. Like the exquisite flowers that spring up behind them, these blond and radiant figures are delicate objects which we can only admire. Everywhere the breezes of unreality blow through this charming, refined, but enigmatic picture.

Signed and dated 1444, a large polyptych [109] in the Siena Pinacoteca is the first secure work by Sano di Pietro, an almost exact contemporary of Giovanni di Paolo.[13] An eclectic, cautious, but talented painter, he was the head of a large

108. Giovanni di Paolo. *Madonna of Humility.* Siena, Pinacoteca Nazionale.

109. Sano di Pietro. Polyptych. Siena, Pinacoteca Nazionale.

workshop which produced scores of paintings of widely varying quality. Like all Sienese artists, he was conservative and unwilling to discard or ignore the heroic pictorial legacy to which he fell heir. Perhaps the most popular of all the Sienese Quattrocento artists—hundreds of works from his hand and shop still survive—his painting is in many ways a summation of the stylistic tendencies of the late Trecento and the first half of the Quattrocento.

Sano, Giovanni di Paolo, Sassetta and other fifteenth-century Sienese artists were well aware of the momentous events taking place in Florence, and a number of their pictures reveal that they borrowed from some of the most daring Florentine artists.[14] Yet the realistic, often highly dramatic and straightforward styles of Masaccio, Donatello and the early Fra Filippo Lippi (to name just three Florentines) were not for them. The Sienese were concerned with a more fantastic, unreal, and mystical narrative; the robust Florentine vision must have seemed crude, and too closely related to the spectator. Consequently, it is not correct to think of Sienese painters like Sano di Pietro as benighted and backward. They did understand and could, if they wished, have copied the new Florentine styles. Yet they consciously avoided adopting them because they did not find them congenial to their own strongly held pictorial ideals.

Sano's polyptych is, above all, splendid. Like almost all Sienese paintings, it exhibits a richness of color, an abundant amount of gold, and a fascination with costume. In its characteristically fretted, pinnacled, and gilded frame, it is like some multicolored jewel set in an intricate brooch. Throughout the history of Sienese art there was a love for the costly and sumptuous, nowhere better exemplified than in Sano's paintings. The polyptych abounds with wonderful things: elaborately embroidered copes, thick woolen robes, pillows and hems encrusted with embroidery, variegated, multicolored marble pavement, flowers, and radiant tooled haloes of gold. Ablaze with color and gold, the polyptych is an iridescent mirage.

The quality of invention of Sano's color is remarkable. Varied, bright hues race across the altarpiece, forming a rainbow of color. Cool greys and blues alternate with warm reds, pinks, blues, and other colors whose uniqueness leaves them nameless. All these are set off by the ample amount of gold in the haloes and background, and by the wonderful ivory skin tones of the holy figures. In the originality and skill of the palette, Sano proves himself a sophisticated colorist worthy of the distinguished tradition begun by Duccio.

In the midst of this riot of color and form kneels the Blessed Giovanni Colombini, a Sienese holy man and founder of the order of the Gesuati.[15] With

hands fervently held in prayer and eyes transfixed on the infant, he exists in a state of religious ecstasy. The gracious Madonna, a direct descendant of Simone's comely Virgins, returns his gaze with benevolent eyes. The side saints are lost in meditative isolation; aloof, detached, yet animated by a deep-seated religious fervor, they make little real contact with the spectator, who stands in wonder before this glowing panel. The magical and enigmatic quality of Sano's polyptych, which stems from both its form and figures, is something already seen in Giovanni di Paolo's paintings. Indeed, it is a marked characteristic of most of the Sienese artists working in the first half of the Quattrocento. Rising from the last decades of the Trecento but indebted to the major painters of the first part of that century, the idiom of Sano and his contemporaries is nevertheless highly original. Reflective of different and new sensibilities, it is a visionary art of surpassing beauty and refinement, a worthy heir to the remarkable tradition begun nearly two centuries before.

CONCLUSION

T HE STYLISTIC EVENTS described in this book demonstrate that fourteenth-century Siena witnessed the birth and development of an artistic language of power, inventiveness, and beauty. The earliest remaining examples of the city's art already reveal certain characteristics native to Siena. From Guido da Siena to Duccio these traits—a highly decorative use of color, the construction of complex space, a particular emotional expression—were formed into a regional style which served as the foundation for the city's art during the next two centuries.

Duccio, perhaps the most important figure in Siena's long and distinguished history, was in certain respects a revolutionary artist. Departing from the art of his teachers, he created an idiom remarkable for its grace, sophistication and refined drama; of all the artists working in the Italian peninsula in the early Trecento, only Giotto formulated a style which ventured more beyond his immediate past. Duccio's connections with the art of his predecessors are more obvious than Giotto's, and his evolution away from them is more orderly and gradual, yet his innovations are not any less noteworthy.

Both painters exerted a strong sway on the art of the Trecento, but the nature and the extent of their influence differed considerably. Giotto's vast stylistic legacy was inherited by a group of talented, energetic pupils and followers who helped spread the Giottesque idiom to the remotest parts of Italy. But so revolutionary, rich and profound was this heritage that the majority of Florentine painters who came after Giotto spent most of their lives exploring the artistic territory he had already mapped out.[1] The implications of his late fresco cycles in the Bardi and Peruzzi chapels were to preoccupy artists for the next hundred years.[2] Those who

followed him were independent artists with fully formed personal styles, not drones, but each of them worked within the boundaries of Giotto's inventions.

In Siena the situation was different. Certainly Duccio had numerous imitators, but his three most brilliant and independent heirs—Simone, and Pietro and Ambrogio Lorenzetti—invented and developed styles and techniques of narration unknown to him. They moved outside his orbit, while using his idiom to help construct new visual worlds expressive of a different spirituality.

In fact, a survey of the artists of Trecento Tuscany, with the obvious exception of Giotto, reveals that the most radical and exciting developments took place not in Florence but in Siena, where there was a greater vocabulary of form, emotional range and variety of drama. Seldom in the history of art have four painters like Duccio, Simone, and Pietro and Ambrogio Lorenzetti worked in one city in the span of just several decades. Of course there were artists of outstanding quality in Florence, but many of them were still grappling with the implications of Giotto's discoveries.

In the second half of the Trecento and early Quattrocento, Siena maintained its distinguished tradition. The painters of this period, like all Sienese artists, were the guardians of their glorious past, which they mined for form and idea; but within this framework they developed a visionary pictorial language unlike anything else in the history of European art. Avoiding the works of the more realistic and sterner Florentines, whom they influenced to an extent yet unknown, the Sienese shaped images of considerable invention and great beauty. Their art was different from that of Florence, but no less original or interesting.

An art as accessible and attractive as Siena's was bound to have an impact on other places and other schools of painting. In Tuscany, those towns under the political or economic domination of Siena often commissioned the major masters of that city or their followers. Of course, whatever native artistic activity occurred in the Sienese dependencies was imitative of the Sienese idiom.[3]

But soon the influence of the painters of Siena began to spread. One of the first places to come under its spell was Florence, where Duccio's *Rucellai Madonna* of 1285 was destined. It is quite likely that Duccio did other works for Florence, and it is certain that Ugolino da Siena, a close follower, painted the high altarpiece for the church of Santa Croce sometime around 1320.[4] Vasari claims that Ugolino also executed the high altarpiece of Santa Maria Novella, but even if this is untrue, Ugolino's large polyptych for Santa Croce proves that there existed in Florence a strong taste for Sienese art, even during the peak of Giotto's career.[5]

There are several Sienese, including Ambrogio Lorenzetti, listed in the register of the Florentine painters' guild, and from Duccio's *Rucellai Madonna* onward, Florentine artists studied Sienese painting closely. Cimabue, Giotto, Bernardo Daddi, Jacopo del Casentino, Giovanni del Biondo, and others fell under the spell of the Sienese masters. It is interesting to note that while Sienese influence played a role in the development of Florentine Trecento painting, the opposite is not true. Certainly Giotto influenced all the Sienese painters of the fourteenth century, yet his sway is often generic and hard to define. But Giotto's influence appears, aside from Cimabue's brief sway at the end of the Duecento, to be the only recognizable Florentine one on the Sienese. One looks in vain for substantial borrowings from other Florentine artists. Perhaps this is because the art of Siena offered its artists stylistic and expressive alternatives not available from the Florentines.

But Sienese art was to spread much further afield. By the first several decades of the Trecento Sienese artists were at work for the court of Naples.[6] Naples never developed a strong regional style, in part perhaps because its rulers patronized foreign artists. Giotto spent several years in the city, and Simone, as we have seen, painted a major altarpiece for King Robert of Naples.[7] In the blend of style that is characteristic of Neapolitan painting, the strong and pervasive influence of Siena suggests that by the early Trecento, the city's art was already famous far beyond the borders of Tuscany.

Further proof of the growing influence of Sienese art is found at Assisi where, after the death of St. Francis in 1226, there arose the great double church of San Francesco. Assisi remains a small provincial town set deep within the rolling Umbrian landscape. Lacking local artists, those in charge of the decoration of San Francesco imported painters from other parts of Italy. The painting of the upper church seems to have been given over to Roman artists of the late Duecento and to some of Giotto's first followers. But in the lower church, decorated during the first half of the Trecento, Simone Martini and Pietro Lorenzetti were each commissioned to paint major fresco cycles. It is true that Giotto's school, perhaps sometimes under his supervision, also executed several chapels in the lower church; nonetheless, the fact that two such important commissions were given to Sienese painters suggests that the art of Siena was held in high esteem.[8]

Rimini, an important but little-studied center of Italian painting, was also deeply affected by Siena.[9] It is quite likely that Giotto worked in Rimini, and although nothing exists by him in the city, the influence of his style can be seen in the pictures of many Riminese artists. Yet these same artists also turned to the

Sienese for inspiration and ideas. The easy grace of Duccio's and Simone's idioms appealed to them and this is clearly reflected in their frescoes and panels. Painters like the Master of Tolentino, the Master of the St. John the Baptist Dossal, and Pietro da Rimini eagerly took both style and motif from the Sienese.[10] Often they did not understand the sophisticated use of space and illusionism, and they were not inclined toward the restrained but tense drama of Simone or Duccio. Sometimes the borrowing verged on caricature, but more often than not Riminese artists successfully integrated the Sienese style with other imported idioms which helped to shape their art. The painters of Rimini were, like so many other Trecento artists, captivated by the color of Sienese painting. Often, as in a noteworthy series of panels by the Master of St. John the Baptist, the luminous and serene Sienese palette is combined with a fantastic narrative worthy of the best artists of Siena.[11]

The art of other locations in Italy was also influenced by Sienese painting which, for the Trecento at least, seems to have rivaled and sometimes surpassed Florentine art as the most influential in the peninsula. But its sway was not limited to Italy, for, as we have seen, a number of talented Sienese painters worked in the papal city of Avignon in the south of France. Drawn there by the possibility of commissions from the Curia and from numerous wealthy merchants who had their firms there, the artists of Siena brought their attractive painting across the Alps. The most famous was Simone Martini, a painter already partially responsible for introducing the style of Siena to Naples. Simone was one of the most popular Sienese artists, so the prestige and pay of work in Avignon must have been great to lure him away from Tuscany and the rest of Italy.

Only the sinopie of Notre-Dames-des-Doms remain, but Simone probably executed a number of other important paintings in the city. Avignon was a thriving center around the middle of the Trecento and most likely he established a workshop there. Perhaps some members of the shop remained in France after his death in 1344 and carried on as independent artists.[12]

Although Simone was the most famous Sienese artist to paint in Avignon, others trained in the Sienese idiom were also at work there. The most important of these was Matteo Giovannetti, a cleric born at Viterbo around 1300.[13] His paintings reveal that he was trained by someone under the strong influence of the Sienese school in general, and Simone and the Lorenzetti brothers in particular. Nothing is known of his work before the mid-forties when he was paid for painting in the Palace of the Popes in Avignon.[14] He was to spend about twenty years in France working for the Curia in Avignon and elsewhere, returning to his native

Italy only in the late sixties when his name appears in documentation for work at the Vatican between 1367 and 1368.

Although not a great artist, Matteo is a figure of some importance.[15] Much of the evidence is missing, yet it seems that his art had a considerable impact on a number of European centers. Artists and patrons from many countries went to Avignon to have audiences with the Pope and conduct business with the Curia and the city's many merchants. Certainly those who saw it must have been impressed by Simone's work, but perhaps they did not take to that aloof and ultra-refined style as readily as to Matteo's tamer adaptation. No doubt Matteo's many commissions in Avignon and other parts of France also helped spread the impact of his style.

Simone, Matteo Giovannetti, and the unknown artists who worked in the Sienese style in Avignon were the exponents of an art which must have been a revelation to travelers from London, Prague, Barcelona and Paris who worshipped before it. The grace, clarity and illusionism of their work fascinated both the artist and merchant visitor to the French papal city, and it was not long before variants of it appeared in several European countries.

For the next century or so the refinement and high grace of the Sienese style was a component in European art. But a number of artists, some of whom may have traveled to Siena and others who were introduced to the idiom through Avignon, were also fascinated by the daring Sienese use of color, space and landscape. It was the French artists who were most enchanted. The painting of Jean Pucelle, Jean Bondol, the Master of the *Parement de Narbonne,* Melchior Broederlam and, finally, the remarkable Limbourg brothers would not have been the same without the influence of Sienese art—an influence which fundamentally shaped the course of European painting.[16]

That a city as small as Siena could be so influential and produce so many artists of high quality and a style of such uniqueness and brilliance remains one of the most fascinating aspects of the art of fourteenth- and fifteenth-century Italy.

This occurred only because Sienese artists pursued certain specific goals. From Guido da Siena onward, with the exception of Pietro and Ambrogio Lorenzetti, they strove for a tightly controlled formal presentation of elegant figures in dignified and measured action. Drama there certainly was, but this was always held in tight check. A strong sense of decorum, restraint and tact runs through all these pictures of refined sensibility.

If the development of space, color or the figure is studied, it becomes clear

that the Sienese, while fascinated with illusionism, used it to create vistas of unreality: ultimately one of their principal aims was to separate the world of the picture—no matter how inventive or visually exciting—from that of the worshipper. The onlooker is constantly reminded that he does not belong to the picture's realm and that he does not occupy its space.

The one real exception to this is found in the work of Pietro and Ambrogio Lorenzetti, who time and again attempted to break down the barriers between painting and worshipper: Ambrogio's Pinacoteca *Annunciation* is the last and most sophisticated statement of this. But Pietro and Ambrogio's aims were not taken up by the next generation precisely because they were not congenial to Sienese religious sensibilities. It is likely that most of Ambrogio's contemporaries thought the *Annunciation* too crudely realistic, a profanation. What was wanted in Siena was not proximity but separation.

Sienese painting never tried to secularize religious narrative and image, but to elevate them. Regal, sumptuous and glittering, the pictorial language of the city grew increasingly fertile and personal. Opulent, filled with a vast spectrum of emotion and color, flooded with light, vibrant and alive, Sienese art retains its compelling power. There is a self-sufficiency about its imagery which indicates that its artists and patrons believed firmly in the permanence and rightness of their cosmos, even as, in the early Quattrocento, it veered more and more toward its phantasmagoric apex.

NOTES

INTRODUCTION

1. For a photographic survey of Siena and its countryside, see *I centri storici della Toscana* (ed. C. Cresti), Milan, 1977, vol. I, pp. 177–218.

2. For the Palazzo Pubblico, see A. Cairola and E. Carli, *Il Palazzo Pubblico di Siena*, Rome, 1963, and E. Southard, *The Frescoes in Siena's Palazzo Pubblico, 1289–1539: Studies in Imagery and Relations to Other Communal Palaces in Tuscany*, New York, 1979.

3. On the Duomo, see V. Lusini, *Il Duomo di Siena*, Siena, 1911.

4. There is no recent comprehensive history of Siena. For two good but out-of-date studies in English, see R. Langton Douglas, *A History of Siena*, London, 1902, and F. Schevill, *Siena: The History of a Mediaeval Commune*, New York, 1909. The paperback edition (New York, 1964) of Schevill's book has a useful essay on the more recent historical literature by W. Bowsky.

5. For a shop manual of the Trecento, see C. Cennini, *The Craftsman's Handbook: Il libro dell'arte* (trans. D. Thompson, Jr.), New Haven, Conn., 1933. See also J. Larner, *Culture and Society in Italy 1290–1420*, New York, 1971, pp. 285–298.

6. For the Sienese painters' guild, see G. Milanesi, *Documenti per la storia dell'arte senese*, Siena, 1854, vol. I, pp. 1–152; S. Fehm, "Notes on the Statutes of the Sienese Painters Guild," *Art Bulletin*, LIV, 1972, 198–200: and Larner, pp. 298–303. On artistic contracts, see Larner, pp. 335–348, and D. Chambers, *Patrons and Artists in the Italian Renaissance*, Columbia, S.C., 1971.

7. See, for example, the image of the Christ Child in D. Shorr, *The Christ Child in Devotional Images in Italy During the XIV Century*, New York, 1954.

8. On the apparition of saints, see M. Meiss, *Painting in Florence and Siena after the Black Death*, New York, 1964, pp. 105–131.

I: THE BEGINNINGS OF SIENESE PAINTING

1. On the early crosses and the origins of the Sienese school in general, see E. Garrison, *Italian Romanesque Panel Painting*, Florence, 1949, pp. 29–30.

2. For the earliest Florentine art, see O. Sirén, *Toskanische Maler im XIII. Jahrhundert*, Berlin, 1922, and Garrison, p. 18.

3. On the schools of Lucca and Pisa, see Garrison, pp. 21–22 (Lucca) and 24–25 (Pisa), and E. Carli, *Pittura medievale pisana*, Milan, 1958.

4. On Nicola Pisano, see G. and E. Crichton, *Nicola Pisano and the Revival of Sculpture in Italy*, Cambridge, 1938, and J. Pope-Hennessy, *Italian Gothic Sculpture*, London, 1972, pp. 169–175.

5. On Lapo, see C. Gnudi, *Nicola, Arnolfo, Lapo*, Florence, 1948, and Pope-Hennessy, *passim.* For Arnolfo, see Pope-Hennessy, pp. 180–183, and A. Romanini, *Arnolfo di Cambio e lo 'stil novo' del gotico italiano*, Milan, 1969.

6. See note 19.

7. On Guido da Siena, see R. Offner, "Guido da Siena and A.D. 1221," *Gazette des Beaux-Arts*, XXXVII, 1950, pp. 61–90; J. Stubblebine, *Guido da Siena*, Princeton, N.J., 1964; and R. Oertel, *Early Italian Painting to 1400*, New York, 1968, pp. 42–43.

8. On St. Francis and his writings, see *St. Francis of Assisi: Writings and Early Biographies* (ed. M. Habig), Chicago, 1973, and "San Francesco d'Assisi," *Dictionary of Italian Literature* (ed. P. and J. Bondanella), Westport, Conn., 1979, pp. 220–222. For St. Francis and art, see H. Thode, *Franz von Assisi und die Anfänge der Kunst der Renaissance in Italien*, Vienna, 1934.

9. On Coppo, see Garrison, pp. 15–16.

10. For this radiograph, see C. Brandi, *Duccio*, Florence, 1951, plate 5.

11. On the dating of the Palazzo Pubblico *Madonna*, see Offner, *passim;* Stubblebine, pp. 30–42; and Oertel, pp. 42–43.

12. On this modernization, see B. Cole, "Old in New in the Early Trecento," *Klara Steinweg in Memoriam, Mitteilungen des Kunsthistorischen Institutes in Florenz*, XVII, 1973, pp. 229–248.

13. See note 18.

14. On Duccio, see Chapter II.

15. On the St. Peter Master, see Garrison, p. 144; Stubblebine, pp. 92–97; and P. Torriti, *La Pinacoteca Nazionale di Siena*, Genoa, 1977, pp. 41–43.

16. On the St. John the Baptist Master, see Garrison, pp. 143–144, and Torriti, pp. 44–45.

17. For the influence of Byzantine art in Italy, see O. Demus, *Byzantine Art and the West*, New York, 1970, and E. Kitzinger, *The Art of Byzantium and the Medieval West*, Bloomington, Ind., 1976, pp. 357–378.

18. For Cimabue, see E. Battisti, *Cimabue*, University Park, Pa., 1967, and B. Cole, *Giotto and Florentine Painting 1280–1375*, New York, 1976, pp. 26–32.

19. For Giovanni Pisano, see H. Keller, *Giovanni Pisano*, Vienna, 1942; M. Ayrton, *Giovanni Pisano, Sculptor*, New York, 1969; and Pope-Hennessy, pp. 175–176.

II: DUCCIO AND HIS SCHOOL

1. On Duccio, see C. Weigelt, *Duccio di Buoninsegna*, 2 vols., Leipzig, 1911; C. Brandi, *Duccio*, Florence, 1951; R. Oertel, *Early Italian Painting to 1400*, New York, 1968, pp. 195–201; and G. Cattaneo and E. Baccheschi, *L'opera completa di Duccio*, Milan, 1972. For the documents mentioning Duccio, see ibid., pp. 83–84, and Brandi, pp. 75–89.

2. On the Biccherna covers, see E. Carli, *Le tavolette di Biccherna*, Florence, 1950.

3. An engrossing collection of these documents is found in G. Brucker's *The Society of Renaissance Florence*, New York, 1971.

4. I refer to Cimabue's Santa Trinita *Madonna* and Giotto's *Ognissanti Madonna*, both in the Uffizi.

5. On the history of the *Rucellai Madonna*, see W. and E. Paatz, *Die Kirchen von Florenz*, Frankfurt-am-Main, 1952, vol. 3, pp. 706, 762 n.16, 831 n.431.

6. For Duccio's early influence in Florence

and Tuscany, see E. Garrison, *Italian Romanesque Panel Painting,* Florence, 1949, p. 30.

7. For the *Maestà* contract, see Brandi, pp. 84–87, and J. Larner, *Culture and Society in Italy 1290–1420,* New York, 1971, p. 336.

8. For the *Madonna degli Occhi Grossi,* see Chapter I.

9. The debate on the reconstruction of the *Maestà* has been long and vigorous. For some of the more recent discussion on the problem, see E. DeWald, "Observations on Duccio's *Maestà,*" *Late Classical and Medieval Studies in Honor of Albert Mathais Friend, Jr.,* Princeton, N.J., 1955, pp. 362–386; F. Cooper, "A Reconstruction of Duccio's *Maestà,*" *Art Bulletin,* XLVII, 1965, pp. 155–171; J. White, "Measurement, Design and Carpentry in Duccio's *Maestà,*" *Art Bulletin,* LV, 1973, pp. 334–366, 547–569; and J. Stubblebine, "Duccio and His Collaborators on the Cathedral Maestà," *Art Bulletin,* LV, 1973, pp. 185–204.

10. For these and almost all other Tuscan saints, see G. Kaftal, *The Iconography of the Saints in Tuscan Painting,* Florence, 1952.

11. On this question, see Larner, pp. 65–118; M. Becker, *Florence in Transition,* 2 vols., Baltimore, 1967 and 1968, *passim;* and J. Hyde, *Society and Politics in Medieval Italy,* New York, 1973.

12. On the influence of Giotto's style, see B. Cole, *Giotto and Florentine Painting 1280–1375,* New York, 1976, pp. 121–145.

13. For the *Ognissanti Madonna,* see *ibid.,* pp. 57–62.

14. The *Last Supper* in the Cathedral Museum, Siena, and the *Raising of Lazarus* in the Kimbell Museum, Fort Worth, seem to reveal the designs of assistants in some of the figures.

15. On the Master of Badia a Isola, see Brandi, pp. 142–143, and B. Berenson, *Italian Pictures of the Renaissance: Central Italian and North Italian Schools,* London, 1968, pp. 118–120. For another early follower of Duccio, see B.

Cole, "A Madonna Panel from the Circle of the Early Duccio," *Allen Memorial Art Bulletin,* XXV, 1968, pp. 115–122.

16. On Segna, see Brandi, pp. 150–152; Berenson, pp. 392–394; E. Carli, "Nuovi studi nell'orbita di Duccio di Buoninsegna," *Antichità viva,* XI, 1972, pp. 3–15; and J. Stubblebine, "The Role of Segna di Buonaventura in the Shop of Duccio," *Pantheon,* XXX, 1972, pp. 272–282.

17. On Ugolino, see Brandi, pp. 152–157; G. Coor-Achenbach, "Contributions to the Study of Ugolino di Nerio's Art," *Art Bulletin,* XXXVII, 1955, pp. 153–165; M. Davies, *The Earlier Italian Schools* (National Gallery Catalogues), London, 1961, pp. 533–542; and Berenson, pp. 437–439.

18. For the Santa Croce altarpiece, see H. Loyrette, "Une source pour la reconstruction du polyptyque d'Ugolino da Siena à Santa Croce," *Paragone,* XXIX, 1978, pp. 15–23.

III: SIMONE MARTINI

1. On Simone, see G. Paccagnini, *Simone Martini,* London, 1957; G. Paccagnini, "Simone Martini," *Encyclopedia of World Art,* 1964, vol. 9, pp. 502–508; F. Bologna, *Gli affreschi di Simone Martini ad Assisi,* Milan, 1965; C. Volpe, *Simone Martini e la pittura senese da Duccio ai Lorenzetti,* Milan, 1965; and G. Contini and M. Gozzoli, *L'opera completa di Simone Martini,* Milan, 1970.

2. For a survey of the documentation on Simone, see Contini and Gozzoli, pp. 83–84, and P. Bacci, *Fonti e commenti per la storia dell'arte senese,* Siena, 1944, pp. 113–191.

3. On artistic clans in Siena, see J. Larner, *Culture and Society in Italy 1290–1420,* New York, 1971, pp. 287–297.

4. For the papacy in Avignon, see G. Mollat, *The Popes at Avignon, 1305–1378,* New York, 1963.

5. On the Palazzo Pubblico, see E. Carli and

A. Cairola, *Il Palazzo Pubblico di Siena,* Rome, 1963.

6. For the history of the church, see *Arciconfraternita di Misericordia: San Casciano Val di Pesa,* San Casciano, n.d.

7. On the Santa Maria Novella cross, see B. Cole, *Giotto and Florentine Painting 1280–1375,* New York, 1976, pp. 40–46.

8. On the question of archaism in the altarpiece, see B. Cole, "Old in New in the Early Trecento," *Klara Steinweg in Memoriam, Mitteilungen des Kunsthistorischen Institutes in Florenz,* XVII, 1973, pp. 229–248.

9. On art made for the Angevins in Naples, see F. Bologna, *I pittori alla corte Angioina di Napoli 1266–1414,* Rome, 1969. See also the same author's "Povertà e umiltà. Il 'S. Ludovico' di Simone Martini," *Studi storici,* X, 1969, pp. 231–259.

10. On the legend of St. Louis of Toulouse, see G. Kaftal, *The Iconography of the Saints in Tuscan Painting,* Florence, 1952, pp. 633–638.

11. On the frame types of Trecento altarpieces, see M. Cämmerer-George, *Die Rahmung der toskanischen Altarbilder im Trecento,* Strasbourg, 1966.

12. For the discussion on the dating of the fresco, see U. Feldges-Henning, "Zu Thema und Datierung von Simone Martinis Fresko 'Guido Riccio da Fogliano,' " *Klara Steinweg in Memoriam, Mitteilungen des Kunsthistorischen Institutes in Florenz,* XVII, 1973, pp. 273–276. The suggestion by G. Moran in "An Investigation Regarding the Equestrian Portrait of Guidoriccio da Fogliano in the Siena Palazzo Pubblico," *Paragone,* XXVIII, 1977, pp. 81–88, that the work is not by Simone cannot be taken seriously.

13. See the copy dated 1409 by Taddeo di Bartolo (Pinacoteca, Siena) discussed in Chapter VI.

14. For a document of 1420 which mentions

a new frame, see Bacci, pp. 163–164.

15. For several color illustrations of Simone's Assisi frescoes, see F. Bologna, *Gli affreschi.*

16. For the story of St. Martin, see Kaftal, pp. 707–714.

17. On the identification of the patron, see Bologna, pp. 6–7.

18. For the sinopia, see C. Brandi, "Una sinopia di Simone Martini," *Arte antica e moderna,* IV, 1961, pp. 17–20.

19. For the frescoes of the legend of St. Francis, see A. Martindale and E. Baccheschi, *The Complete Paintings of Giotto,* New York, 1966, pp. 90–94, and Cole, *Giotto,* pp. 146–160.

20. For instance, in the *Raising of Lazarus* in the Arena Chapel, Padua. See Cole, *Giotto,* plate 28.

21. Compare, for example, the single privileged friar who witnesses the assumption of St. Francis in the Bardi Chapel, Santa Croce, Florence. See Cole, *Giotto,* plate 39.

22. For a survey of art in Trecento Avignon, see E. Castelnuovo, "Avignone rievocata," *Paragone,* X, 1959, pp. 28–51, and E. Castelnuovo, *Un pittore italiano alla corte di Avignone,* Turin, 1962.

23. For a survey of the various sinopie, see F. Enaud, "Les fresques de Simone Martini à Avignon," *Les monuments historiques de la France,* IX, 1963, pp. 114–181.

24. On Simone's Virgil frontispiece, see J. Rowlands, "Simone Martini and Petrarch: A Virgilian Episode," *Apollo,* LXXXI, 1965, pp. 264–269; B. Degenhart, "Das Marienwunder von Avignon: Simone Martinis Miniaturen für Kardinal Stefaneschi und Petrarca," *Pantheon,* XXXIII, 1975, pp. 191–203; and J. Brink, "Francesco Petrarca and the Problem of Chronology in the Late Paintings of Simone Martini," *Paragone,* XXVIII, 1977, pp. 3–9.

25. For a survey of these panels and their attri-

butions, see Contini and Gozzoli, pp. 99–100. See also H. W. Van Os and M. Rankleff-Reinders, "De reconstructie van Simone Martinis zgn. Polyptiek van de Passie," *Festschrift H. K. Gerson,* Bussum, 1972, pp. 13–26, and J. Brink, "Simone Martini's 'Orsini Polyptych,' " *Jaarboek van het Koninklijk Museum voor Schone Kunsten Antwerpen,* 1976, pp. 7–23.

26. On Lippo, see R. Van Marle, *The Italian Schools of Painting,* The Hague, 1924, vol. 2, pp. 251–274; L. Coletti, *I primitivi: I senesi e i giotteschi,* Novara, 1946, pp. xxix–xxx; E. Carli, "Ancora dei Memmi a San Gimignano," *Paragone,* XIV, 1963, pp. 27–44; B. Berenson, *Italian Pictures of the Renaissance: Central Italian and North Italian Schools,* London, 1968, vol. 1, pp. 269–270; and A. Caleca, "Tre polittici di Lippo Memmi, un'ipotesi sul Barna e la Bottega di Simone e di Lippo," *Critica d'arte,* XLI, 1976, pp. 49–59; XLII, pp. 55–86.

27. On the Master of the Palazzo Venezia Madonna, see C. Volpe, "Precisazioni sul 'Barna' e sul 'Maestro di Palazzo Venezia,' " *Arte antica e moderna,* X, 1960, pp. 149–158, and Berenson, pp. 404–405.

IV: PIETRO LORENZETTI

1. For Pietro Lorenzetti, see E. Cecchi, *Pietro Lorenzetti,* Milan, 1930; E. DeWald, *Pietro Lorenzetti,* Cambridge, 1930; G. Sinibaldi, *I Lorenzetti,* Siena, 1933; E. Carli, *Pietro Lorenzetti,* Milan, 1956; and E. Carli, *Pietro e Ambrogio Lorenzetti,* Milan, 1971.

2. For a survey of documentation on Pietro, see DeWald, pp. 5–6.

3. See note 14.

4. On Tino, see W. R. Valentiner, *Tino di Camaino,* Paris, 1935; E. Carli, *Tino di Camaino scultore,* Florence, 1934; and J. Pope-Hennessy, *Italian Gothic Sculpture,* London, 1972, pp. 183–186.

5. For the reconstruction of this altarpiece, see

F. Zeri, "Pietro Lorenzetti: Quattro panelli dalla pala del 1329 al Carmine," *Arte illustrata,* LVIII, 1974, pp. 146–156, and H. Maginnis, "Pietro Lorenzetti's Carmelite Madonna: A Reconstruction," *Pantheon,* XXXIII, 1975, pp. 10–16. For the documents on the Carmelite altarpiece, see P. Bacci, *Dipinti inedite e sconosciuti di Pietro Lorenzetti, Bernardo Daddi etc. in Siena e nel contado,* Siena, 1939, pp. 83–86, 88–89.

6. On the cross and its development, see E. Sandberg-Vavalà, *La croce dipinta italiana e l'iconografia della Passione,* Verona, 1929.

7. For an illustration of Giotto's *Crucifixion,* see A. Martindale and E. Baccheschi, *The Complete Paintings of Giotto,* New York, 1966, plate XXXII.

8. For the Assisi frescoes, see DeWald, pp. 22–26; C. Volpe, *Pietro Lorenzetti ad Assisi,* Milan, 1965; H. Maginnis, "Assisi Revisited: Notes on Recent Observations," *Burlington Magazine,* CXVII, 1975, pp. 511–517; and H. Maginnis, "The Passion Cycle in the Lower Church of San Francesco, Assisi. The Technical Evidence," *Zeitschrift für Kunstgeschichte,* XXXIX, 1976, pp. 193–208.

9. For discussion of the plague and art, see M. Meiss, *Painting in Florence and Siena after the Black Death,* New York, 1964, *passim,* and B. Cole, *Giotto and Florentine Painting 1280–1375,* New York, 1976, pp. 131–139.

10. For this panel, see J. Stubblebine, *Guido da Siena,* Princeton, N.J., 1964, pp. 52–53.

11. For Duccio's *Deposition,* see G. Cattaneo and E. Baccheschi, *L'opera completa di Duccio,* Milan, 1972, plate LVB.

12. For a discussion of the date and physical history of the panel, see L. Marcucci, *Gallerie Nazionali di Firenze. I dipinti toscani del secolo XIV,* Rome, 1965, pp. 157–159.

13. For the documents on this altarpiece, see Bacci, pp. 90–92. On the original appearance of

the work, see M. Davies, *The Earlier Italian Schools* (National Gallery Catalogues), London, 1961, pp. 300–301.

14. For this document, see Bacci, pp. 90–91. On San Sabinus, see G. Kaftal, *The Iconography of the Saints in Tuscan Painting*, Florence, 1952, pp. 913–914.

15. See Davies, pp. 300–301.

16. For Arnolfo's Duomo *Madonna* and the rest of his sculpture, see V. Mariani, *Arnolfo e il gotico italiano*, Naples, 1967; A. Romanini, *Arnolfo di Cambio e lo 'stil nuovo' del gotico*, Milan, 1969; and Pope-Hennessy, pp. 180–183.

17. For the very close followers of Pietro, see B. Berenson, *Italian Pictures of the Renaissance: Central Italian and North Italian Schools*, London, 1968, vol. 2, pp. 221–222.

18. On Niccolò di Segna, see G. Coor, "A Painting of St. Lucy in the Walters Art Gallery and Some Closely Related Representations," *Journal of the Walters Art Gallery*, XVIII, 1955, pp. 78–90; Berenson, vol. 2, pp. 299–300; and H. W. Van Os, *Sienese Paintings in Holland*, Leiden, 1969.

19. On the Ovile Master, formerly called Ugolino Lorenzetti, see B. Berenson, *Essays in the Study of Sienese Painting*, New York, 1918, pp. 1–36; M. Meiss, "Bartolommeo Bulgarini altrimenti detto 'Ugolino Lorenzetti?,'" *Rivista d'arte*, XVIII, 1936, pp. 113–136; and Berenson, *Italian Pictures*, vol. 2, pp. 435–436.

V: AMBROGIO LORENZETTI

1. On Ambrogio Lorenzetti, see E. von Meyenburg, *Ambrogio Lorenzetti*, Zurich, 1903; G. Sinibaldi, *I Lorenzetti*, Siena, 1933; G. Rowley, *Ambrogio Lorenzetti*, 2 vols., Princeton, N.J., 1958; L. Becherucci, "Ambrogio and Pietro Lorenzetti," *Encyclopedia of World Art*, 1964, vol. 9, pp. 324–337; and E. Borsook, *Ambrogio Lorenzetti*, Florence, 1966.

2. On the early Trecento membership of the Arte dei Medici e Speziali, see I. Hueck, "Le matricole dei pittori fiorentini prima e dopo il 1320," *Bollettino d'arte*, LVII, 1972, pp. 114–121.

3. For a survey of the documents on Ambrogio, see Rowley, pp. 129–132.

4. For Ambrogio's will, see V. Wainwright, "The Will of Ambrogio Lorenzetti," *Burlington Magazine*, CXVII, 1975, pp. 543–544.

5. On the question of archaism, see B. Cole, "Old in New in the Early Trecento," *Klara Steinweg in Memoriam, Mitteilungen des Kunsthistorischen Institutes in Florenz*, XVII, 1973, pp. 229–248.

6. On the cherry, sometimes called Fruit of Paradise, see J. Hall, *A Dictionary of Subjects and Symbols in Art*, New York, 1974, p. 13.

7. For a pictorial survey of the Duomo facade figures, see M. Ayrton, *Giovanni Pisano Sculptor*, New York, 1969, plates 93–110.

8. For Nino's statue, see J. Pope-Hennessy, *Italian Gothic Sculpture*, London, 1972, p. 194, fig. 40.

9. For the history and documentation of these panels, see L. Marcucci, *Gallerie Nazionali di Firenze. I dipinti toscani del secolo XIV*, Rome, 1965, pp. 161–163.

10. For the possible influence of Ambrogio and Duccio on Giotto, see B. Cole, *Giotto and Florentine Painting 1280–1375*, New York, 1976, pp. 116–118.

11. For Gentile's panel, see E. Micheletti, *L'opera completa di Gentile da Fabriano*, Milan, 1976, plate LXI. An illustration of Angelico's picture is found in B. Berenson, *Italian Pictures of the Renaissance: Florentine School*, London, 1963, vol. 2, plate 607.

12. On the frescoes of the Sala della Pace, see N. Rubinstein, "Political Ideas in Sienese Art: The Frescoes by Ambrogio Lorenzetti and Taddeo di Bartolo in the Palazzo Pubblico," *Journal of the Warburg and Courtauld Institutes*,

XXI, 1958, pp. 179–207; E. Borsook, *The Mural Painters of Tuscany*, London, 1960, pp. 135–137; and A. Gonzalez-Palacios, *Ambrogio Lorenzetti. La Sala della Pace*, Milan, 1969.

13. For photographs of the Sienese countryside, see T. Burckhardt, *Siena: The City of the Virgin*, London, 1960, and C. Cresti, ed., *I centri storici della Toscana*, Milan, 1977, vol. 1, pp. 177–218.

14. On these frescoes, see M. Davies, *The Earlier Italian Schools* (National Gallery Catalogues), London, 1961, pp. 298–299, and M. Seidel, "Wiedergefundene Fragmente eines Hauptwerks von Ambrogio Lorenzetti," *Pantheon*, XXXVI, 1978, pp. 119–127.

15. See, for example, Borsook, p. 135. For a photograph of Giotto's fresco, see Cole, *Giotto*, plate 38.

16. This triptych may originally have been a polyptych. Two full-length saints and an *Entombment of Christ* hang with it in the Siena Pinacoteca. While the saints, although of a quality not worthy of Ambrogio, might have belonged to the altarpiece, the *Entombment* is both too crude and too large to have formed part of it. For illustrations of these panels, see P. Torriti, *La Pinacoteca Nazionale di Siena*, Genoa, 1977, pp. 110–112.

17. For a detailed study of the history of this painting, see M. Seidel, "Die Fresken des Ambrogio Lorenzetti in S. Agostino," *Mitteilungen des Kunsthistorischen Institutes in Florenz*, XXII, 1978, pp. 185–252.

18. For illustrations of all of the frescoes in the chapel at Montesiepi and their iconography, see E. Borsook, *Gli affreschi di Montesiepi*, Florence, 1968.

19. For a discussion of the iconography of this picture, see M. Meiss's article in *The Great Age of Fresco*, New York, 1968, pp. 64–70.

20. Only in a ruined *Annunciation* from Giotto's shop (Badia, Florence) in which the Virgin runs from the angel does the same spirit appear. For this fresco, see U. Procacci in *Omaggio a Giotto* (ed. P. dal Poggetto), Florence, 1967, pp. 12–14.

21. For this discussion, see N. Muller, "Ambrogio Lorenzetti's Annunciation: A Re-examination," *Mitteilungen des Kunsthistorischen Institutes in Florenz*, XXI, 1977, pp. 1–12.

22. For the documentation on this panel, see Marcucci, pp. 164–165.

VI: PAINTING AFTER MID-CENTURY

1. On Barna, see J. Pope-Hennessy, "Barna, the pseudo-Barna and Giovanni d'Asciano," *Burlington Magazine*, LXXXVIII, 1946, pp. 34–37; S. Delogu Ventroni, *Barna da Siena*, Pisa, 1972; and O. Nygren, *Barna da Siena*, Helsingfors, 1963.

2. On the dating, see Pope-Hennessy, "Barna."

3. For a discussion of Barna and the plague, see M. Meiss, *Painting in Florence and Siena after the Black Death*, New York, 1964, pp. 53–58. See also E. Borsook, *The Mural Painters of Tuscany*, London, 1960, pp. 138–140, and B. Cole, *Giotto and Florentine Painting 1280–1375*, New York, 1976, pp. 131–140.

4. On Niccolò di Ser Sozzo, see C. Brandi, "Niccolò di Ser Sozzo Tegliacci," *L'Arte*, III, 1932, pp. 223–236; M. Meiss, "Notes on Three Linked Sienese Styles," *Art Bulletin*, XLV, 1963, pp. 47–48; F. Zeri, "Sul problema di Niccolò Tegliacci e Luca di Tommè," *Paragone*, IX, 1958, pp. 3–16; S. Fehm, *The Collaboration of Niccolò Tegliacci and Luca di Tommè*," Los Angeles, 1973; and B. Berenson, *Italian Pictures of the Renaissance: Central Italian and North Italian Schools*, London, 1968, vol. 1, pp. 425–426.

5. For this collaboration, see Fehm and Zeri.

6. On Luca di Tommè, see Meiss, "Sienese," and Fehm. See also Berenson, vol. 1, pp. 224–226; R. Van Marle, *The Development of the*

Italian School of Painting, The Hague, 1924, vol. 2, pp. 465–483; and F. M. Perkins, "Luca di Tommè," in Thieme-Becker's *Allegemeines Lexikon der bildenden Künstler,* 1929, vol. 23, pp. 427–428.

7. On Paolo di Giovanni Fei, see Berenson, pp. 127–130, and M. Mallory, *The Sienese Painter Paolo di Giovanni Fei,* New York, 1976.

8. On Bartolo di Fredi, see Van Marle, pp. 483–508; P. Schubring, "Bartolo di Fredi," in Thieme-Becker's *Allegemeines Lexikon der bildenden Künstler,* 1908, vol. 2, pp. 558–560; E. Carli, "La data degli affreschi di Bartolo di Fredi a San Gimignano," *Critica d'arte,* VIII, 1949, pp. 75–76; Berenson, vol. 1, pp. 29–31; and E. Carli, *Bartolo di Fredi a Paganico,* Florence, 1968.

9. On Taddeo di Bartolo, see Van Marle, pp. 544–569; F. M. Perkins, "Taddeo di Bartolo," in Thieme-Becker's *Allegemeines Lexikon der bildenden Künstler,* 1938, vol. 32, pp. 395–397; N. Rubenstein, "Political Ideas in Sienese Art: The Frescoes by Ambrogio Lorenzetti and Taddeo di Bartolo in the Palazzo Pubblico," *Journal of the Warburg and Courtauld Institutes,* XXI, 1958, pp. 179–207; S. Symeonides, *Taddeo di Bartolo,* Siena, 1965; Berenson, vol. 1, pp. 418–423; and B. Cole, "Il Cristo in Pieta, un Taddeo di Bartolo trascurato," *Commentari,* XXV, 1974, pp. 279–280.

10. The best history of Sienese Quattrocento painting is J. Pope-Hennessy, *Sienese Quattrocento Painting,* Oxford, 1947. See also C. Brandi, *Quattrocentisti senesi,* Milan, 1949, and B. Berenson, *Italian Painters of the Renaissance,* London, 1952, pp. 102–108.

11. For Giovanni di Paolo, see J. Pope-Hennessy, *Giovanni di Paolo,* London, 1937; C. Brandi, *Giovanni di Paolo,* Florence, 1947; J. Pope-Hennessy, *A Sienese Codex of the Divine Comedy,* London, 1947; and J. Pope-Hennessy, "Giovanni di Paolo," in *Encyclopedia of World Art,* 1962, vol. 6, 358.

12. On Sassetta, see B. Berenson, *A Sienese Painter of the Franciscan Legend,* London, 1909; J. Pope-Hennessy, *Sassetta,* London, 1939; J. Pope-Hennessy, "Rethinking Sassetta," *Burlington Magazine,* XCVIII, 1956, pp. 364–370; and E. Carli, *Sassetta e il Maestro dell'Osservanza,* Milan, 1957.

13. For Sano di Pietro, see E. Gaillard, *Sano di Pietro,* Chambéry, 1923; J. Truebner, *Die stilistische Entwicklung der Tafelbilder des Sano di Pietro,* Strasbourg, 1925; C. Brandi, *La Regia Pinacoteca di Siena,* Rome, 1933, pp. 246–274; and C. Brandi, *Quattrocentisti,* pp. 75–87.

14. On Florentine painting of the early Renaissance, see B. Cole, *Masaccio and the Art of Early Renaissance Florence,* Bloomington, Ind., 1980.

15. For the Beato Colombini, see G. Kaftal, *The Iconography of the Saints in Tuscan Painting,* Florence, 1952, pp. 581–582, and Meiss, *Black Death,* pp. 86–88.

CONCLUSION

1. On Giotto's followers, see O. Sirén, *Giotto and Some of His Followers,* 2 vols., Cambridge, 1917, and B. Cole, *Giotto and Florentine Painting 1280–1375,* New York, 1976, pp. 121–145.

2. On the Bardi and Peruzzi chapels, see Cole, *Giotto,* pp. 96–120.

3. For Sienese art and the Sienese style outside Siena, see E. Carli, *Dipinti senesi del contado e della Maremma,* Milan, 1955.

4. For Ugolino's altarpiece, see Chapter II, note 18.

5. Vasari's statement is found in his *Le vite de' più eccellenti pittori, scultori ed architettori* (ed. G. Milanesi), Florence, 1878, vol. 1, p. 454.

6. For Neapolitan Trecento painting, see O. Morisani, *Pittura del Trecento in Napoli,* Naples, 1947, and F. Bologna, *I pittori alla corte Angioina di Napoli 1266–1414,* Rome, 1969.

7. Simone may have introduced the Madonna of Humility image to Naples. See M. Meiss,

Painting in Florence and Siena after the Black Death, New York, 1964, pp. 132–156, and H. W. Van Os, *Marias Demut und Veherrlichung in der sienesischen Malerei 1300–1450,* 's-Gravenhage 1969, pp. 75–142.

8. On San Francesco, Assisi, see B. Kleinschmidt, *Die Basilika San Francesco in Assisi,* 3 vols., Berlin, 1915–28, and E. Zocca, *Assisi: Catalago delle cose d'arte e di antichità d'Italia,* Rome, 1936, pp. 9–169.

9. On Riminese painting, see C. Volpe, *La pittura riminese del trecento,* Milan, 1965.

10. On these artists see Volpe, pp. 45–48 (Master of Tolentino), pp. 38–39 (Master of St. John the Baptist), and pp. 23–29 (Pietro da Rimini).

11. For this series of pictures, see F. Shapley, *Paintings from the Samuel H. Kress Collection,* London, 1966, vol. 1, pp. 68–69.

12. For Avignon in the Trecento, see E. Castelnuovo, *Un pittore italiano alla corte di Avignone. Matteo Giovannetti e la pittura in Provenza nel secolo XIV,* Turin, 1962.

13. For Matteo Giovannetti, see note 12.

14. For the Palace of the Popes, see L. H. Labande, *Le Palais des Papes et les monuments d'Avignon au XIVe siècle,* 2 vols, Marseille, 1925.

15. On the possible influence of Matteo's landscapes on palace decoration, see B. Cole, "The Interior Decoration of the Palazzo Datini in Prato," *Mitteilungen des Kunsthistorischen Institutes in Florenz,* XIII, 1967, pp. 70–71.

16. For a dicussion of the Italian influence on early French art, see M. Meiss, *French Painting in the Time of Jean Berry,* London, 1967, pp. 23–29.

SELECTED BIBLIOGRAPHY

GENERAL

P. Bacci, *Alcuni documenti nuziali di artisti senesi del XIV e XV secolo*, Siena, 1934.

——, *Documenti e commenti per la storia dell'arte*, Florence, 1944.

——, *Fonti e commenti per la storia dell'arte senese*, Siena, 1944.

B. Berenson, *Essays in the Study of Sienese Painting*, New York, 1918.

——, *The Italian Painters of the Renaissance*, New York, 1959.

——, *Italian Pictures of the Renaissance: Central Italian and North Italian Schools*, 3 vols., London, 1968.

F. Bologna, *Early Italian Painting*, Leipzig, 1964.

S. Borghesi and L. Banchi, *Nuovi documenti per la storia dell'arte senese*, Siena, 1898.

E. Borsook, *The Mural Painters of Tuscany*, London, 1960.

C. Brandi, *La Regia Pinacoteca di Siena*, Rome, 1933.

——, *Quattrocentisti senesi*, Milan, 1949.

F. Brogi, *Inventario generale degli oggetti d'arte della Provincia di Siena*, Siena, 1897.

Burlington Fine Arts Club, *Catalogue of Pictures of Siena*, London, 1904.

A. Cairola and E. Carli, *Il Palazzo Pubblico di Siena*, Rome, 1963.

M. Cämmerer-George, *Die Rahmung der toskanischen Altarbilder im Trecento*, Strasbourg, 1966.

E. Carli, *La tavolette di Biccherna*, Florence, 1950.

——, *Dipinti senesi del contado e della Maremma*, Milan, 1955.

——, *I primitivi senesi*, Milan, 1956.

——, *Sienese Painting*, Greenwich, 1956.

——, *La pittura senese*, Milan, 1955.

——, *Musei senesi*, Novara, 1961.

E. Cecchi, *I Trecentisti senesi*, Milan, 1948.

C. Cennini, *The Craftsman's Handbook: Il libro dell'arte* (trans. D. Thompson, Jr.), New Haven, Conn., 1933.

B. Cole, *Giotto and Florentine Painting 1280–1375*, New York, 1976.

L. Coletti, *I primitivi: I senesi e i giotteschi*, Novara, 1946.

J. Crowe and G. B. Cavalcaselle, *A New History of Painting in Italy*, 3 vols., London, 1864 (later German and Italian edns.).

M. Davies, *The Earlier Italian Schools* (National Gallery Catalogues), London, 1961.

G. Edgell, *A History of Sienese Painting*, New York, 1932.

E. Garrison, *Italian Romanesque Panel Painting: An Illustrated Index*, Florence, 1949.

L. Gielly, *Les primitifs siennois*, Paris, 1926.

F. Hartt, *History of Italian Renaissance Art*, New York, n.d.

W. Heywood and L. Olcott, *Guide to Siena*, Siena, 1924.

J. Hyde, *Society and Politics in Medieval Italy*, New York, 1973.

D. Jacobsen, *Die sienesische Meister des Trecento in der Gemäldegalerie zu Siena*, Strasbourg, 1907.

G. Kaftal, *The Iconography of the Saints in Tuscan Painting*, Florence, 1952.

B. Kleinschmidt, *Die Basilika S. Francesco in Assisi*, 3 vols., Berlin, 1915–28.

R. Langton Douglas, *A History of Siena*, London, 1902.

J. Larner, *Culture and Society in Italy, 1290–1420*, New York, 1971.

V. Lusini, *Il Duomo di Siena*, Siena, 1911.

H. Maginnis, "The Literature of Sienese Trecento Painting 1945–1975," *Zeitschhift für Kunsgeschichte*, XL, 1977, pp. 276–309.

L. Marcucci, *Gallerie nazionali di Firenze. I dipinti toscani del secolo XIV*, Rome, 1965.

R. Van Marle, *The Development of the Italian Schools of Painting*, 19 vols., The Hague, 1923–38.

M. Meiss, *Painting in Florence and Siena after the Black Death*, New York, 1964.

G. Milanesi, *Documenti per la storia dell'arte senese*, 3 vols., Siena, 1854–56.

V. Morandi and A. Cairola, *Lo spedale di Santa Maria della Scala*, Siena, 1975.

R. Oertel, *Early Italian Painting to 1400*, New York, 1968.

H. Van Os, *Marias Demut und Verherrlichung in der sienischen Malerei, 1300–1450*, 's-Gravenhage 1969.

————, *Sienese Paintings in Holland*, Leiden, 1969.

J. Pope-Hennessy, *Sienese Quattrocento Painting*, London, 1947.

————, *Italian Gothic Sculpture*, London, 1972.

W. Rothes, *Die Blütezeit der sienesischen Malerei*, Strasbourg, 1904.

E. Sandberg-Vavalà, *Sienese Studies*, Florence, 1953.

F. Schevill, *Siena: The History of a Mediaeval Commune*, New York, 1964.

D. Shorr, *The Christ Child in Devotional Images During the XIV Century*, New York, 1954.

G. Sinibaldi and G. Brunetti, *Pittura italiana del Duecento e Trecento (Catalogo della Mostra Giottesca di Firenze del 1937)*, Florence, 1943.

O. Sirén, *Toskanische Maler im XIII. Jahrhundert*, Berlin, 1922.

E. Southard, *The Frescoes in Siena's Palazzo Pubblico 1289–1539: Studies in Imagery and Relations to Other Communal Palaces in Tuscany*, New York, 1979.

H. Thode, *Franz von Assisi und die Anfänge der Kunst der Renaissance in Italien*, Vienna, 1934.

P. Toesca, *Il trecento*, Turin, 1951.

P. Torriti, *La Pinacoteca Nazionale di Siena. I dipinti dal XII al XV secolo*, Genoa, 1977.

G. Della Valle, *Lettere sanesi*, 3 vols., Venice-Rome, 1782–1786.

C. Volpe, *Simone Martini e la pittura senese da Duccio ai Lorenzetti*, Milan, 1965.

D. Waley, *The Italian City-Republics*, New York, 1969.

C. Weigelt, *Sienese Painting of the Trecento*, New York, 1930.

J. White, *Art and Architecture in Italy 1250–1400*, Baltimore, 1966.

AMBROGIO LORENZETTI

E. Borsook, *Ambrogio Lorenzetti*, Florence, 1966.

————, *Gli affreschi di Montesiepi*, Florence, 1968.

E. Carli, *Ambrogio Lorenzetti*, Ivrea, 1954.

————, *I Lorenzetti*, Milan, 1960.

————, *Pietro e Ambrogio Lorenzetti*, Milan, 1971.

U. Feldges-Henning, "The Pictorial Programme of the Sala della Pace: A New Interpretation," *Journal of the Warburg and Courtauld Institutes*, XXXV, 1972, pp. 145–162.

A. Gonzalez-Palacios, *Ambrogio Lorenzetti. La Sala della Pace*, Milan, 1969.

E. von Meyenburg, *Ambrogio Lorenzetti*, Zurich, 1903.

R. Offner, "Reflections on Ambrogio Lorenzetti," *Gazette des Beaux Arts*, LVI, 1960, pp. 235–238.

G. Rowley, *Ambrogio Lorenzetti*, 2 vols., Princeton, N.J., 1958.

N. Rubenstein, "Political Ideas in Sienese Art: The Frescoes by Ambrogio Lorenzetti and Taddeo di Bartolo in the Palazzo Pubblico," *Journal of the Warburg and Courtauld Institutes*, XXI, 1958, pp. 179–207.

G. Sinibaldi, *I Lorenzetti*, Siena, 1933.

V. Wainwright, "The Will of Ambrogio Lorenzetti," *Burlington Magazine*, CXVII, 1975, pp. 543–544.

BARNA DA SIENA

A. Caleca, "Tre polittici di Lippo Memmi, un'ipotesi sul Barna e la bottega di Simone e Lippo," *Critica d'arte*, XXII, 1976, pp. 49–59; XXIII, 1977, pp. 55–80.

S. Delogu Ventroni, *Barna da Siena*, Pisa, 1972.

A. Dayez, "Barna et les fresques du 'Nouveau Testament' de la Collegiata de San Gimignano," *L'information d'histoire de l'art*, XV, 1970, pp. 81–87.

G. Moran, "Is the Name 'Barna' an Incorrect Transcription of the Name Bartolo?", *Paragone*, XXVII, 1976, pp. 76–80.

O. Nygren, *Barna da Siena*, Helsingfors, 1963.

J. Pope-Hennessy, "Barna, the pseudo-Barna and Giovanni d'Asciano," *Burlington Magazine*, LXXXVIII, 1946, pp. 34–37.

C. Volpe, "Precisazioni sul 'Barna' e sul 'Maestro di Palazzo Venezia,'" *Arte antica e moderna*, X, 1960, pp. 149–158.

BARTOLO DI FREDI

E. Carli, *Bartolo di Fredi a Paganico*, Florence, 1968.

————, "La data degli affreschi di Bartolo di Fredi a San Gimignano," *Critica d'arte*, VIII, 1949, pp. 75–76.

G. Moran, "Bartolo di Fredi e l'altare dell'Arte dei Fornai del 1368: Nuova interpretazione di un documento," *Prospettiva*, IV, 1976, pp. 30–31.

F. Zeri, "Un appunto su Bartolo di Fredi," *Paragone*, XIII, 1962, pp. 55–57.

CIMABUE

E. Battisti, *Cimabue*, University Park, Pa. 1967.

B. Cole, *Giotto and Florentine Painting 1280–1375*, New York, 1976, pp. 26–32.

COPPO DI MARCOVALDO

G. Coor "Coppo di Marcovaldo, His Art in Relation to the Art of His Time," *Marsyas*, V, 1949, pp. 1–21.

————, "A Visual Basis for the Documents Relating to Coppo di Marcovaldo and His Son Salerno," *Art Bulletin*, XXVIII, 1946, pp. 233–247.

E. Garrison, *Italian Romanesque Panel Painting: An Illustrated Index*, Florence, 1949, pp. 15–16.

DUCCIO

C. Brandi, *Duccio*, Florence, 1951.

————, *Duccio di Buoninsegna: La Maestà*, Milan, 1954.

E. Carli, *Duccio di Buoninsegna*, Milan, 1952.

G. Cattaneo and E. Baccheschi, *L'opera completa di Duccio*, Milan, 1972.

J. Stubblebine, "Byzantine Sources for the Iconography of Duccio's *Maestà*," *Art Bulletin*, LVII, 1975, pp. 176–185.

————, "Duccio and His Collaborators on the Cathedral *Maestà*," *Art Bulletin*, LV, 1973, pp. 185–204.

C. Weigelt, *Duccio di Buoninsegna*, 2 vols, Leipzig, 1911.

J. White, "Measurement, Design and Carpentry in Duccio's *Maestà*," *Art Bulletin*, LV, 1973, pp. 334–336, 547–569.

GIOVANNI DI PAOLO

C. Brandi, *Giovanni di Paolo,* Florence, 1947.
J. Pope-Hennessy, *A Sienese Codex of the Divine Comedy,* London, 1947.
——, *Giovanni di Paolo,* London, 1937.
——, "Giovanni di Paolo," in *Encyclopedia of World Art,* 1962, vol. 6, p. 358.

GIOVANNI PISANO

M. Ayrton, *Giovanni Pisano Sculptor,* New York, 1969.
H. Keller, *Giovanni Pisano,* Vienna, 1942.
J. Pope-Hennessy, *Italian Gothic Sculpture,* London, 1972, pp. 175–176.

GUIDO DA SIENA

C. Brandi, "Relazione sul restauro della Madonna di Guido da Siena del 1221," *Bollettino d'arte,* XXXVI, 1951, pp. 248–260.
Offner, R. "Guido da Siena and A.D. 1221," *Gazette des Beaux Arts,* XXXVII, 1950, pp. 61–90.
E. Sandberg-Vavalà, "The Madonnas of Guido da Siena," *Burlington Magazine,* LXIV, 1934, pp. 254–271.
J. Stubblebine, *Guido da Siena,* Princeton, N.J., 1964.

LIPPO MEMMI

A. Caleca, "Tre polittici di Lippo Memmi, un'ipotesi sul Barna e la bottega di Simone e Lippo," *Critica d'arte,* XXII, 1976, pp. 49–59; XXIII, 1977, pp. 55–80.
E. Carli, "Ancora dei Memmi a San Gimignano," *Paragone,* XIV, 1963, pp. 27–44.
M. Mallory, "An Altarpiece by Lippo Memmi Reconsidered," *Metropolitan Museum Journal,* IX, 1974, pp. 187–202.
L. Ozzola, "Lippo Memmo collaboratore del padre Memmo e di Simone Martini," *Rassegna d'arte,* XXI, 1921, pp. 117–121.
L. Vertova, "Lippo Vanni versus Lippo Memmi," *Burlington Magazine,* CXII, 1970, pp. 437–441.

LUCA DI TOMMÈ

S. Fehm, *The Collaboration of Niccolò Tegliacci and Luca di Tommè,* Los Angeles, 1973.
——, "A Reconstruction of an Altarpiece by Luca di Tommè," *Burlington Magazine,* CXV, 1973, pp. 463–464.
M. Meiss, "Notes on Three Linked Sienese Styles," *Art Bulletin,* XLV, 1963, pp. 47–48.
G. Moran and S. Fineschi, "Niccolò di Ser Sozzo-Tegliacci or di Stefano (Some Unpublished Documents Relating to the Problem of Luca di Tommè and Niccolò di Ser Sozzo)", *Paragone,* XXVII, 1976, pp. 58–63.
F. Zeri, "Sul problema di Niccolò Tegliacci e Luca di Tommè," *Paragone,* IX, 1958, pp. 4–16.

MASTER OF BADIA A ISOLA

G. Coor-Achenbach, "A Dispersed Polyptych by the Badia a Isola Master," *Art Bulletin,* XXXIV, 1952, pp. 311–316.
——, "The Early Nineteenth Century Aspect of a Dispersed Polyptych by the Badia a Isola Master," *Art Bulletin,* 1960, p. 143.
——, "The 'Missing' Panel from a Dispersed Polyptych by the Badia a Isola Master," *Art Bulletin,* XXXVIII, 1956, p. 119.

MASTER OF CITTÀ DI CASTELLO

G. Moran and C. Seymour, "Studies of Two Sienese Altarpieces: The Master of Città di Castello and Ambrogio Lorenzetti," *Yale University Art Gallery Bulletin,* XXXI, 1967, pp. 14–39.
L. Vertova, "Un frammento duccesco," *Arte illustrata,* XXII, 1969, pp. 38–47.

MASTER OF THE PALAZZO VENEZIA MADONNA

C. Volpe, "Precisazioni sul 'Barna' e sul 'Mae-

stro di Palazzo Venezia,'" *Arte antica e moderna*, X, 1960, pp. 149–158.

NICCOLÒ DI BUONACCORSO

K. Ames, "An *Annunciation* by Niccolò di Buonaccorso," *Wadsworth Atheneum Bulletin*, II, 1966, pp. 24–31.

B. Berenson, *Italian Pictures of the Renaissance: Central Italian and North Italian Schools*, London, 1968, vol. 2, 294.

B. Cole and A. Gealt, "A New Triptych by Niccolò di Buonaccorso," *Burlington Magazine*, CXI, 1977, pp. 184–187.

NICCOLÒ DI SEGNA

P. Bacci, "Identificazione e restauro della tavola del 1336 di Niccolò di Segna da Siena," *Bollettino d'arte*, XXIX, 1935, pp. 1–13.

G. Coor, "A Painting of St. Lucy in the Walters Art Gallery and Some Closely Related Representations," *Journal of the Walters Art Gallery*, XVIII, 1955, pp. 78–90.

C. De Benedictis, "I Corali di San Gimignano 2: Il secondo miniatore," *Paragone*, XXVII, 1976, pp. 87–95.

H. W. Van Os, "Possible Additions to the Work of Niccolò di Segna," *Bulletin of the Cleveland Museum of Art*, LIX, 1972, pp. 78–83.

NICCOLÒ DI SER SOZZO

C. Brandi, "Niccolò di Ser Sozzo Tegliacci, pittore e tavole," *Mitteilungen des Kunsthistorischen Institutes in Florenz*, IV, 1932, p. 140.

M. Bucci, "Proposte per Niccolò di Ser Sozzo Tegliacci," *Paragone*, XVI, 1965, pp. 51–60.

C. De Benedictis, "I corali di San Gimignano 1: Le miniature di Niccolò Tegliacci," *Paragone*, XXVII, 1976, pp. 103–120.

———, "Per un catalogo di Niccolò Tegliacci," *Paragone*, XXVII, 1976, pp. 74–76.

———, "Sull'attività giovanile di Niccolò Tegliacci," *Paragone*, XXV, 1974, pp. 51–61.

S. Fehm, *The Collaboration of Niccolò Tegliacci and Luca di Tommè*, Los Angeles, 1973.

M. Meiss, "Notes on Three Linked Sienese Styles," *Art Bulletin*, XLV, 1963, pp. 47–48.

G. Moran and S. Fineschi, "Niccolò di Ser Sozzo-Tegliacci or di Stefano (Some Unpublished Documents Relating to the Problem of Luca di Tommè and Niccolò di Ser Sozzo)", *Paragone*, XXVII, 1976, pp. 58–63.

F. Zeri, "Sul problema di Niccolò Tegliacci e Luca di Tommè," *Paragone*, CV, 1958, pp. 4–16.

OVILE MASTER

B. Berenson, *Essays in the Study of Sienese Painting*, New York, 1918, pp. 1–36.

E. DeWald, "The Master of the Ovile Madonna," *Art Studies*, I, 1933, pp. 45–54.

M. Meiss, "Ugolino Lorenzetti," *Art Bulletin*, XIII, 1931, pp. 376–397.

———, "Bartolommeo Bulgarini altrimenti detto 'Ugolino Lorenzetti,'" *Rivista d'arte*, XVIII, 1936, pp. 113–136.

PAOLO DI GIOVANNI FEI

M. Mallory, "An Early Quattrocento Trinity," *Art Bulletin*, XLVIII, 1966, pp. 85–89.

———, *The Sienese Painter Paolo di Giovanni Fei*, New York, 1976.

PIETRO LORENZETTI

C. Brandi, *Pietro Lorenzetti, Affreschi nella basilica inferiore di Assisi*, Rome, 1958.

E. Carli, *I Lorenzetti*, Milan, 1960.

———, *Pietro e Ambrogio Lorenzetti*, Milan, 1971.

———, *Pietro Lorenzetti*, Milan, 1956.

E. Cecchi, *Pietro Lorenzetti*, Milan, 1930.

E. DeWald, *Pietro Lorenzetti*, Cambridge, 1930.

H. Maginnis, "Assisi Revisited: Notes on Re-

cent Observations," *Burlington Magazine*, CXVII, 1975, pp. 511–517.

———, "The Passion Cycle in the Lower Church of San Francesco, Assisi. The Technical Evidence," *Zeitschrift für Kunstgeschichte*, XXXIX, 1976, pp. 193–208.

G. Sinibaldi, *I Lorenzetti*, Siena, 1933.

C. Volpe, *Pietro Lorenzetti ad Assisi*, Milan, 1965.

F. Zeri, "Pietro Lorenzetti: Quattro pannelli dalla pala del 1329 al Carmine," *Arte illustrata*, LVIII, 1974, pp. 146–156.

SANO DI PIETRO

C. Brandi, *Quattrocentisti senesi*, Milan, 1949, pp. 75–87.

———, *La Regia Pinacoteca di Siena*, Rome, 1933, pp. 246–274.

E. Gaillard, *Sano di Pietro*, Chambéry, 1923.

J. Truebner, *Die stilistische Entwicklung der Tafelbilder des Sano di Pietro*, Strasbourg, 1925.

SEGNA DI BONAVENTURA

P. Bacci, "Una pittura ignorata di Segna di Buonaventura," *Le arti*, II, 1939–40, pp. 12–16.

E. Carli, "Nuovi studi nell'orbita di Duccio di Buoninsegna," *Antichità viva*, XI, 1972, pp. 3–15.

M. Salmi, "Il crocefisso di Segna di Bonaventura ad Arezzo," *L'arti*, XV, 1912, pp. 33–35.

J. Stubblebine, "The Role of Segna di Buonaventura in the Shop of Duccio," *Pantheon*, XXX, 1972, pp. 272–282.

———, "Segna di Buonaventura and the Image of the Man of Sorrows," *Gesta*, VIII, 1969, pp. 3–13.

F. Zeri, "Un politico di Segna di Bonaventura," *Paragone*, IX 1958, pp. 63–66.

SIMONE MARTINI

F. Bologna, "Povertà e umilità. Il 'S. Ludovico'

di Simone Martini," *Studi storici*, X, 1969, pp. 231–259.

C. Brandi, "Una sinopia di Simone Martini," *Arte antica e moderna*, IV, 1961, pp. 17–20.

———, "Stilentwicklung des Simone Martini," *Pantheon*, XIV, 1934, pp. 225–230.

J. Brink, "Simone Martini's 'Orsini Polyptych,' " *Jaarboek van het Koninklijk Museum voor Schone Kunsten Antwerpen*, 1976, pp. 7–23.

———, "Francesco Petrarca and the Problem of Chronology in the Late Paintings of Simone Martini," *Paragone*, XXVIII, 1977, pp. 3–9.

E. Carli, *Simone Martini*, Milan, 1959.

E. Castelnuovo, "Avignone rievocata," *Paragone*, X, 1959, pp. 28–51.

G. Contini and M. Gozzoli, *L'opera completa di Simone Martini*, Milan, 1970.

L. Dami, *Simone Martini*, Florence, 1921.

C. De Benedictis, "Sull'attività orvietana di Simone Martini," *Antichità viva*, VII, 1968, pp. 3–9.

B. Degenhart, "Das Marienwunder von Avignon: Simone Martinis Miniaturen für Kardinal Stefaneschi und Petrarca," *Pantheon*, XXXIII, 1975, pp. 191–203.

F. Enaud, "Les fresques de Simone Martini à Avignon," *Les monuments historique de la France*, IX, 1963, pp. 114–181.

U. Feldges-Henning, "Zu Thema und Datierung von Simone Martinis Fresko 'Guido Riccio da Fogliano,' " *Klara Steinweg in Memoriam, Mitteilungen des Kunsthistorischen Institutes in Florenz*, XVII, 1973, pp. 273–276.

W. Grob, *Simone Martini: Verkundigung 1333*, Zurich, 1970.

V. Mariani, *Simone Martini e il suo tempo*, Naples, 1971.

R. Van Marle, *Simone Martini et les peintres de son école*, Strasbourg, 1920.

H. Van Os and M. Rankleff-Reinders, "De reconstructie van Simone Martini's 3gn. Polyptiek van de Passie," *Festschrift H. K. Gerson*, Bussum, 1972, pp. 13–26.

G. Paccagnini, *Simone Martini*, Milan, 1955.

J. Pope-Hennessy, "Three Panels by Simone Martini," *Burlington Magazine*, XCI, 1949, pp. 195–196.

J. Rowlands, "The Date of Simone Martini's Arrival in Avignon," *Burlington Magazine*, CVII, 1965, pp. 25–26.

E. Sandberg-Vavalà, *Simone Martini*, Florence, 1950.

K. Steinweg, "Beiträge zu Simone Martini und seiner Werkstatt," *Mitteilungen des Kunsthistorischen Institutes in Florenz*, VII, 1954, pp. 162–168.

C. Volpe, *Simone Martini e la pittura senese da Duccio ai Lorenzetti*, Milan, 1965.

TADDEO DI BARTOLO

B. Cole, "Il Cristo in Pietà, un Taddeo di Bartolo trascurato," *Commentari*, XXV, 1974, pp. 279–280.

N. Rubinstein, "Political Ideas in Sienese Art: The Frescoes by Ambrogio Lorenzetti and Taddeo di Bartolo in the Palazzo Pubblico," *Journal of the Warburg and Courtauld Institutes*, XXI, 1958, pp. 179–207.

S. Symeonides, *Taddeo di Bartolo*, Siena, 1965.

C. Wolters, "Ein Selbstbildnis des Taddeo di Bartolo," *Mitteilungen des Kunsthistorischen Institutes in Florenz*, VII, 1953–55, pp. 70–72.

UGOLINO DI NERIO

G. Coor-Achenbach, "Contributions to the Study of Ugolino di Nerio's Art," *Art Bulletin*, XXXVII, 1955, pp. 153–165.

M. Davies, "Ugolino da Siena: Some Observations," *Klara Steinweg in Memoriam, Mitteilungen des Kunsthistorischen Institutes in Florenz*, XVII, 1973, pp. 249–256.

H. S. Francis, "An Altarpiece by Ugolino da Siena," *Bulletin of the Cleveland Museum of Art*, XLVIII, 1961, pp. 195–203.

H. Loyrette, "Une source pour la reconstruction de polyptyque de Ugolino da Siena à Santa Croce," *Paragone*, XXIX, 1978, pp. 15–23.

J. Pope-Hennessy, *Heptaptych: Ugolino da Siena* (Stirling and Francine Clark Institute), Williamstown, Mass., 1962.

SELECTED BIBLIOGRAPHY
for the Paperback Edition

BOOKS

W. Bowsky, *A Medieval Italian Commune: Siena under the Nine: 1287–1355*, Berkeley, Los Angeles, and London, 1981.

E. Carli, *Il Duomo di Siena*, Genoa, 1979.

————, *La pittura senese del Trecento*, Milan, 1981.

————, *Sienese Painting*, Florence, 1982.

B. Cole, *Sienese Painting in the Age of the Renaissance*, Bloomington, 1985.

F. Deuchler, *Duccio*, Milan, 1983.

U. Feldges, *Landschaft als topographisches Portrait: der Wiederbeginn der europaischen Landschaftsmalerei in Siena*, Bern, 1980.

J. Hook, *Siena: A City and Its History*, London, 1979.

H. Van Os, *Sienese Altarpieces 1215–1460*, I, Groningen, 1984.

P. Riedl and M. Seidel, eds., *Die Kirchen von Siena*, I, Munich, 1985.

J. Stubblebine, *Duccio di Buoninsegna and His School*, 2 vols., Princeton, 1979.

J. White, *Duccio: Tuscan Art and the Medieval Workshop*, London, 1979.

F. Zeri, *Italian Paintings: A Catalogue of the Collection of the Metropolitan Museum of Art: Sienese and Central Italian Schools*, New York, 1980.

EXHIBITION CATALOGUES

Mostra di opere d'arte restaurate nelle province di Siena e Grosseto, I, 1979, Genoa, 1979.

Mostra di opere d'arte restaurate nelle province di Siena e Grosseto, II, 1981, Genoa, 1981.

Mostra di opere d'arte restaurate nelle province di Siena e Grosseto, III, 1983, Geona, 1983.

Il gotico a Siena: miniature, pitture, oreficerie, oggetti d'arte, Siena, 1982.

Simone Martini e "compagni," Siena, 1985.

LIST OF ILLUSTRATIONS

Unless otherwise noted all paintings are in tempera on wood.

COLOR PLATES

INDEX

Icon Editions